Francesca Slooin

Obsessed by Art

Obsessed by Art

Aby Warburg:
His Life and His Legacy

Francesca Cernia Slovin

Winner of the 1996 Premio Selezione Comisso

Copyright © 2006 by Francesca Cernia Slovin.

Translated from the Italian by Steven Sartarelli

Library of Congress Control Number: 2006909300
ISBN 10: Hardcover 1-4257-3916-4
 Softcover 1-4257-3915-6

ISBN 13: Hardcover 978-1-4257-3916-4
 Softcover 978-1-4257-3915-7

This book was printed in the United States of America.

To order additional copies of this book, contact:
Xlibris Corporation
1-888-795-4274
www.Xlibris.com
Orders@Xlibris.com
35805

CONTENTS

1

THE RITUAL OF THE SERPENT

kreuzlingen, switzerland, april 23, 1924

Letting the pen drop onto the sheet of blotting-paper, he propped his elbows on the cramped arms of his chair and read slowly, in a soft voice:

"The annihilation of the sense of distance threatens to plunge the planet into chaos. The shrinking of space and time through modern means of communication has done grave damage to the human mind; nevertheless, myths and symbols, by re-establishing an area for reflection, a pause for contemplation, will restore the individual to his proper place in the history of civilization and will continue to stand as the restraints of conscience of which man is still greatly in need."

Thus concluded the lecture on the *Serpent Ritual*, which he was to give the following day to the community of patients at Kreuzlingen hospital, which had been his home now for more than six years. He had rewritten those closing lines at the bottom of the page, in keeping with his custom of jotting notes and disorderly variants next to every sentence. That unsteady, unpunctuated handwriting, with its disconnected, unfinished letters, expressed an anxiousness to capture on the white surface of the page the ideas that rapidly came to his mind. The little slips of paper with his notes, which nobody could really decipher, were always eliciting reproaches and protests from colleagues. They didn't understand that writing was, for him,

an intermediate phase, a pause between formulating a thought and conveying it; everything else was just ornament and empty literary exercise. Only when read aloud, when enlivened by an extemporaneous comment or a spontaneous repetition, did the text assume its full significance.

For some years, in fact, Fritz Saxl actually forbade him to write, choosing to take down Aby's dictations himself. He said that Warburg would otherwise have gotten too tired, and that, "in his condition," excessive writing would have weakened and further confused him . . .

Under the hospital's porch, with its too-slender columns and somewhat disconnected flooring, he would dictate for hours, sometimes too hurriedly, sometimes stopping for long pauses, while Saxl, crouching on a wooden bench, his limbs stiffening from the lakeside dampness, diligently transcribed his words. Sometimes above the sound of his languid voice a distant clatter from the kitchen could be heard, announcing the approach of the evening meal; the sound of that gentle din of pots and pans would reawaken his hunger, making him lose concentration and look for childish excuses to bring the exposition to a rapid end. At other times, however, he would unexpectedly break off for long pauses that increased in duration until they became a continuous, stubborn silence, as though the chill invading his mind were numbing his lips as well. Caught in that terrible, uncontrollable immobility, he would look on helplessly as his friend discreetly took his leave; he would see Fritz slip away into the faint light of dusk after making sure that his blanket was well tucked in about his legs, withdrawing almost on tiptoe, clutching those pages in his hand and imperceptibly shaking his head, while his own body lay drained and stiff in that lonely darkness.

Yet during the years of his stay at Kreuzlingen, he had never stopped harboring suspicions about Fritz Saxl—his disciple, trusty assistant, and friend. For years he had believed Saxl was destroying his work, altering the order and significance of his famous library, and most importantly, secretly publishing the notes he kept squeezing out of him during his visits. For years he had believed that the usurpation he had suffered, and his

internment at the clinic, were actually the results of a conspiracy, and he had begun to doubt everybody, even his own family. Why had Mary accepted all this? Why had Max not taken his side? Why did none of them do anything to protect something that was slipping from his hands but nevertheless still belonged to him?

Now, however, the panic had subsided; now he could look at Saxl with less mistrust and resentment. Poor Fritz: he was so quiet, and so tenacious. Perhaps he really did want to help him; he was, after all, the sole witness to all the work, which was in danger of foundering. The text of the *Ritual of the Serpent*, in any case, could never be published; it was only a chaotic jumble of pages on which he had jotted down (in his own hand, this time) the necessary notes to accompany a vast photographic display. Nevertheless, today that lecture was of vital importance: it was his passport to freedom, the proof of his mental and physical recovery. Tomorrow the clinic's doctors, and Dr. Binswanger himself, would attest to his mental fitness and finally allow him to return home, to his work and his family.

The topic of the serpent—he thought, overcoming a slight trembling in his hand—was a real challenge. He had chosen as the lecture's protagonist a ubiquitous, ancient symbol capable of penetrating every credo and superstition, of slithering from the unconscious into the shadows of dreams, inspiring fear and demanding worship. During his attacks, that seductive image, which appears time and again in the figurative arts of the millennia, would transform itself into a sensation of terror that built its nest in his entrails, debilitating as a disease, erosive as gangrene.

Yet the serpent he was to speak about the following day was not the one that had dwelt inside him for years, nor was it the snake that adorned the heads of the Maenads in their wild dance, nor the one that had lured Adam and Eve into the realm of sin, or the one that tangled Laocoon and his sons in its vice-like grip. The serpent he was to speak of was the vigorous animal twisted about the staff of Asclepius, god of health and healing; it was the only living creature which in changing its skin went on living—indeed, began a new life, from the beginning.

He would be very careful to conceal, from the suspicious doctors and impressionable patients, the other lives of that polymorphous animal. He would make no mention of the times when it had been the object of his obsession for days on end, or when, angered by his resistance, it would wriggle to the surface and stay there, right under his skin, between the muscles and veins, and make him howl in fear and pain. He would forget that viscous, undulant spiral that had tried to strangle him in his sleep, hissing into his ear the sinister phrase, "*la folie circulaire, la folie circulaire . . .*" It was the very same hiss he had heard on one of his first nights at Bellevue, when Binswanger stood behind his door whispering to an assistant. He could never forget that night: a white reflection behind the door of glass, a satanic whisper and then sleep, a long, deep sleep. Perhaps it had been something more than sleep, a veritable journey into the darkest, remotest region of his illness, a visit to that region of Hades which even the demons shun, where darkness has devoured the shadow.

And today he had succeeded in returning from such a place. When, after many years, he realized he had come back to the threshold of reason, he recalled the age-old habit of the serpent that sinks down into the earth for long periods of time and then reemerges after a long hibernation.

For the Pueblo Indians, the serpent—he now recalled nostalgically—is the symbol of lightning, bestower of rain, water and life. The *humiskatchina* dance, which he had seen performed so many years ago in the market square of the village of Oraibi, follows the sinuous rhythms of live snakes. The shamans, protected by colorful masks, clutch the venomous animals in their hands, where they become a symbol of man's power over the forces of nature, a sacred antidote to the threat of drought.

It had been more than twenty-seven years since that journey; yet it was the very thing he wanted to talk about on his departure from Kreuzlingen. It had not been an escape, as Binswanger maintained, not at all; rather, it had been a return, a voyage back in time, an immersion into the dawn of humanity.

*

When, in September of 1885, he had arrived in New York with the entire Warburg family and a great many Hamburg notables, his physical and mental condition had unexpectedly taken a turn for the worse. The feverish pace of the city, combined with the frenzy of his brother's wedding, had plunged him into a state of senseless confusion.

After a year of protests, his father, Moritz Warburg, had finally consented to the marriage of his youngest son, Felix, Aby's junior by five years, with a young woman named Frieda Schiff. In the family annals, this event proved to be one of the many failures accompanying the many successes.

Grandma Sara, repository of the clan's secrets and pride, loved to say, on important occasions, that the Warburgs belonged to the purest Jewish aristocracy of Europe; it was no accident that Moritz, "her son" (as she liked to emphasize with a pause), was the leader of the 16,000-strong Jewish community of Hamburg. Although the M.M. Warburg Bank was founded in 1798, the Warburgs had ranked among the most powerful bankers of Germany as early as the 16th century. The family's more distant roots could be traced back to Italy, however, and their original name, Banco, left no doubts as to the source of their tradition. From their beginnings in Pisa, the Bancos had eventually moved north to Cassel, where they took on the name Von Cassel; they later settled in Warburgum, near the boundary with Westphalia, which gave them their current name. Having fled the persecutions of the Counter-Reformation, the Warburgs began to multiply and to root their professional expansion in safer ground. Through well arranged marriages consistent with the family's class and religion, the Warburgs' power had gradually grown and established its influence in all the major commercial centers of the old world. "Thus our great genealogical tree," Grandma Sara used to say with a severe but satisfied air, "became solidly grafted with branches of the Oppenheims of Frankfurt, the Rosenbergs of Kiev, the Ginzburgs of Petersburg, and the Ashkenazis of Odessa." Yet the stern woman, with her starched lace bonnet and her hand-embroidered shawl draped impeccably about her shoulders, always omitted saying what all of them knew to be true (though from other sources): that is, that the

architect of these strategic alliances had been she herself, Sara Marcus Warburg, absolute mistress and unyielding guardian of the Bank and the family's power.

At the time of Aby's birth, the Warburg family consisted of two main branches: Sigmund's (whose offspring had kept the initial S. next to everyone's name) and Moritz's (whose children and grandchildren bore the letter M.). By the end of the 19th century, when Aby and his six siblings were in the full flower of their youth, the Warburgs were a veritable institution in the city of Hamburg, and with such an impressive array of young scions the dynasty looked to grow still more in size and power. Felix's stubborn passion for Frieda Schiff was therefore a kind of lightning bolt in a clear blue sky: his father and grandmother had other plans for that capable, intelligent young man. With the second son, Max, having acquired fifty percent of the Bank's stock, Felix was supposed to follow a career as a lawyer. And after Aby's "treason," there simply was no more room for rebellion.

Yet between Felix and Frieda it was love at first sight, and the parents' opposition only strengthened their bond. The Warburgs looked on Jacob Schiff, Frieda's father, as a poor immigrant who had come to America to forget his humble origins and had managed to win the trust of Solomon Loeb, marry his daughter, and insinuate himself into the family bank. Even though he had, by then, become one of the richest men in America, the chief executive of the Loeb Bank and the architect of the growth of the Union Pacific railroad, old man Schiff never succeeded in overcoming the mistrust of his future in-laws. Aby never quite understood whether the hostility shown by his father on that occasion was the fruit of jealousy and envy or a genuine disapproval of someone who had betrayed his Ashkenazi origins and had preferred that "country of savages" to the solid civilization of Central Europe.

Upon the Warburgs' arrival in New York, therefore, an atmosphere of restlessness and alternating moods began to reign in the family. There were arguments, quarrels, and reproaches followed by a succession of reconciliations and enthusiasm.

And then a great flurry of preparations and ceremonials, a carousel of clothes and gifts. With their future sisters-in-law the Warburg sisters discussed the differences between European and American fashion; the brothers and future brothers-in-law compared horse races and horsepower levels in the automobiles. Meanwhile the mothers were putting the finishing touches on the elaborate preparations for the ceremony.

Aby felt like a fish out of water. That gigantic metropolis unnerved him, even though friends and family kept repeating:

"It's the city of the future, the civilization of tomorrow, man's great wager." He would look at them bewildered and disgusted, but he had a good excuse for fleeing all that useless chatter: he went to Washington, where he established contact with the Smithsonian Institution and met Adolf Bastian, one of the most famous pioneers of anthropology in America, who very enthusiastically encouraged him to undertake his journey to New Mexico. The Smithsonian, in fact, approved highly of his initiative, for it was an excellent opportunity to obtain precious information, at no cost to themselves, from the efforts of a wealthy, self-employed scholar.

At the Schiff apartment on Fifth Avenue, meanwhile, Felix was establishing lively relations with New York high society. An incurable dandy, he never missed a fashionable event: he would have sold his soul for a *chic* party, a fast car or an enchanting woman. Felix had more lust for life and curiosity about the world than all the other Warburgs combined. With his large, flashing eyes, his great curling mustaches, his elegant bearing and clothes, Felix was a character not easily forgotten. His optimism and opportunism blended together like savory spices in an exquisite dish; his ironic, unrestrained manner of speech could disarm the most skeptical of interlocutors and seduce the most disdainful of women. His hand-kissing became legend among the debutantes: it was beyond reproach, yet ever so slightly suggestive. At age eighteen, during his stay in Frankfurt, Felix had created a big stir with his romantic affections for Clara Schumann, seventy years old at the time. The composer's widow, in certain ways not unlike Felix herself, was a masterly

make-up artist as well as a peerless matron of literary salons. It was, in fact, at one such celebration given by Mrs. Schumann for her cosmopolitan friends that Felix had first met Frieda. The rich American girl was immediately informed that this attractive gentleman was the most sought-after bachelor in town and that, with so much competition, there was little hope of ever attracting his attention. Frieda, however, a spoiled girl with "a laugh that had the ring of money," understood men better than her advisors imagined.

And so the day of the wedding finally arrived. The ceremony was celebrated by no fewer than two rabbis: Jacob Schiff did not want to miss any opportunity to show off his wealth and influence in the New York Jewish community. The great ball at the Plaza Hotel was a parade of the most illustrious names, the smartest dresses, and the brightest jewels in town.

On that very day, however, an unexpected "accident" threw a wrench into poor Moritz Warburg's plans.

The third son, Paul, a serious, introverted intellectual, was himself struck by Cupid's arrow. Nina Loeb, Frieda's young aunt her own age, who, like Paul, was a witness to the marriage, began to cast languid glances at him through the veils of the *chuppah*. Paul at first pretended not to notice, but they became so bold that after the first rabbi's sermon he couldn't help but return her attentions with a discreet wink. The ceremony, meanwhile, continued with the customary rituals: chants, prayers and sermons echoed within the temple walls. Nina and Paul were by now immersed in an ardent, mutual courtship, and when the groom broke the traditional glass against the ground, they both gave a start, as if it were their own emotions that had just burst in air. They soon regained their composure, however, during the sumptuous dance that followed, which aided Nina in her designs. For hours they circled round and round in each other's arms under the crystal chandeliers. Paul remained somewhat overwhelmed and confused, but Nina, a resolute woman like her niece, had already made up her mind.

A few days after Felix and Frieda's departure, Paul and Nina announced their engagement. Moritz had thus lost two of his sons to America, and a branch of the Warburg family had been

firmly grafted onto one of the most powerful Jewish families in the world.

Aby would not wait to attend the second marriage. All those crazy events had bewildered and confused him. He needed peace and solitude. Leaving the East Coast, with its excesses and its childish thrills, was like jettisoning unwanted ballast.

*

It was November 1896 and he was finally on his way to Albuquerque. The reassuring rhythm of the rails seemed to recite an ancient tribal invocation. As the chaotic urban agglomerations began to thin out around him, primordial colors and shapes appeared on the horizon. Having quit the pale, unhealthy life of the city, he felt entranced by the strength of the mountains slowly rising up in his milieu. Great walls of stone surrounded the plain where dense clumps of juniper scented the air and tempered the harshness of the landscape.

Heading then north to Santa Fe, he traveled for long stretches on horseback. He savored the pleasure of that hot, dry air, which roused him from his torpor. Pleased by the horse's rhythmic sway, its panting breath keeping time with its slow but sure steps, he was comforted by the barely audible squeaking of the saddle, slight noises enhanced by the wind. In front of him the guide, nearly motionless on his mule, now and then mumbled incomprehensible remarks that quickly evaporated in the increasingly rarefied atmosphere.

They had left behind their first two travel companions in the village of Laguna: a Mormon with a long, unkempt beard and an Irishman given excessively to bursts of song. Now he was all alone with that olive-skinned man with long black hair. They climbed up narrow paths between the rocks and the emptiness below; one by one, the narrow gorges of Kearn's Canyon opened up before them. Atop these plateaus, among villages of adobe and dung inhabited by peaceful Indians, he was searching for the origins of the symbols that had helped man to represent the world and ward off its harm: signs and symbols that had crossed space and time and which in their endless transformations had left indelible

marks on the history of civilization. The representations of the serpent on the pottery and the walls inside the Pueblo homes had spanned the globe more than twenty-five centuries earlier: starting from Eastern cultures they had found their way into ancient Greek civilization and from there had returned to the East through an unceasing migration in many different forms and aspects. The drawings that little Anacleto Jurino had given him on the day of his arrival had something remarkable about them. The boy's father, a teacher of drawing at the school in Cochiti, had encouraged his son to welcome the important stranger with a drawing. Affable and obedient as all Pueblo children were, Anacleto had thus waited for Aby outside the village church, holding some large sheets on which he had depicted in colored chalk his idea of the world. Aby thanked him graciously, bid him an affectionate goodbye and left on his horse for his next destination. Once he was settled in his saddle, however, he turned his attention to his newly received gift and was astonished by it. That childish image of the cosmos contained the very same age-old symbols that had managed to survive the superimposition of subsequent cultures and the monotheism of the colonizers. He realized then that he was on the right path: in that land of fluid time, he would find the foothold he was looking for, a stairway to descend and re-ascend in a new theoretical dimension. He knew he would have to step down from the history of art to the history of religions, and from anthropology to psychology, if he was to grasp the meaning of those vestiges that from the depths of individual consciousness are deposited in the collective memory and finally re-emerge in the culture and art of a people.

After two days' journey, Aby had reached the top of the plateau where the village of Walpi was situated. There the drought had left deep scars in the walls of the houses and on the people's faces. The provisions he had brought afforded a moment of euphoria to a hospitable population otherwise unaccustomed to receiving visitors. Once again he was showered with gifts and expressions of welcome; once again he displayed his camera with the mannerisms of a magician; and once again he was compelled to smoke the long peace-pipe, whose bitter taste made him terribly dizzy.

At night, he would spend long hours outside, in the open air, between the still-warm cobblestones and the already cold wall of the house, contemplating the celestial vault, which looked as pure as at the time of creation. He tried to imagine the bewilderment that primitive man must have felt when gazing into that darkness, and the fear that those chaotically arrayed lights had inspired in him for so many centuries. What daring and effort it must have taken to chart out the constellations and make them comprehensible to our intellect! He knew that the constellations and the signs of the Zodiac, the antique cosmogonies and its mythologies, were bound by profound links and relations of cause and effect, but he was not yet able to grasp these and clearly identify them; they belonged to the same universe of symbols that he was investigating, whose centripetal force was threatening to engulf him. Whenever this force seemed to seize his limbs and press hard into his stomach, he would try to lift himself a little further up, to slough off part of his heavy cover of blankets; then sighing deeply, he would try to bring new light to his tumultuous search.

Then that feeling of calm and purity, which he needed so much, would return. At such moments it was hard to believe that only a few weeks had passed since he had left behind the chaos of the city and all the people.

2

BORN IN HAMBURG, JEWISH BY BLOOD, FLORENTINE IN SPIRIT

Now, revising his notes, Aby looked up from time to time at the motionless expanse of water before him: from the window, Lake Constance seemed to lie there with a stillness reminiscent of late summer afternoons. Binswanger's clinic gave onto the southern arm of the lake: to the right, in the distance, rose the white-spotted foothills of the Alps; all around and to the west, the tilled fields of the Thurgau lay in orderly rows. At sunset, when the lake's surface would ripple with reddish reflections, depositing the night's first shadows at the water's edge, the memory of the olive trees and cypresses of Tuscany would seize his thoughts: it was a nostalgia for a country, more than for a time or an era, and in the melancholy peace of Kreuzlingen, it made him feel even more isolated and foreign. Florence, a place of the soul to which he would flee from the walls of his room, was the country of his youth and his studies: he had met Mary there, and there he had amassed his first, modest collection of books, and discovered the Renaissance. Yet he was indebted to that generous, intense city for perhaps even more than this, for there he had discovered emotions that in his original milieu he had had to ignore and repress.

The strict bourgeois upbringing and Spinozan ethics of their Jewish background had carefully purged the Warburgs, from a very young age, of all manifestations of emotion and unreason.

He was taught that the fortunes of the family depended on the sense of responsibility of every member. In his house, it was the women, almost more than the men, who taught and perpetuated this strict sense of duty in the young, making no concessions to the impulses and weaknesses of the heart. Being a Warburg, moreover, also meant being German, being a German of Hamburg, where Prussian traditions had successfully wed the spirit of the Hanseatic League.

In that sweet, sensual land to the South, on the other hand, he had at last been able to let himself go, to find an inner harmony in which the separate features of his character might finally fuse and coalesce. His nerves had always been fragile and tense, anxiety lying in wait, ready to destroy every instant of serenity and well-being. And yet at that time, at least, he had been able to overcome that threat in the moments of crisis. In a country where all expressed their moods without hesitation or shame, his anxiety would evaporate upon contact with the people, with a handshake, a pleasant joke, a glass of wine. He had absorbed this sort of extroversion so faithfully that at times he was taken for a Florentine. He had so well learned all the subtleties of the dialect and the language of gesture, all the figures of speech, the manners of feeling and communicating, that when asked what his origins were, he used to say jokingly that he was *amburghese di nascita, ebreo di sangue, ma nell' animo fiorentino* (born in Hamburg, Jewish by blood, but Florentine in spirit).

Even when the anxiety gave way to leaden moods, the lights and colors of Florence were still able to lift his spirits. He would walk for hours on end, wandering the narrow streets that unexpectedly gave onto a small bridge or a piazza of Euclidean proportions; he would look up at bell-towers and domes or venture down to the Arno's banks and delight in the miracle of that perfection. But the contours and colors of an architecture so simple and majestic displayed "balance" above all—an equilibrium that was not the product of stasis but of a fluid oscillation between opposing forces, of fusion and synthesis. And was it not balance that he needed most? While roaming those streets and piazzas, he was studying their components,

striving to assimilate their governing principles, to uncover their mystery.

*

He had arrived in Florence on a cold October morning. The southward journey had seemed as though it would never end. Having just turned twenty three, it was his first real separation from the family. He had brought with him a new wardrobe of grey flannel suits, a perhaps excessive amount of accoutrements and accessories and a carefully selected number of art-history books bound in white vellum or red morocco leather.

Having left the two friends in whose company he was supposed to spend his stay in Florence, he entrusted his bags to a porter from his hotel and headed off, still dazed from the train, toward the center of the city.

Under a crystal-clear sky, Florence displayed an extraordinary riot of colors and voices, and an endless gamut of faces still bearing the features of an ancient beauty. After crossing Piazza della Stazione, he skirted the side of a church for about a block. At that hour of the morning, the cobblestones and the walls of the surrounding buildings were pink in color, perhaps a mere reflection enhanced by the tufts of green jutting out along the low stone walls.

Turning the corner, he suddenly found himself in front of Santa Maria Novella. Centuries earlier, Leon Battista Alberti had given this gloomy Gothic structure a polychrome facade of splendid proportions. He let his gaze run slowly over the smooth marble surfaces, through the modular play of inlays, over the solid, powerful mass of the lower structure, which grew light and agile as it rose, a contest between equilibrium and elegance.

The darkness inside the church allowed his tired eyes a moment of rest. He walked slowly up the nave, waiting for his pupils to adjust to the diminished light. Out of the indistinct darkness, structures and images began slowly to emerge, and with them, the colors and details. The Gothic vault overhead entwined the upward sweep of its lines in a play of blue-green inlay, while the stained glass lancets of the choir in the

background cast a richly colored beam of light onto the pale flagstones. To his left Masaccio's *Trinity* seemed to bid him a solemn welcome. He continued on towards the main altar and then the Tornabuoni chapel, where he finally stopped, for a long time, drawn by those frescoes and their irrepressible vitality. His eyes began to wander quickly and attentively from one image to another, from one detail to another, while his mind ran through an endless series of observations, connections, and reflections. Hidden beneath the trappings of Biblical characters, the faces, gestures and eyes of those figures actually belonged to the Medicis, the Tournabuonis, the Bencis and Albrizzis, to Poliziano and Ficino, the summit of the economic and cultural power that ushered in the age of the Renaissance in Florence. It was a world that held a special fascination for him: the great Florentine patrons appearing in the frescoes of Ghirlandaio had been bankers, like his own ancestors, and the milieu in which they had operated was not that much different, after all, from that of the modern Hanseatic traders in whose midst he had grown up.

Among the stories of the *Blessed Virgin*, he was especially struck, in the *Birth of Mary*, by the pearly luminescence of the face blossoming from a rich brocaded dress, probably a portrait of Giovanna Tornabuoni; and he paused in amusement to study the variety of facial expressions in the crowd in the *Angel Appearing to Zachariah*. Then, looking up, he saw the *Birth of John the Baptist* where Elizabeth lay down from fatigue on her bed, while the midwives coddled the newborn with motherly solicitousness. A scattered light filtered into the room, brightening the long necks of the crystal bottles on a tray of victuals brought in by a maid. Three young women approached the bed with elegant, measured steps; in one of them he recognized the serene, aristocratic face of Lucrezia Tornabuoni. These were the ladies come to pay their respects and bring presents to the mother. Yet that atmosphere of peaceful domestic intimacy was broken, on the right-hand side of the painting, by a young maiden bursting into the room with a great copper tray on her head, laden with fruit; her flowing dress tousled by her sudden movement was more Classical in cut, while the rather simple

style of her hair gave relief to her delicate profile. On the tray lay a ripe pomegranate, fleshy and slightly open like her lips, a visible echo of the maiden's sensuality.

Aby was perturbed by this image; he couldn't take his eyes off that seductive figure. That lively, light-footed gait, that irresistible energy, that striding step, which contrasted with the aloof detachment of all the other figures, what could it all mean?

"I lost my heart to her," he confessed years later to his Dutch friend, Jolles, in his rich correspondence on that dazzling vision, "and in the days of preoccupation that followed I saw her everywhere . . . In many of the works of art I had always liked, I discovered something of my Nymph. My condition varied between a bad dream and a fairy tale . . . Sometimes she was Salome, dancing with her death-dealing charm in front of the licentious tetrarch; sometimes she was Judith, carrying proudly and triumphantly with a gay step the head of the murdered commander; then again she appeared to hide in the boy-like grace of little Tobias . . . Sometimes I saw her in a seraph flying toward God in adoration and then again a Gabriel announcing the good tidings. I saw her as a bridesmaid expressing innocent joy at the *Sposalizio* and again as a fleeing mother, the terror of death in her face, at the Massacre of the Innocents. I lost my reason. It was always she who brought life and movement into an otherwise calm scene. Indeed, she appeared to be the embodiment of movement . . . but it is very unpleasant to be her lover. Who is she? Where does she come from? Have I encountered her before?"

In his moments of deepest dejection at Kreuzlingen, he liked to think back on her image as he had described it to his friend: as though the most beautiful butterfly in his collection had burst through the showcase in which it was resting, and flown away. When he felt the sanatorium walls begin to close in on him, he would remember the thrill that this symbol of lightness and freedom used to give him in his younger days. For many years he had wondered why she aroused so much emotion in him. Why did that image have such power over

him? There was certainly a strong erotic appeal in it, something secret and profound. Perhaps it tempted him to seize what could not be seized, to stop what could not be stopped, to possess the impossible. Yet in the years when he first began to settle into his vocation as art historian he had felt the need to overcome so visceral a response and to translate it into more theoretical terms. Amorous intoxication would have to give way to intellectual pleasure. The butterfly, after all, had first been a caterpillar: she had been created by history, and if as a sedentary scholar he was incapable of leaping forth to snatch her from the air, his philological abilities might enable him to recapture her past. The ability to "look backward" would thus transform individual experience into historical research, and retrace in her a still living past. From that moment on, he would pursue her in all her various aspects: as Nymph, handmaid, pagan goddess in exile. He would recognize her in the cold surfaces of Roman sarcophagi and the soft curves of Greek pottery, amid the cracks of medieval engravings and in the splendid frescoes of the Renaissance. He would study and analyze her until she became a model of figuration, a symbol of classicism and beauty.

*

The hotel where Ulmann, Burmeister and Aby had taken up residence was somewhat dilapidated but right in the center of town. After a day of work and study his two friends usually headed to the Corso in search of distraction, while he himself liked to browse in the antiquarian bookstores. Those in Florence had that same smell of dust and dampness that he loved to breathe in the bookshops of Bonn, Munich and Hamburg, and in which he had often taken refuge to escape his adolescent frustrations.

During the long dinners at the house on the Mittelweg, around a table set with English porcelain and glistening Bohemian crystal, Aby, sporting his first grown-up mustache, had been subjected to incessant, humiliating reproaches. Grandma Sara would have liked him to become a rabbi; his father wanted him to be the heir to the M.M. Warburg Bank; his mother saw

him as a man of law and the worthy perpetuator of the family traditions. Amidst all the complaints, voiced in the flickering light of an imperious silver menorah, he used to feel confused and prey to conflicting emotions. His desire for rebellion clashed with an oppressive sense of guilt, and his attempts to seek support from the siblings closest to him—Max and Olga—always met with a desolate silence. It was at such times that he sought refuge in books. No sooner was the meal over than he would race to the little bookshop in the Poststrasse, sit down in a corner, behind the shelves, and spend hours thumbing through the pile he had left half-read the time before, his fingers running slowly, carefully over the pages.

None of the luxuries to which he was accustomed—the sumptuousness of the family house, the smartness of his wardrobe, the sober elegance of the oak carriages, the aesthetic perfection of the objects surrounding him—could give him the same sensual pleasure he found in the smell of a book, in the feel of the leather in which it was bound, the solid structure of the spine, the smooth gloss of the paper. Books were the silent companions of his solitude, constant presences in his day-to-day-life, silent receptacles of his dreams and desires.

He was looking for something among those pages, but he didn't know quite what. He was, moreover, convinced that in a book one never found only what one was looking for, but much more. Opening a book was almost a sacred act: it was disclosing a world. He would run his forefinger over those strong bindings as if wanting to assure himself of the objects' wholeness; he would open the first page and carefully read the author's name, the title, the year of publication; he would slide the palm of his hand over the frontispiece, savoring the low relief of the characters on the page. At last he would open the volume at random, usually at a point somewhere in the first half of the book, wondering whether he might not find what he was looking for on that very page. Art books—the ones supplemented with images, sometimes actual prints—exerted an irresistible power over him, but then so did books of science and literature, when they were illustrated. As a very young boy he had discovered an edition of Balzac's *Petites misères de la vie conjugale* with illustrations that he would

never forget; those devilish images had tormented him without respite during his bouts of typhoid fever and came back to him in nightmares every time he had a troubled sleep.

His love of books had begun long before he ever started school. He used to look with envy on the ability of adults to hold a book in their hands and read: he would watch his Grandmother Sara, an avid reader of poetry and the Talmud; or father Moritz, who had a passion for history and political writings, and the mother, Charlotte, whose literary tastes reached levels of great refinement; he would watch his Uncle Sigmund, a devoted reader of the classics; and Franziska, the governess, who every evening, before going to bed, would read a passage from the Old Testament or a parable from the Gospels.

When he finally did learn to read, the doors to his father's library were opened to him, with no restrictions or limitations. How many hours he used to spend in that room. With its heavy mahogany paneling, it was as protective and reassuring as the womb itself. In that place reigned a silence and atmosphere pleasant in any season, while through the windows a silvery light filtered by the tops of the poplars would fall right in the middle of a big leather armchair. At the center of the room, adorned with sober, tasteful objects, there stood a long, stately desk on which lay rows of pens and reams of handmade paper. The books, arranged according to discipline and author (an order that Aby did not agree with, and never would), lined the room's four walls with faultless precision; the colors of their spines blending harmoniously together, their widths describing smooth, symmetrical curves.

The library was his kingdom. He used to enter it the way someone soaked to the bone from the winter rain sinks at last into a big hot tub. He would settle into the act of reading with similar caution, with a slow rhythm interrupted by regular breaks, sometimes to follow the train of his own thoughts, sometimes the flight of a fly; then, after a few pages, his attention would become more focused and the rhythm lighter and quicker. The outside world would then gradually disappear, and after a few hours of reading, one could speak, shout or shake little Aby, but he wouldn't hear or react. He was "reading." In his effort

to concentrate, he used to clench his jaws without realizing, and when he did have to close his book for certain unavoidable interruptions (meals, school, music and French lessons), he would open his mouth and twist his face up into a series of odd grimaces.

The book—which rarely took him more than two or three days to read would then be laid furtively in a corner of his room. Only if forced to do so would he return it to its rightful owner. Possessing a book was in fact a matter of great importance to him. It wasn't enough merely to have read it; it had to remain there, available for all future and repeated consultation, a reassuring presence.

The number of books in his room thus began to grow: they were carefully lined up on the shelves, piled on the desk and the bedside table, hidden in the dresser and under the bed. They were books that he had taken from his father's library, that he had borrowed from the school library or had begun to buy with the few pennies of his allowance and the few additional pennies he secretly borrowed from his brother Max.

He had made a pact with Max. Toward the end of September 1879, Aby and Max had met under the great fir tree in the garden of Mittelweg, where the younger brothers used to gather to tell ghost stories. There was still a late-summer warmth in the air, and the clouds of the morning had since been swept away by a light wind. Supper that evening was late in being announced, and while the little ones were getting ready for bed, Aby and Max proudly enjoyed the freedom granted them as elder brothers. Aby was thirteen at the time, with deep, spirited black eyes and an olive complexion that recalled the Mediterranean traits of his mother; Max, on the other hand, was blond, with blue eyes and a soft, sincere smile, and though one year his junior, was taller than Aby. Aby felt endless admiration and envy for Max's candid, confident manner and his sincere gaze, which seemed to offer friendship, understanding and security.

Under the great fir that day, Aby offered Max his own birthright as firstborn in exchange for the promise that he would buy him all the books he might want. The majority share of the M.M. Warburg estate would thus go to Max on the condition

that he should agree to pay for any and all books his brother might request.

He still remembered that intense, impassioned conversation, the emphatic adolescent tones with which he had tried to make his brother understand how important culture and knowledge were to him. He wanted to devote himself to study and research, not to making money. If Grandma Sara wanted him to be a rabbi, perhaps it was because she had already sensed that vocation in him. He had no desire to become involved with the bank and take upon himself the weight of relations with the world of finance and politics. Max was much better suited to that sort of thing: he was stronger, braver. Aby only wanted the company of books, wanted to collect, accumulate them, own as many as possible.

The pact was sealed with a long handshake and a warm embrace. Max was astonished, but he could not hide his sense of satisfaction and elation; Aby, on the other hand, retained his solemn expression.

Neither of the two brothers ever violated this oath or betrayed the friendship and complicity established between them that day. With the passage of time, these feelings actually became stronger and deeper, and their destinies, while diverging, remained inextricably intertwined

*

In Florence too, in the spacious hotel room from whose window one could see a stretch of the Arno, the books began to accumulate, first on the shelves at the entrance, then on the desk and on any other available surface, then finally on the floor, where tall stacks grew in every corner of the room.

Having by now mastered Italian, Latin, and finally Greek, he devoured the *Treatises* of Vitruvius and Alberti, Vasari's *Lives*, and Ovid's *Metamorphoses*, while discovering Poliziano, Marsilio Ficino and Pico della Mirandola. But the money was beginning to run out: all those frequent and costly purchases quickly drained his savings and the monthly allowance that his family had allocated for his stay abroad.

In the letters to his parents, he skillfully balanced news of his research with requests for money; he unveiled the subject of his studies little by little, while imploring them to send more money so he could buy the books he needed. In the end he confessed to having acquired a considerable number of them, yet he added that he had to expand and develop the collection further still, to make it a living, growing thing that would keep pace with his expanding interests. In the letters addressed exclusively to the mother, however, he actually made illicit requests, asking her, for example, to send little sums that would not be recorded in the account books, or small objects that he could sell without their absence being noticed. And only his mother did he tell, in great detail, of his studies, recounting their development step by step.

"Winckelmann, *chère maman*," he wrote in a tone a bit presumptuous for his age, "got it all wrong! The serene grandeur of which he spoke was anything but serene; it was animated by a Dionysian spirit, a pathos that Nietzsche alone had been able to grasp, to understand. Winckelmann's vision is completely erroneous and misleading: look at the fluttering veils and togas in Greco-Roman sculptures and bas-reliefs. Do they not perhaps suggest the violent, agitated movements of the body? And are such movements not outward expressions of emotion, of inner passion? In the Renaissance, *chère maman*, the human figure finally bursts tree of the rigid cocoon in which it had remained during the Middle Ages and once again represents life as it is lived, no longer a moral pronouncement or image of sacred texts as it had been in prior centuries. In the Renaissance, it moves and is moved, it rejoices and suffers; it runs, fights, dances, loves. In the Renaissance, the Classical pathos returns, giving the human body a new gestural emphasis."

Despite such obvious enthusiasm for his research—reports of which were for now directed only at the limited circle of his family—Aby always felt a strong need for confirmation. Every new idea first had to be verified by a great marshalling of documents, images published or conserved in archives. It was not a question of insecurity, however, as his friends used to maintain; it was, rather, a question of rigor. He was incapable

of making conclusions without having first examined every detail of his hypothesis with the caution of a jeweler and the fussiness of an accountant. He had in fact a real aversion for groundless hypotheses advanced merely to impress, and this often distanced him from Ulmann and Burmeister, whose intellectual arrogance he found rather unpleasant. Unlike theirs, Aby's propositions were always supported by a philological rigor of which he was rather proud. Of late, however, the two friends had learned to keep silent when the subject was one in which he was stronger.

Months earlier, when his teachers had suggested he study the theme of movement in Classical and Renaissance art, he had started by analyzing the *Laocoon*, which led him to read Lessing's work of the same name. Ulmann and Burmeister, his childhood friends and later university colleagues, had emulated his daring intellectual choice and decided to follow him in exploring the question, comparing the works of Masolino and Masaccio. This was first suggested by Professor Schmarsow who invited them, the year before, to come to Florence and develop the study of these two painters. When the three later returned for a longer stay, they spent entire days in the Brancacci Chapel, hungry for discoveries and new theoretical formulations. The church of Santa Maria del Carmine, in which the Chapel stands, had a constant flow of tourists, many of whom would stop in curiosity and watch the three young men as they argued endlessly in loud voices, forgetting they were in a church. Ulmann had suggested analyzing Masaccio's frowning faces and the laconic gestures of the Apostles in the *Tribute Money* before confronting the more general subject of movement. Aby, however, was not satisfied: reading Darwin, he had discovered that facial expressions are the symbolic residue of a feral gesturality, of acts once biologically useful in communication among animals. Thus broadening the field of investigation, he wondered to what extent a symbolism analogous to that identified by Darwin was also evident in gesture. The study of gesture in Classical art had to begin with the study of the draperies through which the motion of the body was conveyed. Following the extreme of medieval representation, where the human body remained

motionless and unnaturally rigid, the Renaissance asserted the opposite of this extreme, and yet in a certain way absorbed it as well, becoming a balance of contrary forces, a triumphant reconciliation of extreme immobility and extreme motion. Thus the Renaissance concept of *pathos* was to be understood as "e-motion" in both its physical and psychological sense.

For years he pondered these ideas, which had spontaneously arisen in discussions with his friends, and after months of study and meditation he gave them the name of *Pathosformel*. In this guise they were to become the interpretative key of his research and the central focus of all his later investigations.

There in Kreuzlingen, his reminiscences of that period in Florence merged with the memory of his first encounter with Mary, which would resurface in his mind like a recurring dream that arouses strong emotions but whose precise details remained hazy. At the time, he frequented the Uffizi with a daily regularity, and one afternoon a storm broke out as he was wandering the galleries. In the sudden darkness, the roar of thunder and heavy splashing of the rain assailed his senses, and for a brief moment, his heart began to race. After a few minutes, he heard voices speaking animatedly in German in an adjacent room. Entering the room, he saw, in the dim light, an elderly couple and a blonde young woman gathered in a semicircle about a small painting protected by a pane of glass.

The first image that superimposed itself on that sharp, delicate profile was that of the Nymph. Believing he was seeing her there again before him, Aby gave a start. The girl, for her part, was also admiring the image of a woman, Botticelli's *Judith*, and for a moment, in Aby's mind, the three images overlapped, as in a regression in multiple mirrors.

The old man, a sturdy-looking sort with white hair, was explaining the painting to the two women; the older woman nodded in assent, while the girl, standing a bit to the side, quietly admired the little painting, her head slightly bowed, hands folded behind her back.

Suddenly the rain stopped and the voices fell silent. The museum's half-empty rooms became pervaded with a strange atmosphere of suspense. He saw this sudden transformation

as a sign, a suggestion to act, to catch the moment. With his forehead beaded with sweat and his limbs trembling slightly, he approached the three practically on tiptoe. Introducing himself, he asked if he might add a word or two to the fascinating description he had just overheard. Keeping his back turned to the girl, he began in a rather subdued voice:

"This work," he said, "is clearly linked to the later Lippi. I would call it a kind of meditation on the theme of sentiment. Judith is shown leaving, in the faint light of dawn; the breeze is wrinkling the veils of her dress; the undefined movement of the folds conceals the motion of her body, makes her posture and step uncertain. This is the melancholy, the feeling of emptiness that follows the act: not a clearly defined sentiment, but a state of mind, an aspiration to something vague without knowing whether it is an expectation of the future or a nostalgia for the past. It is the uselessness of action, of history—and the melancholy onset of the sense of nature, where everything occurs without the determination of any will."

The young woman turned about slowly, as though waking up from a dream; she looked at Aby in amazement, knotting her eyebrows. Now he could admire her from the front, in all her beauty. Her gaze radiated an astonishing sense of strength. He stepped back slightly, intimidated, trying to conceal his strong feeling of attraction behind conventional civilities. They introduced themselves to each other again, this time more formally and in greater detail. They were the Hertz family, also from Hamburg, and had come to Florence for the sake of their daughter Mary, a very talented painter. Their meeting was thus a happy coincidence, since the two young people could now continue their cultural itinerary together, while the elderly couple enjoyed the city in a more tranquil manner.

It had, meanwhile, started to rain again, but the raindrops were sparser now and streaking the windows with a gentle sound, like a whispered prayer. As the afternoon's last light was slowly abandoning the treasures in the room, Mary and Aby lingered in front of that painting, exchanging glances and silently questioning each other. They knew that something had happened and that Judith had been witness to it. As if in

the background, her parents continued making plans for the following day, while his words seemed still to resonate among the echoes of that soft oration.

3

JEWISH BY BLOOD

Sometimes the hygienic conditions of Florence bothered him; they frightened him, in fact. After the market at San Lorenzo or in via degli Strozzi, there was so much refuse left to rot on the cobblestones that the darkest thoughts would invade his mind. He would imagine a horde of rats invading the piazza at night, and then slowly, bit by bit, taking over the city. He was afraid the vile creatures would climb the stairs of his hotel, come all the way up to his hotel room and bite him in his sleep, infecting him with the plague. Indeed the filth of these people was a perennial source of contagion. He knew, for example, that in Naples cholera was a familiar phenomenon, and that it was from there that, in 1832, the century's first and greatest epidemic had begun its spread throughout Europe. And then there was always the threat of typhus, a horrible disease that caused thousands of deaths each year. His mother and friends accused him of being a hypochondriac. He, who had suffered so much, who had nearly lost his life at age eight, a hypochondriac? In Italy people coughed in public without the slightest consideration for bystanders, transmitting every sort of germ and disease imaginable. He had even looked into the documentation: the mortality rate from tuberculosis was 82% in southern Italy and 52% in the north, and there was no end of other infectious diseases such as smallpox, scarlet fever, and diphtheria, which each year struck thousands of victims,

especially children. Was it being a hypochondriac to try to avoid falling victim to such horrors?

Yet as if spellbound, when he was with Mary he forgot all about illness and filth, epidemics and infections. That luminous gaze, that rare and precious smile, that complexion so fair as to be nearly transparent, would immediately reassure and enchant him. He could sense both strength and gentleness emanating from that woman, her artistic sensibility enhancing these qualities rather than undermining them. When, after much insistence, he had finally persuaded her to show him her drawings and sketches, he discovered that she was a truly talented painter. Even the studies that she drew in the museums had something firm and decisive about them; there was never any uncertainty or approximation, pretentiousness or arrogance, in those honest copies of the masters.

Mary was a very good listener. She would follow his explanations in silence, interrupting him only with brief comments, or accompanying his words with thoughtful facial expressions. With Mary, he finally had a chance to display his great wealth of culture and information, which was truly unusual for someone his age. And he knew how to do it without pedantry, and with Mediterranean vivacity and irresistible humor. His tone of voice was continuously changing, his choice of words always precise, almost cutting, while the rhythm of the discourse always varied according to the subject and to Mary's mood.

Day after day he had taken her to churches and palaces, holding her hand in front of the Botticellis and Leonardos, lightly touching her neck inside the great church-naves of Alberti, taking her arm in front of the bronzes of Donatello, taking her solemnly before the *Porta del Paradiso*, where Ghiberti's gold shone warmly in the autumn light.

Mary followed and understood everything, and with each passing day seemed to take on the features of a Florentine Madonna. Her dresses seemed to fall with the same folds as those that Aby was studying; the movements of her body, having relinquished their initial stiffness, became like those of a nymph; her eyes lost the tenseness they had at first, growing more and more languid until they filled with tears on the day of her departure.

Thus Aby was left alone, or so he thought. Alone with his studies and his books, with his anxieties and depressions, alone in a Florence made sadder and grayer by the first cold days of the new winter.

During his time with Mary, Aby had written often to his mother. He had told her of the marvelous days he had spent in her company, describing the young painter's grace and talent, underscoring her quick-wittedness and intelligence, and telling of the pleasure of sharing one's cultural interests with a person endowed with a profound artistic sensibility. He had deliberately omitted one detail, however, which later could hardly be overlooked: he had not had the courage to tell his mother that the Hertz family was strict Protestants and that Mary's Christian faith was solid and unshakeable.

*

How Aby had wrestled with his Jewishness! Now in that hospital room full of books and useless objects, he knew that his most obsessive demon had not been the serpent still nesting under his skin, nor the angel of Melancholy that Dürer had revealed to him, nor the mob of pagan gods that accompanied him on his visits to Hades, but the demon of an ancient religion against which he had rebelled but to which he indissolubly belonged.

Sara used to repeat to the Warburg children that one cannot escape Judaism: there is no baptism, marriage or conversion that can make a Jew a Gentile. The Warburgs had learned this long ago and had made their religion a way of life and a rule to live by. Their empire, moreover, had been built not on a birthright conferred by aristocracy, but on the challenge of survival and a sense of ethnic pride; the members of the family were conscious of their belonging to a "chosen people" and had taken upon themselves the task of carrying on an age old tradition. The intelligence and industriousness of the Warburgs was the same as that of any Jew in search of the recognition which, while denied to the race, might be granted the individual. Though the Jewish people had always remained foreign wherever they

went, and though they had always looked on Palestine as their true country of origin and destination, each representative of that people had always to confront the reality around him, to overcome fear, and to use his gifts to become integrated, even while preserving his identity. This was the conviction of Grandma Sara, a strong, open-minded woman, friend and adviser to Bismarck—to whom she sent almond cookies every year for *Pesach*—and whose acumen and charisma had put her in charge of the growth and welfare of the Warburg family.

Aby and his brothers used to listen wide-eyed to those speeches. They would choke up with a mixture of fear and pride as their grandmother uttered solemn pronouncements with the sharp, clean syllables of her Hamburg accent. The children, however, had never had any way, at that time, to understand in full what she was saying: the Warburgs were too well respected and powerful in Hamburg to be discriminated against. In that haven of free trade, where north, south, east and west met and intersected every morning at sunrise amid wharves and docks filled with merchandise and foreigners, what mattered most was money, the principal commodity of exchange, and some of the city's inhabitants, the Jews especially, were a precious source of it. Thanks to the Warburgs, Hamburg enjoyed financial and business relations with Eastern and Southern Europe, with countries that would have remained inaccessible if they had not been tied in with M.M. Warburg's elaborate banking network. Uncle Sigmund had been awarded the title of "citizen of Hamburg," one of the most coveted of honors, and enjoyed great decision-making power in the city government; Grandmother Sara, for her part, received some of the country's most noted and influential politicians, poets, bankers, and musicians at her country house. Yet in spite of all this, in the Warburg house they were never supposed to forget that they were Jewish. Indeed Aby never would forget it, especially after the day when, during a brief stay in Strasbourg, he was pointed at in the street and insulted by a man who cried out in the harsh Alsatian dialect: "Desch ischt e Jud!" Only then did he understand his grandmother's tenacity, his grandfather's shrewdness, his uncle's sense of defiance, his parents' devotion and perseverance.

Yet even having understood, he still did not believe in the god of the Jews. This brought back the guilt complex that had afflicted him as a child, but now the torment was more acute than ever. The relentless anguish that attacks the psyche of every Jew was twofold for him. He could not escape feeling guilty for having separated his own destiny from that of his people, for having wanted to forget that destiny. The rebellion that had freed him from an overly oppressive bond of belonging had come at a high price, and his break from that world was painful and exhausting. How could he tell his family that he wanted to marry a Protestant and still expect to depend on Max's generosity? Might he not have broken the rules one too many times?

Around that same time, his break from Judaism had found support in the theories of Tito Vignoli, an Italian philosopher and follower of Darwin. In *Mito e scienza (Myth and Science),* a book that left a profound impression on many young people of Warburg's generation, Vignoli not only proposed a concentric model of human studies for anthropology, ethnology, psychology and physiology which knocked down the barriers between disciplines, but also provided Aby with a reassuring answer to the question of religion. Retracing the steps that led from animism and polytheism to monotheism, Vignoli argued that most monotheistic religions preserved two fundamental aspects of paganism: anthropomorphism and the possibility of exorcizing fear through sacrifice. Judaism, to stave off God's wrath, resorted to regular and clearly prescribed sacrifices, while Christianity resolved the need for security with spiritual sacrifices and the consecration of work. It was science's task to depersonalize nature and the universe, to turn them into knowable and predictable materials. The measurability of the cosmos, the knowledge of matter, the predictability of natural phenomena, thanks to scientific progress, had freed man from fear, releasing him forever from the need for religion.

*

Those intellectual anxieties, as he now remembered them, seemed to have left an indelible mark in him, a deeper impression

37

than any of the other theoretical researches. Yet when, in 1892, he had left for his tour of military duty and succeeded in entering the Horse Artillery, he had wanted to leave all that behind and turn his attention to new ideals; his unexpected acceptance in the prestigious military order (usually reserved for Germans of Christian birth), seemed to offer him a chance to give his life new impetus. His letters to the family from this time clearly displayed such a need; he expressed a childish enthusiasm for that impeccable uniform and a feeling of pride in serving Germany as a small pawn in the grand design of the Triple Alliance, which had been renewed by Wilhelm II's recent ascent to the throne.

Aby had always been an enthusiastic supporter of the Empire and a firm believer in the leadership role of his country. He believed that the Germany of Goethe and Beethoven, of Dürer and Hölderlin, could set an example of civilization and culture for all of Europe. He had also been an ardent supporter of Wilhelm I and the Iron Chancellor—and of any other conservative force capable of stemming the dangerous rise of the Social Democrats and their pernicious doctrine. The threat of the Congress of Erfurt was still worrying him and now that England had a liberal prime minister, it was time for Wilhelm II to consolidate that power of Empire that Bismarck had striven so masterfully to attain. Aby's natural aversion for France had brought him even closer to Italy, and now the German alliance with Italy complemented his longstanding affection for that country with a sense of political esteem as well.

Immersing himself in the soldier's role during his exhilarating drills on horseback, Aby would become drunk with patriotism and forget his family, his rebellions and his guilt. He remembered only Mary and her soft body: that pearly complexion, those smooth curves, awakened a new sensation in him, making him feel part of a larger, more mysterious world, one in which his sense of manhood would play an important role.

*

A long, harrowing cry rang out from the next room: it was the new arrival. Apparently Binswanger was there to pay a visit. Aby

tried to pay no attention to it and continued jotting notes in the margins of his papers, small details that he wanted remember to say the following day. He was, however, a little concerned about Binswanger's imminent arrival in his room, as heralded by that cry. He would rather have finished his work first, before receiving visits from the doctor and then Saxl, since both men were rather demanding, even overbearing at times.

The visitors who came to see their loved ones at Kreuzlingen had one trait in common which especially irritated him. They would always arrive with big false smiles that made all those different faces look grotesquely alike. The same long row of teeth displayed like some sort of treasure, the same ringing voices of greeting and exclamations of surprise at seeing the patient in such fine form. Aby often wondered about the need for so much falsehood: were they really so presumptuous as to think they were bringing joy and happiness to a place like this? But those sham smiles quickly evaporated, and all that remained were the bewildered, lost expressions of mothers and fathers, children and brothers, friends and acquaintances.

Mary had never allowed Marietta and little Frede to go into that place to see their wreck of a father; she had only requested their presence there once, on their silver anniversary. It had been a memorable weekend: the cheerfulness and fondness displayed by the children gave him the momentary illusion of being back in the bosom of the family. They made long excursions into the surrounding area, ate great quantities of fish, and even launched into lively political discussions, to which he reacted with unexpected self-control. All in all, it had gone very well, especially since it had been months since he had seen even Mary. Indeed, after Max Adolph himself was interned at Kreuzlingen, many months passed before she could find the courage to go back. To see her own son in that psychiatric hospital, immersed for hours in a tub of water, was a shock she didn't have the strength to bear. Yet this treatment had been necessary for the boy's condition, and the Warburgs' confidence in Binswanger left them no choice but to accept it. In the end, however, Max Adolf had enjoyed great benefits from it, so much so that after a few months he had happily said

goodbye to his father and returned to Hamburg to continue his studies in archaeology.

Once back, though, Mary's behavior was not the same. During her periodic visits she had always remained a bit cold and distant, as if with age—and with the years of sorrow—a certain German roughness, a rigidity of character, had emerged in her. Even if her smiles were rare but sincere, she would sit in front of him for hours, motionless, telling news of the family and children, with a flat, dull voice, devoid of emotion and color. Her eyes would avoid his gaze, come to rest on small objects on the room and inevitably end up in a corner on the floor. Was such attitude the product of fear, resentment, or exasperation? Was this remoteness only momentary, or was it irreversible? For years he had imagined that Mary was in mortal danger, that someone, because of him, was threatening her life. At other times, however, he would feel inexplicably resentful toward her: he imagined she did not want him to come back, or that she had remarried or was living with another man. Even his brother Max, on his very rare visits, had looked at him with that same empty, bewildered gaze, or even, perhaps, with hatred: perhaps he too was hoping for Aby's end so he could stop bearing that financial burden, a quiet, discreet death that wouldn't sully the family's name; perhaps they were all hoping for an end to this humiliating episode. And how could he ever know anyway? How could he understand what was happening out there, in the world? From that desolate exile, everything was imaginable, and at times it seemed best to prepare oneself for the worst.

*

The surrounding hills began to darken with the evening, casting bands of shadow on the already sleeping water. The city of Constanz, on the other side of the lake, was turning on its lights one by one, which flickered faintly in the dusk's unsteady glow. Aby recalled with great precision the intense color of the Florence sky at nightfall. With all trace of rose vanished after sunset, the sky would become a deep blue again, unalloyed with any other color, floating over the city's rooftops, around the gutters, along

the walls of the noble palaces, before quickly slipping behind the horizon line, where darkness lay ready to take over.

Florence, upon his return from the military in October, 1893, had seemed indeed too dazzling to him. The fin de siècle euphoria was rampant in all fields and even fashion followed art, conducting sinuous dialogues with the now ubiquitous Art Nouveau style. The air was abuzz with invention, open-mindedness and novelty. The town had become a pilgrimage destination for many German and British intellectuals, who would come for long sojourns, some of them to settle there permanently. The atmosphere was saturated with people: the churches and museums were besieged by what he liked to call "art tourists," distracted, superficial visitors who spouted pretentious comments and judgments of every sort.

Aby needed more peace and quiet. The light and noise, to which he was no longer accustomed, became unbearable to him; to avoid the clamor, he often used to remain indoors with the windows closed. On certain days he suffered from terrible migraines that forced him to remain totally motionless in his bed, and even when he felt a little better he still preferred to stay indoors in the afternoon, to avoid unexpected encounters or overly intrusive friends. He disliked those long soirées at the homes of arrogant intellectuals with their unending diatribes on the concept of "modernity," and he was quite bored by discussions of the new currents in art criticism. Actually, they were what he hated most, especially the recent fashion for interpreting Botticelli in a "decadent" vein, as an inspiration for the Pre-Raphaelites, a painter—they said—who was weak and calligraphic in his stroke, vague and fluctuating in his message. In his dissertation, and later in an article in the *Gazzetta dell'Arte*, Aby had emphasized the Florentine master's intellectual vigor, manly discipline, and dramatic language: how could anyone impute decadence to one who was able to contain, in line and color, so strong a sense of movement, of matter arising and growing, of "life," in a word? The *Birth of Venus* and the *Primavera* echoed with the breath of the wind, the flutter of veils, the crystalline voices of the Graces, the fluid steps of light feet, the distant echoes of Poliziano's *Giostra*. Aby

could still listen to those murmurs of life on long winter nights, there in his room at Kreuzlingen. When all at last fell silent, when the shouts and cries finally ceased, he would call up those mysterious echoes of a distant but still living past, that magical fusion of eras and images that had so totally ravished him in his youth. Yet despite all this enchantment, Botticelli remained in essence a philosopher: endless allegories linked his works with the history of thought, from the Homeric tradition to the Neo-Platonists, and his magical universe of symbols had led him into new, fascinating explorations.

In fact, Botticelli was the portal through which Aby had entered the realm of the symbol, of what arises in the freedom of the mind and, eluding all rational convention, transforms itself into a universal language uniting different peoples and epochs. At this time he had realized that the symbol—alphabet of dream, grammar of myth and syntax of art—is born of the depths of the unconscious and rises on the top of ineffable thoughts; it flows, subliminally, from the oneiric universe to that of imagination, then re-emerges like a spring of water in the manifest landscape of visual art.

Reading Theodor Vischer, he then discovered that the symbol was the primary mark of distinction between man and animal, and that for this reason it was up to psychology to retrace the origins of this heritage. With this new conviction, Aby re-immersed himself in his studies with a different perspective on things. He felt the need to follow more latent, subterranean pathways that with time would prove more revealing.

During this very period of new explorations, however, he started suffering from a mental condition of which he was fully aware but powerless to overcome. It was as though a block suddenly arose between his threads of association; those that carry general ideas and those involved in the visual impressions underlying such ideas, and this block were preventing these ideas from interrelating and crossing together, at once, the threshold of consciousness. The associations would lose their continuity, and the thread of logic, or a whole bundle of threads, would suddenly break off, at random. Two or more entirely disparate ideas would condense into one, losing all differentiation, all distinction.

Strange associations, for the most part auditory or verbal, would then flood his mind, taking on excessive importance and meaning. The process of apperception, in general, would slow down or come almost to a complete halt, while a multitude of useless details obstructed the flow of thoughts.

Nor, if truth be told, was that new study method of much help: he had acquired the habit of writing in aphorisms or brief maxims that he would jot down on little sheets of handmade paper. He would draw a kind of conceptual grid in which he would place, one by one, the ideas that surfaced incoherently in his mind, changing and inverting their order and positions in accordance with the methods used in psychological associationism, which had lately become very fashionable. Later, however, he tried more coherently to keep a diary, which he filled with an assortment of personal notes and sundry reflections. In the years of his Florentine sojourn, the diary became a kind of alter ego with which he would converse daily, confiding all his anxieties and depressions, his frustrations and rages. Through that minuscule, sloppy handwriting he would try to understand what was happening to him—those moments where his reasoning was suspended and obscured, those ideas that kept returning so insistently, so repetitively to his mind without ever leading to any new conclusions or formulations. When he knew he was close to a new and important theoretical discovery, for example, he would immediately perceive its importance and correctness, but could not bring it into focus, isolate it from that indistinct mass. And that was when he would start dismantling and reconstructing all the scattered data tied together by arrows of ink and predetermined signs. As in some Expressionist mosaic, he would rearrange those thousands of little sheets of paper on which he had jotted notes, phrases, comments: he would lay them out on the desk before him, move them back and forth with frantic speed, and arrange them in vertical columns or in horizontal lines. Then he would gather them back together in a single pile, to thumb through them again, as if hoping to discover something he hadn't noticed before, some new fact, some new detail that might help him create the wholeness he was so desperately seeking.

At other times, however, on sunny, breezy days, his whole being would suddenly grow calm: his thoughts would clear up and brighten as the morning progressed, his heartbeat would resume a calm, regular rhythm, and his mood would lighten as readily as a child's smile. At such times he would try to focus his research in a more methodical manner, restricting his field of investigation and subjecting it to greater logical rigor. It was on one such fortunate day, in fact, many years later, that he succeeded in resolving the enigma of the Schifanoia frescoes.

He still vividly recalled the images of that day, when he first set foot in the Palazzo Schifanoia at Ferrara.

With his stomach still full from the sumptuous meal given him—indeed, forced on him—by his rather talkative traveling companion, encountered by chance on the train, Aby had entered the Salone dei Mesi (The Hall of the Months) happy to be left alone and ready to abandon himself to contemplation and meditation.

There, at last, were the images he had already been studying for so long. Before him lay the largest cycle of secular frescoes of the Renaissance. A great calendar, subdivided into twelve sections and three horizontal bands, adorned the room's walls like an imaginary tapestry hung between the columns of a simulated loggia giving onto an imaginary outside. In the lower band were scenes of life at the court of Borso d'Este; in the central band, the signs of the Zodiac; and in the upper band, knights and ladies riding on triumphal chariots, transformed into the tutelary deities of the months. Finding the main door closed for the restoration being done inside, Aby had pushed a side door open and found himself in front of the cycle of the months of March, April, and May. In the central area, three enigmatic figures alongside the Zodiac signs draped in fire-red cloaks, seemed to step out from the dark, unadorned background and form a circle around him. Who was that angry figure dressed in rags, with a rope tied round his waist, one end of which he held in his hand? Why was his face so dark? And what was that thing sticking out from his belt? Was it an axe? And who was that half-naked man astride a bull, holding a great key? And

those warriors dressed in various styles and bearing lances on the right-hand side of every frame, who were they?

The stentorian voice of a guard brusquely interrupted his thoughts to announce that they were closing. If only that overbearing traveling companion hadn't kept him at the table for so long, he would have had more time to study the frescoes. The faces of the middle band were surprisingly homogeneous in style, but what could be the reason behind that strange Zodiac, so charged with symbols and messages? From what distant traditions did those figures derive, and by what routes had they come down to the painter, Francesco del Cossa, to inspire such a bizarre blend of magic and erudition? He would have to reconstruct the stages of that fabulous migration from Greece to the Orient, and from the Orient back to Europe.

The guard repeated his announcement in a gruff tone, and Aby left in anger. That treacherous, bubbly Lambrusco at lunch had left his brain in a fog. Outside the Palazzo, he turned right, toward the narrow streets of the Jewish ghetto. A number of bicycles were racing across the unevenly cobbled pavement; the women all had wicker baskets attached to the handlebars, brimming with clusters of vegetables. Little children in undershirts toddled freely about those streets, as though they were in their own yards. Aby liked the sound of their confused and noisy cries, and could even hear the different cadences as compared with the street language of Florence. It sounded like music to him.

Continuing his meanderings, he finally arrived at Palazzo dei Diamanti. There the sunset's rays shone between the facets of its rusticated front, while a more intense band of light penetrated as far as the inner courtyard, where a scent of musk and tomcats seemed to guard the freshness and secrecy of the place. He sat down on a low marble wall and looked about, breathing slowly. His anger had subsided, and for a moment, for no reason in particular, he felt happy.

4

GOTT STECKT IM DETAIL

Now it was dark outside and a soft wind tousled the tops of the poplars at the back of the garden. The corridor echoed with the squeaking of the medicine cart, which at that hour was wheeled from room to room for the administration of sedatives to the patients. That medication which each night heralded sleep on command, as the nurse looked vigilantly on, just like when he was a child, was an insufferable humiliation for him. He could never swallow it on first gulp, and always wished he could spit out the viscous casing that gummed up in his mouth; but the nurse was always there, making sure he swallowed the water in a single draught.

In general, however, the nurses were gentle, pleasant girls, sumptuous products of Swiss-German soil. They all had rosy cheeks, and powerful shoulders and bosoms which their severe gray-flannel uniforms, softened by white aprons, could not hide. And Aby's fondness for them was not without physical desire: he wished he could sink his hands into that turgid flesh and find again the scent and warmth of youth, to banish the thought of death that so often tormented him.

Heidi, the most attractive one, was a young schoolteacher who worked the night shift three times a week. The copper-colored curls that stuck out from her starched bonnet accentuated the freshness and radiance of her face. With a mixture of desire and mortification Aby would follow her movements with careful attention, his eyes running along the vase like line of the hips,

the shapely arms, and, when she bent over, the fleshy calves encased in boots. And the more the desire grew, the more he tried to find distraction in the details of her figure: he would take a few steps back to have a better look at her, half-closing his eyes to focus them, and he would try to excise the instinct with the sharp scalpel of analysis.

Heidi had a rather unusual way of extracting the wafers from their metallic container: she would carefully remove the lid, as though checking on some food cooking on the stove, and inserting her forefinger and thumb, she would seize the wrapping and lay it on the little platter like a culinary delicacy. Looking at him straight in the eyes, she would finally proffer him the medicine, remaining utterly motionless for a second or two. When she was certain he had swallowed it, she would breathe more easily and wet her lips with a circular movement of the tongue, furtively turning her eyes away. This little ritual seemed at times perverse, even obscene to him, though perhaps the hardest medicine to swallow was a bitter awareness of his age and his condition.

*

Ever since childhood he had had an extraordinary ability for grasping details. It was an almost spontaneous process, in which the will played a rather passive role. It was the details that, in isolating themselves, would capture his attention, heightening their contours and standing out from their immediate context. His parents and brothers used to tease him about this without actually being able to emulate him. Yet Aby did not feel particularly proud or even responsible for this talent; it was an automatic mechanism that he never really sought to exploit, though he enjoyed its benefits.

He would notice, for example, that Felix in his haste in getting ready for school had put his socks on inside out; or he would see the irregular part in Max's blond hair, the little crease left by the iron in Franziska's starched collar, the pillows arranged helter-skelter on the living-room sofa, the delicate embroidery on the damask linen tablecloth, the fogged up lenses of the

music teacher's glasses, the floral motifs on Uncle Sigmund's pocket watch. He would notice these things with pleasure, indifference, or irritation, but he would notice everything, or almost everything. He would feel a slight thrill whenever he saw new acquisitions in his father's library, volumes of every size and shape that would sit for a few days on the long table before being swallowed up by the shelves, sometimes before he had time to skim through them.

He would study his mother's sweet, steady gaze when she checked his homework, and he always knew whether or not she was satisfied when she turned the pages of his notebook. If all was in order as expected, a little wrinkle under her left eye would form before the lips actually broke out in a smile. That maternal face, which he so loved and worshiped, aroused a feeling of constant expectation in little Aby. And one evening, in that face, he saw the sign that he had long been awaiting. Mother had been sick for some time. He was too young to understand what it was about, but he sensed that there was great concern in the family. He was allowed into her room only for a few minutes each day, together with his brother Max. The two little boys wanted to talk to her, to tell her what they'd done that day, but she wouldn't respond, lying nearly motionless on pillows in an oppressive half-light. Around her hovered a strong smell of disinfectant, and on the commode, on a piece of white linen, stood a tight row of medicine bottles.

Aby had seen his mother confined to her bed, pale and exhausted, many times before, about once a year in fact, yet he had never associated any sense of pain with those scenes. He always knew that before long there would be joy again in the family, with celebrations and parties and the curiosity and surprise of all the children. This time, however, she had an ashen color that provoked a terrible sense of anguish in him, striking him right between the stomach and the diaphragm. He wished he could protect her, save her, but he felt weak and useless. Unlike his father, whom he was willing to share with his brothers, his mother belonged to him alone; she was the only person truly indispensable to him, and he couldn't imagine life without her. And that evening, as crying he found him self

48

praying at her bedside, his mother's face had brightened up and the little wrinkle under her left eye suddenly reappeared. The next morning, Father announced to the children that Mother was feeling better, and that in a couple of weeks she would be able to play with them again.

Aby, that night, did not sleep a wink, for he spent the whole time reciting all the nursery rhymes he knew, to avoid the temptation to start praying again.

<div align="center">*</div>

Thousands of sparkling details used to flash before young Aby's eyes during his stays at his maternal grandparents' home in Frankfurt. Grandfather Oppenheim traded in precious stones, and every once in a while, when Aby would ask him, he would open his safe to show him that stunning glitter of colors and tiny rainbows. Aby had learned everything there was to know about pearls, their shapes, sizes, origins, and formation. Grandfather would roll them around in the palm of his hand with a sensual delight, showing him the nuances of their delicate pallor and telling him many secrets of the trade. These somewhat furtive talks were sometimes interrupted by the arrival of Grandmother, who disapproved of all that complicity between the two of them. Stern and authoritarian, yet not quite so austere and intimidating as Grandma Sara, Grandma Oppenheim looked after the family business, protecting it from her husband's tendencies to dissipation, and running the company during his long absences.

They worshiped music in their house. Grandfather had a great passion for Mozart and each year used to give lavish donations to the Frankfurt Opera. Their living room was often the meeting place of groups of artists and writers of various countries, whose polyphony of languages—Grandfather himself spoke thirteen different tongues—used to fill the air with endless conversations further animated by the rich Rhine wines which the hosts served in great profusion. From behind the door, Aby used to look in on that lively, polite company, in whose conversation, amidst all the various accents, one word kept coming up, a word that most fascinated him: *Kunst*.

Art, for Aby, was like milk: it had been a source of nourishment from childhood. He always had it before his eyes, and could not disassociate it from his earliest feelings. And in his grandparents' house it had exerted an especially powerful attraction on him, perhaps because the atmosphere of the surrounding city, so big and different, excited his imagination even more than usual. In fact his first visit to a Kunsthalle had been in Frankfurt—Hamburg didn't have any museums, a fact his mother never ceased to lament. He had entered the great rooms of the art gallery with a sense of excitement and patience and had left them overwhelmed with amazement and questions. During those visits, his native city seemed small and distant to him, dull and provincial, and interested only in commerce; he sometimes used to wish the whole Warburg family could move into the grandparents' house.

Life with Grandfather and Grandmother was a perpetual celebration. When Max's younger brothers, Paul and Felix, moved to Frankfurt for their banking apprenticeships, Aby had felt a profound envy for them, even though at the time his studies were taking him traveling around between Strasbourg, Bonn and Berlin. Felix and Grandfather had quickly established the complicity that had once been his own appanage, and as the "libertines" and *bons vivants* of the family, they understood each other perfectly. Grandfather had been the only one not to cry scandal when social circles had begun whispering about the liaison between the very young Felix and Clara Schumann; actually, he chuckled about it quietly to himself, avoiding his wife's indignant gaze. "Frankly, the Warburgs" he commented, "can allow themselves a few transgressions, after all that sense of duty and all those philanthropic *mitzvahs.*"

<p style="text-align:center">*</p>

So many details from his childhood and years of study remained clearly etched in the memory. Even now as an old man, in that dank cage to which his fits of panic and depression had consigned him, and even despite the sense of confusion and bewilderment, his powers of observation had remained intact.

It actually seemed as though the darkness of the lake, at that moment, were bringing back to him, in vivid, precise form, fragments of images he had thought were forever lost to him.

As a child he used to notice things with pleasure, indifference, or irritation, but as he grew older he began to apply intelligence, analytical acumen, and an investigative spirit to his observations. It was not long before this approach became a veritable method of study.

He now remembered, not without some satisfaction, the time when he had finally mastered his new method and had begun to use it with the casualness and confidence of a true professional. He would begin his researches with an iconographical analysis of the artwork in question, and—starting from the bottom up—would slowly, little by little, weave in the dense contextual warp. The work of disassembling and deciphering, the most creative part of his task, was what excited him the most. He remembered with great emotion the times when, from a painting or fresco, he had experienced the slow, gradual emergence of life—when he could see that the myriad fragments he had managed to discover, recompose and recombine, had conferred upon an inert image the power of speech. And for him, this was the first and most important duty of the historian: to make a work of art speak, to free from within it the inaudible voice that unveils and recounts the past.

Separating an image from history or concurrent events, from religion or poetry, was the same as cutting it off from its vital lymph, condemning it to an eternal immobility. Purists! How they had twisted the teachings of Burckhardt in elaborating the theory of "pure visibility"—or worse yet, the *Einführung*—which was in danger of becoming reductive and without meaning. Even the greatest among them, Wölfflin, was not aware that he had taken a wrong turn that led to sterility. A work of art could not and must not remain detached from its context: it cannot be understood by "pure intuition," by "sympathetic reaction." There are no "anonymous powers of history," as some idealists maintained; there is only history with a thousand faces! What matters is not the whole or essence of a painting, but the sum of its parts: the faces, objects, headdresses, poses, inscriptions,

51

decorations. Each of these fragments is a carrier of meaning, a piece of "circumstantial evidence." And proof that *God is hidden in the detail.*

To those who accused him of not seeing the forest for the trees, he had never deigned to give so much as a response. Was it an unacknowledged weak point? In all honesty, he didn't think so: his asystematic manner of investigation and the care he took in formulating broad syntheses were a conscious choice. Besides, he had never aspired to the *esprit de systeme;* indeed he never wanted it, nor could he subordinate himself to a theoretical consequentiality that would cramp research in an area that by definition entailed incessant investigation.

Yet in following the untrammeled paths that led him beyond the border areas, he had in fact felt quite alone—alone in breaking down previously well-cemented barriers and in refuting professional categorizations. It was remarkably similar to how he had felt as a young man, when struggling against the prohibitions of family traditions in the attempt to assert his own choices, torn between the dark moments of depression and the blinding lights of anxiety.

Yet after Mary had come into his life, the loneliness had slowly subsided. After her departure from Florence, he had begun a copious correspondence with her, which took up every moment not spent on his studies. He had written her almost daily for months, reinventing every kind of literary genre just for her: from epistolary narrative to poetry, from drama to the essay. He had tried to ridicule their respective families' prohibitions against their marriage plans, attempting to recapture the élan, the verve he had shown during their first days in Florence. It was the writing of a man in love: free, passionate, full of imagination and humor, delicate and vibrant.

He remembered how, in the room in which he had written that intense correspondence, Mary's photo used to hang on the wall in front of his desk, next to the images he was studying. Between the sorrowful face of *Laocoon,* the *Gioconda's* inscrutable smile, and the romantic expression of Bocklin's *Calipso,* beamed the luminous eyes of his loved one. Mary had the coloring and features typical of Nordic beauty; and although, with

the nostalgia of distance, he liked to soften them until they blended with the traits of Lippi's and Botticelli's maidens, that photograph nevertheless showed them in all their psychological and geographical determination. Aby had always associated fairness with steadfastness of character, and it had always elicited an unacknowledged, reverential awe on his part. Max's clear, transparent gaze and tall stature had from childhood commanded his admiration and respect. And his other brothers, though dark like him, were endowed with a physical beauty with which he could never have hoped to compete. The intensity of Paul's face, the irony of Felix's eyes, Olga's grace and elegance, all filled him with pride, but made him uneasy. Only the two little twins, Fritz and Louise, had something awkward about them: bad teeth, nearsightedness, something that made them a little pathetic but very loveable. He, on the other hand, looked like his mother and grandfather Oppenheim. Charlotte was not what one would call pretty: her build tended to rotundity and her complexion was very dark, yet her resolute gaze and candid smile had always overwhelmed and intimidated him. Max's blond hair came from his father, who nevertheless was more of a dirty blond. As the years passed, his hair became so thin and colorless that he was forced to don a toupee (or rather, many toupees, since he had a rich and varied collection).

Papa Moritz, for his part, was the spitting image of Grandfather Abraham, whom Aby had only seen in a portrait, since he had died ten years before Aby was born. When Grandmother Sara had married him, Grandfather Abraham worked for Moses Marcus. The marriage was supposed to preserve control of the bank and couple the age-old fortune of the Marcuses with the illustrious name of the Warburgs. In her stories about the family, Grandmother used to talk about her husband as "a great love," even though Aby had secretly heard that poor Abraham had always been crushed by his wife's overbearing personality. Although Grandmother Sara had never been beautiful, she had a magnetic charm and used to tell the family that she had been the inspiration for Heinrich Heine's famous poem, "Ein Jüngling liebt ein Mädchen." Aby could never forget her penetrating, imposing gaze, that iris as light

as a polar sky, the pupil sharp as the eye of a needle. His own father was afraid of her, and only Uncle Sigmund, who was Grandmother's favorite, had the courage to confront that gaze, and sometimes even to oppose it.

Grandmother Sara's orders were never transgressed or called into question, yet her inflexibility was always accompanied by an explanation that made even the most preposterous requests seem to have a rational foundation. One particularly memorable episode among the many of his childhood was when Aunt Marianne, Sara's eldest child, died, and the family had gathered for her *shiva* in a room decorated with great bouquets of flowers in season. It was five o'clock in the evening on a Friday, and to the general confusion of all present, Grandmother had asked everyone to come down to the dining room. Sitting at the head of the table, she began, in an impassive tone, to recite the Sabbath prayers, and at the end of the celebration she folded her hands in her lap and explained without a tear in her eye that "God has no concern for human sorrow on the day devoted to him."

The meal that evening was unusually simple; Aby could still remember the bitter taste of the bland barley soup, the *krugel* of meat, the ginger and almond cookies. Even the wine, in the Warburg house, was kosher, and nobody ever dared transgress the culinary rules imposed by his grandmother. The silver trays on which the cook, carefully chosen from the synagogue community, used to arrange the meats prepared by the *schohet*, were kept in a separate area from where the dairy-based foods were prepared. During Passover, the kitchen would be cleaned and shined under the strict supervision of the rabbi, and flour and all its derivatives were banned from the house for days, forcing Aby and Max to hide their favorite cookies under their beds.

*

What a joy it had been when he was sent to Bonn, at age twenty, for his first year of university. He remembered that period as a reawakening of his senses. He had just discovered and was beginning to enjoy the sweet taste of transgression. Having abandoned the kosher restaurant his family friends had

recommended to him, he finally crossed into uncharted new culinary territories. He wanted to try all the available variations of sausage, pork, and meat: *weisswurste* with a thick coat of mustard; *blaue zipfel* drowning in sweetened vinegar; crisp, well-done *schweinshaxe;* stewed pig with lentils or with cabbage and potatoes, or cooked with strong spices and sweetened with pear sauce; jugged hare in hunting season, wild boar in sweet and sour sauce; venison cutlets with rosemary. To say nothing of fish, whose strong aromas used to intoxicate him on the benches of St. Pauli in the unforgettable days of his adolescence.

Mussels, lobster, and all fish without scales or fins were prohibited at the Warburg table, and in their place one ate pickled herring or carp with onions and sour cream.

He still remembered the tumultuous delight of eating at the Kneipe or the Weinstube, where those succulent dishes and that dense, rich beer gratified the connoisseur's palate and initiated him to the pleasures of disobedience. Often, at lunchtime, he used to meet his friends at the Scharrenbroich cafe, and in the evening, in more adult, sophisticated company, he would play billiards at the Burgerverein. More than once, between shots he would fill up on the good red wine of the house, and by game's end he would be so tipsy that he would lose, despite his superior ability.

It didn't take long, however, for rumors of his dissipation to come within earshot of his father, who, in an absolute fury, decided to send him to another university. But where? Bonn, after all, boasted a fine academic tradition, and the faculty was absolutely first-rate. Aby from the start was utterly spellbound by all that intellectual fervor, and from the first day on, he frequented every professor's classes. In the autumn of 1886 he attended the art history lectures of Henry Thode and Karl Justi, the archeology lectures of Reinhard Keluke von Stradonitz, the classical mythology course of Hermann Usener and the philosophy of history course of Professor Karl Lamprecht. He would run breathless from one lecture hall to another, frantically taking notes and engaging in long and passionate discussions with his "colleagues," as he proudly called his friends; he also began to cultivate relationships with his professors, to make

himself known and establish a stimulating exchange of ideas on a basis of equality.

In those first months of university study, all had seemed possible to him. It seemed that his potential was developing in a steady, balanced manner, and that in the end his rebellions would produce valuable fruit. Yet he soon realized that the road was not so simple and smooth; at times, in fact, he felt around his neck the squeeze of the umbilical cord he thought he had cut with his hard-fought independence. He could never break away from his mother, nor would he have wanted to: he loved her too much even to think of such a thing, and yet he wished he could at least establish a proper sort of distance between them. He still recalled the vexation he felt at her reproaches for neglecting the laws of his religion; they irritated him terribly, and his letters of response contained an echo of the tantrums he used to have as a child. He wrote bitterly to her that he wanted to be accepted for what he was, and not be seen just as an unwanted member of the Jewish community. He told her sarcastically that he didn't get the highest possible grades at the Gymnasium and the Realgymnasium only to end up at some ordinary German university merely because there was a kosher restaurant nearby. But he also remembered that on those cold winter evenings, when he didn't go to the university club but holed up in his room to catch up on his letter-writing or to study the lessons for the following day, that oppressive umbilical cord became a cable tightly bound to an anchor. In those moments, he not only wanted to be part of the community, but also wished he were back at the long and boring family dinners, where the customary reproaches were always accompanied by much affection and protection. In those moments he would still have liked to be a spoiled adolescent, to be able to indulge in a few fancies, to be the center of attention and surrounded by amusements. He wished he could have new riding boots, the latest ice skates, fur hats, fancy cigars and vintage wines. His mother understood this and, all the while maintaining a gentle severity of tone, used to send him, unbeknownst to the father, all those false necessities, amidst the packages of food provisions—all kosher, of course.

He still felt guilty for the times he used to run away at the sight of Paul Ruben during those first years at university. Paul was too much a part of the familial world he was fighting against for him to remain the close friend he had been in childhood. First of all, he refused to violate the food laws imposed by the family, and continued to eat in that greasy kosher restaurant which Aby couldn't even bear the smell of anymore. And then he was so shabby in appearance, with his *kippa* always propped on his head, attached to his red hair with a bobby pin, his dirty fingernails, his nearsighted, distracted gaze. He had in fact become so rigid in his observation of religious traditions that he allowed no room for doubt or questions. Aby, on the other hand, was gradually sharpening his vision: his thirst for knowledge was not satisfied by exegeses of the Talmud, and his intellectual restlessness kept pushing him to explore and compare cultures in their diversity. The word "culture" itself implied, even then, a very broad approach; it meant the totality of the different disciplines. It meant research and, above all, struggle.

At the end of the second year of study, he had in fact felt the need to go elsewhere, and began to wander from one university to another. In June of 1888, at Munich, he discovered the power of modern art and its provocative social message in the realism of such artists as Uhde and Liebermann; in December of '91, at Strasbourg, he finally discussed his thesis on Botticelli's *Primavera* and *The Birth of Venus* with Hubert Janitschek; in March '92, in Berlin, at the faculty of medicine, he took courses on the central nervous system and optical perception, and by August of '93, after his turn of military service, he was back in Florence to collect his thoughts and put them in order. In the meantime he had continued to accumulate books, which piled up by the hundreds and already formed the nucleus of an unusual library, aside from being the indispensable tool of his trade.

*

Finishing the revisions of the "Lecture on the Serpent" with a few flourishes of the pen, Aby felt satisfied. He tried

rereading the draft in a soft voice to be sure he could dispel all the objections that Saxl would be raising in just a few minutes. He was supposed to arrive at eight; therefore, everything had to be ready. Among the many memories that crowded his brain, he tried to make room again for the more intense moments of his journey to New Mexico: he closed his eyes and tried to remember the smells of the place. There were clumps of gorse growing everywhere, with that unmistakable aroma that now mixed in his memory with the stench of horse urine, which flooded the pavements with an acrid effluvium at every stop they made. He dilated his nostrils and couldn't help but laugh. That arcane, desert like America had won him over more than he liked to admit. When it came time to leave, he said goodbye to that land as he might to a lover, with his heart in his mouth and a promise to return soon.

5

THE LIBRARY

Upon his return from America he realized he had to make a decision. His brothers Paul and Felix had also, in a sense, transgressed the family rules. He only had to follow their examples and announce, without any further ado, his engagement to Mary Hertz.

Thus on a bright June day, amidst the fragrance of the strawberries just served and the slight euphoria brought on by the sweet malvasia wine, Aby rose from the great table under the arcade and began his speech.

The entire family was gathered together at Kosterberg at the time, except for Felix and Paul, who were still on their honeymoons. The absence of Grandma Sara was keenly felt, yet that summer Sigmund Warburg's dense branch of the family countered any lingering sense of emptiness. Cousins Abraham, George and Rosa were terribly intrusive, and could barely control their snobbish instincts. Uncle Sigmund, for his part, considered himself a fully fledged member of the old German aristocracy, and had always felt a little embarrassed of the image of banker, unlike his brother Moritz, who had preserved great respect for the family tradition. Sigmund's first-born son shared with Aby not only his name, but a troubled destiny as well, perhaps even more painful than Aby's. He suffered from diabetes, and that ever imminent menace had prompted him, like his cousin, to cede his birthright to his brother George and to forget all about the family business. Yet lacking the intellectual gifts of

his namesake, a feeling of emptiness and worthlessness had cast a shadowy pall on his person. He had lost his hair before his time (even compared to the rest of the male Warburgs, who all suffered from premature baldness), his eyes had become as though veiled, and he seemed not so much to live as to vegetate in a kind of limbo from which he was occasionally delivered by his cousin's affection and understanding. George in turn suffered from violent headaches, and his responsibilities as heir, redoubled by the father's expectations and ambitions, made his tasks doubly onerous. He had been living in the country for a few years now under the illusion that a simpler, more authentic life would do him good. Tante Melchen was also there that day, more vivacious and amusing than ever, gossiping throughout the meal about the small deeds and misdeeds of various relatives. In her accounts the events of the Warburg family assumed such a dimension that they began to seem like caricatures of the stories Grandma Sara used to tell. Despite her seventy years, Tante Melchen still had the candor and naiveté of a little girl, and the kids were continually making fun of her and making her the butt of their jokes. Even the adults would sometimes tease her benignly, without her even realizing it, and as the years passed, talking about *Tante* Melchen became a little bit like telling a joke.

As he delivered his speech, Aby kept looking at his cousin and at Olga's sweetly expressive face, hoping to receive some sign of encouragement at least from them, but when, between a witty remark and a fine metaphor, it came time to mention the name of Senator Hertz's daughter, a chill descended upon the company. Not even Aby S., Olga, or *Tante* Melchen gave so much as a hint of a smile to reassure him. In the background, from the kitchen, Franziska was the only one to let out an exclamation of joy, ever aware of the storm that was about to be unleashed.

On October 13, 1889, Moritz and Charlotte Warburg did not appear in church. Only Max and Olga, looking sad and worried, came to the wedding of Aby and Mary. Yet the scents from the corbeilles of tuberoses and hyacinths arranged around the altar, and the Bach fugues rising up from the majestic organ, managed to make everyone forget the defection that was taking

place. The peaceful, contemplative atmosphere captured Aby's fancy. Kneeling before the pastor hand in hand, the two young newlyweds recited their vows of fidelity while the whispers and sighs from the pews behind them added a touch of worldly emotion to the ceremony.

Adolph Hertz, erect in his impeccable morning dress, exuded all his authority as father and senator of the Kingdom of Prussia, while Mary's mother, on the other hand, crowned with a hat of plumes and partridges that looked like a hunting trophy, was sobbing uncontrollably. Only their son John seemed to maintain some minimal sense of humor about things. The few friends of Aby who dared to enter a church that morning were each wearing a white gardenia in their lapel, the petals of which seemed strangely yellowed by the end of the ceremony. Mary noticed this upon exiting the church, and jokingly attributed it to the gloomy mood of the invitees. Her own bouquet of orange blossoms was, by contrast, fresh as the day, and to break the ice, she tossed it, laughing, toward her friends. Max, seeming taller and blonder than ever that day, looked and acted like a real Junker, except perhaps for his warm and affectionate manner with the newlyweds. Yet the glow in his eyes was perhaps also owing to the presence of Alice Magnum, to whom he had become officially engaged. They were soon to marry, in just a few months, this time with the blessing and approval of all the Warburgs. Alice was a slight, delicate girl, with an expression as passionate and intense as her nature and character. Her Russian origins had reinforced the sympathies of the Warburgs, who in their marriage policies looked on the Jews of the East with great interest. Born to a very prosperous family, Alice, like Mary, was an accomplished painter and saw her future sister-in-law as a friend and kindred spirit.

That day, however, Mary was the most beautiful woman of all, and Aby was madly in love with her. The pallor that her emotions had brought to her face during the ceremony gave her complexion a cast not unlike the pearls that Aby had loved so much as a child. Her blue-green eyes became glazed with tears under the lacy veil, while her trembling hands sought refuge amidst the folds of her dress.

Woman, artist, wife. Strong and sweet, patient and brave, determined and obliging, discreet and aware. He knew she never would betray him, never leave him alone; she would accompany him everywhere, even down the rockiest paths, without complaint or hesitations. He could tell her courage was silent and indomitable, like Judith's.

*

They left for Wiesbaden the same day, accompanied by a great many suitcases and hatboxes, and two extra trunks: one for Mary's paints and canvases and one for Aby's books.

Under the arcade of the Kur-Park, the newlyweds spent long hours discussing art and love as Strauss's notes fluttered the young ladies' skirts in a swirl of dance. Evenings at the Bad-hotel were continuous gastronomical feasts, as the finest French chefs tried to outdo one another in inventing new delicacies for a sophisticated, demanding clientele. Aby had decided to put his oppressive bad moods out of his mind for the time being, and tried to be an attentive, carefree husband to Mary. Yet despite the good will, his cheer did not last very long.

He retained a vague and yet painful memory of the first scene of their conjugal drama. They were in a wide-open and yet somehow oppressive place. He remembered the dense vegetation; it was probably up on the Nerotal hill, where on Sundays a colorful crowd of motorists and cyclists used to come together for social gatherings and elaborate picnics. Mary was lying on a plaid blanket, her chemise a little rumpled, her hair alight with the glow of the setting sun. He wanted that creature to be entirely part of his world. He wanted to warn her so she might not suffer, and at the same time to have her near at all times, even in the darkest regions of his personal Hades. He wished he could separate her in two, so that she might be half-person, half-spirit. But despite what he thought only few weeks ago in front of the altar, Mary could not be separated: she looked at him enigmatically and let him speak. A strange smile puckered her lips, and Aby didn't know whether it was a tacit form of encouragement or a subtle gesture of mockery.

Mary's equilibrium intimidated him, sometimes irritated him, and he often wanted to shatter it. But there she was, stronger and sweeter than ever, with a blade of grass between her teeth and a branch of verbena in her hand. The crowd of Sunday excursionists had thinned out in the meantime, and in that unexpected silence, her face had taken on a mythic quality; more than remote, she seemed inaccessible and, at that moment for the first time, Aby felt painfully, desperately alone.

A few weeks later, Moritz and Charlotte came to visit the newlyweds. Moritz had announced their visit in a letter addressed to Mary that began: "My dear daughter." Aby was pleased with this; they had finally accepted his wife, peace had returned to the family, and in a few days they would celebrate their reconciliation.

Remembering the early days of his marriage, Aby recalled his mental instability. He should have considered himself lucky then: he was thirty-two years old, blessed with sentimental and financial security, had many intellectual interests and no professional obligations, and could pursue his own projects and continue to accumulate his much beloved books. And yet his new situation as head of a family, instead of seeming advantageous to him, had begun to trouble him, because it invested him with new responsibilities. He had felt immediately compelled to prove to Mary that his work was bearing fruit, and before their honeymoon was over he had written many letters requesting employment. His primary goals were a position at the new Kunsthalle of Hamburg or at the University of Kiel, or some job that would allow him to continue his research. Being rejected in each and every one of his requests was thus a bitter surprise, and only increased his intolerance of all forms of academic institution. He and Mary therefore decided to go back to Florence to live, to the city where, ten years earlier, they had met and fallen in love.

And in Florence they were welcomed with the warmth and affection that only Italy could offer. With tender smiles and a firm will, Mary succeeded in prying Aby out of his stubborn isolation and surrounded him with friends new and old, young

students and refined intellectuals. They began frequenting such venues as the Villa I Tatti, where Bernard Berenson entertained the crème of the intelligentsia and the international aristocracy, and the studio of the sculptor von Hildebrand, who at the time was involved in a large architectural project for the city of Florence. They also formed a close friendship with Andre Jolles and Jacques Mesnil, and with their circle of philosophers and poets.

Aby, however, could never stand Berenson; he found him snobbish and pretentious, with his overly manicured beard, his affected manner of speech, and the way he seemed to make his physical frailty a point of pride and an excuse for dressing in a fastidiously precious manner. And while he did admire Berenson's library, where he often sought refuge during those long social soirées, from the very start he had never agreed with any of his theoretical positions. Those captious, convoluted arguments reflected a typical collector's mentality, one given predominantly to venal concerns. And Berenson wasn't the only one: it was pretty much the same with Morelli and the other attributionists, the "tribe of bloodhounds"—as he called them at the time—who wanted to protect, through delimitations or extensions, the artist's status as hero, so as to impute to him a logical coherence and organic wholeness. In Berenson everything seemed to remain on the surface; even his conversion to Catholicism was purely a matter of social climbing, an attempt to make people forget his undeclared shame for his humble origins.

In short, those circles of peevish intellectuals irritated him more than they stimulated him. Aby preferred the company of artists—real artists, whose intellectual and moral intensity one could touch with one's hand, and whom one could confront openly. Much to his chagrin, the energy of Berenson's cronies used to draw him out, even though he had perceived a kind of sliminess in those pompous intellectuals and feared being sullied by it.

The new German Institute of Art Historians was perhaps the reference point most to his liking; he had formed some real friendships there, such as that with Giovanni Poggi, whose

seminars at the Institute had stimulated and encouraged him to establish parallels between Germany and Italy.

Mary, meanwhile, was proving to be an excellent housewife, extending and returning hospitalities with exquisite dinners on the terrace of their beautiful villa in Fiesole, where the guests could enjoy one of the finest views of Florence while sipping on Chianti selected personally by Aby. After those evenings spent in amiable conversation, Aby would sometimes stay up until dawn. Leaning on the terrace railing, at last immersed in silence, he would admire the shadows cast by the cypresses on the sides of the houses, and turn his thoughts to the great master he was studying at the time: Leonardo. Nobody before or after him had been able to use shadow as a silent color, as a means for communicating the inner life of human beings; nobody had known, as he had known, how to express the states and impulses of the spirit, their serene immobility and their impetuous mutability. Leonardo had succeeded in capturing the subtlest, most elusive feelings, had known how to recognize, represent and convey them. How astonishing were the smiles of the *Virgin of the Rocks* and the *Mona Lisa*, the expressions of Christ in the *Last Supper* and Saint Anne in the *Madonna and Child,* or the violent, agitated movements in paintings like the *Battle of Anghiari*, where men and animals seemed to exude blood and sweat, ferocity and fear. While Leonardo's landscapes and feminine visages seemed to emit a pure, mysterious silence, his battles were bursting with shouts and creaks. But what was the secret behind so much mastery? It wasn't only the study of Classical art, from which he had drawn and inherited canons of proportion and harmony. Indeed, his genius knew how to soar far above all technical artifice; it was a subtle genius, yet one possessing great powers of synthesis, capable of finding a perfect balance between inner beauty and outer drama, a genius that forever remained the great miracle of art history. He had to admit that, in Leonardo's case, he felt incapable of suspending aesthetic judgment: it was the only moment where he ceased to be a historian and became a critic, only to cease being a critic and become an enthusiastic admirer.

His lectures on Leonardo turned out to be a great success: Lichtwark, the director of the Hamburg Kunsthalle, had agreed to host that brief course, and for Aby it was an excellent opportunity to show Mary's family and his own the results of his recent studies.

After that brilliant start, he began traveling frequently between Hamburg and Florence, trying to establish relations in both cities, to carve out a niche for himself in hopes of obtaining more official assignments and public recognition. The knowledge that Mary was now expecting a child had increased his sense of responsibility and the strength of his commitment.

A child! He couldn't wait: Max had just had a son, Eric, that same year and in New York Felix already had three little children and Paul two. Now it was his turn to become a father. He fantasized about how he would share his passions and interests with his child; and though he had never believed in the mission of teaching, much less in proselytism, he felt for the first time the need to pass on, to give or preserve, the little that he believed he had got out of life.

*

His fondest memories from that time were of the holidays they used to spend at Kosterberg. In summertime Moritz and Charlotte, now grandparents, used to bring together the children, their spouses, and the grandchildren on a property that included two new buildings a few steps away from the main house and about four hundred acres of land that stretched to the north, toward the Elbe.

The main house, originally built as a stable in the late eighteenth century and refurbished as an inn in the early nineteenth, had preserved the long, narrow shape of a country cabin. Charlotte had fought not to have the structure changed, wanting to preserve those odd and uncomfortable proportions in homage to history and architecture. The dark, narrow entrance led into a long corridor on either side of which the spacious rooms of the ground floor opened up. The kitchen, which ran along the

entire eastern side of the house, gave onto a narrow portico in front of which rose up a gigantic beech tree from whose lower branches were hung all sorts of ropes and swings. What ancient patience that strong-armed tree had! The children would climb up it like monkeys, hanging from the branches or hiding behind them, always inventing new games and adventures to play amidst its rich foliage, while their mothers and nurses called out in vain from the kitchen or the portico. The bark on the lower part of the trunk was carved up with every manner of children's tool and weapon, and at the end of the season the dried, yellowed leaves seemed to proclaim not so much the arrival of the autumn as a tender weariness, like that of a grandfather who has played too long with his grandchildren.

On the other side of the house, where the yard was broader and better maintained, stood a proud row of linden trees. This was where the adults went for rest and contemplation. From there, one enjoyed a splendid view: the hill sloped gently down, gradually merging with the plain, which continued on toward the river amidst rich vegetation on the southern side and more open spaces to the north, affording a glimpse of the rest of the county all the way to the horizon. The Elbe loomed broad and mighty in the distance, its bright blue waters flowing deep and regular, its banks lushly overgrown. Under those lindens one breathed the most inebriating air in the world, and in the moments of silence, when grandparents and children were napping, the rustling wind sang wondrous lullabies. With the resumption of the customary chatter and bustle, however, the spell was broken by the comforting din of the familial lexicon.

Evenings, after the long sunsets, the Warburg family would spend many hours in friendly conversation in the great dining room, which was surrounded by windows with soft curtains billowed like sails by the wind. After the death of Grandmother Sara, Moritz had become the patriarch of the little clan; it was he who opened and closed the Sabbath with the *Baruch Atta Adonai, Eloinu v'Eloe Avodenu* . . . , while Charlotte silently gave the blessing in front of the Menorah's flames.

After the meal, the brothers would gather in the library to smoke cigars and discuss politics, sometimes heatedly. While

Aby passionately supported the renewal of the Triple Alliance, Felix and Paul explained with conviction the American economic expansion and the advantages of building the Panama Canal. Max, with his typical, balanced impassivity, would limit himself to asking questions, cautioning the others a bit pessimistically as to the dangers of assuming overly inflexible positions, which often led to grief, as with the recent assassination of the king of Italy.

In the adjacent sitting-room, the ladies engaged in conversations no less lively, which ranged from music and literature to embroidery and fashion. They would tell anecdotes about Thomas Mann, the new young star of German literature, the plot of whose just-published first novel, *Buddenbrooks*, seemed to bear so many resemblances to the story of the Warburg family. Frieda and Nina for their part were great music-lovers, with a particular passion for the opera; that summer they had given their mother-in-law Enrico Caruso's first recording as a gift, which they played and played until the ladies had no energy left to turn the crank of the gramophone. The children of the American wives had begun to study violin and cello from the earliest age, and now, at only six years of age, they could already give worthy renditions of little Mozart sonatas.

Alice and Mary had assumed the task of preparing a little performance every evening, and this new attraction ended up becoming one of the most eagerly awaited events of the day. Mary would construct papier-mâché marionettes of the most varied forms, and Alice would paint them with tempera. Under the portico they had set up a veritable theatre in miniature, with changeable sceneries and a red velvet curtain. The two wives, now united by a sisterly bond of friendship, would present their puppet-plays with all the enthusiasm and cheerfulness of two little girls.

Yet the nightly "performance" at Kosterberg was a real undertaking in which the whole family was involved. Aby and Mary were among the most brilliant. Aby would manage to dig up works by unknown authors and adapt them in a few hours, transforming them into irresistibly funny vignettes. It was up to Mary to see to the scenery and costumes, which, when

worn by Aby, added to the comic nature of the performance. A great success that summer was *Aunt Lotte*, in which Aby had given proof of considerable gifts as an actor and Mary as a costume designer. As the undertaking proved to be a success, a real theatre was finally built, between the main house and Max's house. Semicircular in plan like an amphitheatre, it had a system of wings and a *plein air* curtain: large sheets of linen hung from a rope between two tall poles served as the curtain, while the staircase of the main house acted as backdrop. The playbill of activities featured at the little and big theatres thus soon became so varied and complex that Felix—with his inborn entrepreneurial spirit—decided to add, next to the portico, a small ticket booth where the playbills of the week were posted and proposals for the coming weeks were examined. Early in the morning, even the children would abandon the large beech to take part in the discussions about staging. Around that little wooden kiosk one could watch the Warburgs practicing all their histrionic gifts, which spanned the gamut of Jewish humor: Aby was without equal in his imitations and Felix was best at inventing gags, while Paul was a master at witty retorts, with Max as his foil. In all five of the brothers, their bright, cheerful eyes contrasted with their thick, identically trimmed mustaches and the perfect outfits made by the wives in an ongoing, friendly competition.

There under the linden trees and around that kiosk, Aby spent the most carefree days of his life. Even as the old century was slipping away, time had stopped at Kosterberg: for a few months out of the year, the family was reunited and could cultivate the same bonds of blood, affection and culture that had united their forebears for centuries.

*

A sparrow, or perhaps a small blackbird, had just landed on the balcony railing. He saw no grace in the creature, but felt instead slightly irritated by it and was almost tempted to wag his arms to chase him away. The slender wrought iron railing had the sinuous lines of the Art Nouveau houses in

the area, with their ornamental excesses he was never able to appreciate. That stylistic craze, which had invaded Europe at the turn of the century, had not spared even the humble center of Kreuzlingen.

The new century, however, despite the optimism surrounding it, produced a growing sense of anxiety in him. He had no sure foothold in life, and no recognition. He was prey to alternating states of mind. In the old country house, where he was close to everyone and far from everything else, it seemed as if universal harmony would reign forever, though he knew this to be an illusion. The new century had begun clamorously, with news of conquests and discoveries. He too believed in progress and science, was convinced that they would eventually dispel all ghosts and superstitions, and yet he feared that their forward march, if it became too rapid and careless, might trample down that terrain of the spirit out of which grew imagination and respect, reflection and tradition. Would art and culture be able to follow science and technology along their path, to teach them harmony and consistency? He wasn't sure, and thus he hoped that his library might become a tool, however minimal, in the service of this cause.

There were already some several thousand sundry books in the house at Fiesole. While Felix and Paul had put together a fine collection of art in New York, he had collected the most extraordinary library of cultural history on the old continent. The goal now was to seek some sort of official recognition, above all to obtain public support. He needed encouragement to shake off the frustrations of the marginalized scholar and gather the fruits of that precious labor. And thus, on a long walk on the beach one day, he had come up with the idea and the name of the *Kulturwissenschaftliche Bibliothek Warburg*.

It was a very hot Sunday, and he had convinced Max to come out with him to Helgoland, a rather arid island out past the mouth of the river. That day they had both had the same desire to breathe the cool, salty air of the North See and look out on a clearer horizon. Once off the ferryboat, they headed west, to the lowest part of the island, immediately eschewing the idea of any excursions along the rocky cliffs of the eastern

side, which would have been more strenuous. That would have required hours in a carriage, whereas Aby urgently needed to be alone with Max. Max, of course, was well aware of what this was about, and knew there was no escape this time. Thus with patience and goodwill he prepared himself to listen to his older brother, who was slowly but insistently heading toward the beach.

Max had a long, determined step, like a soldier, while Aby had learned in Italy the slow, irregular rhythm of the promenade. On the white sand speckled with dark little pebbles, Aby trudged slowly behind his brother who, a few steps ahead, resisted any pointless stops or delays. The conversation followed their uneven movement, alternately coming together and spreading apart in time and space. At moments Aby had to shout so Max could hear him, while the younger brother, still facing backward, expressed his assent with emphatic nods of the head. Once the question of money arose, however, Aby insisted they be close together, and with a serious expression he pointed to two polished rocks and lightly pressed Max on the shoulder to oblige him to sit down there with him. Like so many years earlier under the great fir tree on the Mittelweg, he asked for books against money, or rather, for money to buy books, and Max could only grant him his wish.

Aby spoke with the same emphasis and awkward gestures as so many years earlier; the financing of the family bank would make it possible to expand the library into new interdisciplinary areas. *Kulturwissenschaftliche* was the term he had chosen to designate its structure and objective: that is, it would be a library for the "science of culture" as a new tool and method for confronting the great problems of humanity. Tracing a physical path from one volume to another, and one shelf to another, it would show how the exact sciences arose from the natural sciences through a slow but certain process; how astrology had given birth to astronomy, alchemy to chemistry, magic to logic and mathematics. These materials would share the same space without discontinuity or contradiction. The history of thought would thus become a tangible experience. Every subject and argument would thus have the possibility of developing and

growing into an analogous or complementary subject, and thus every essay or document would have the possibility of referring to another essay or document. He wanted the library to become a public institution. He was willing to open it up to students and researchers, to provide advice to young scholars, to establish relations with other libraries and university faculties. Before he could do all this, however, he needed greater, more regular support from the M.M. Warburg Bank. He presented the request to Max no longer as a plea but rather as a real strategy—that the Bank should become an example of how capitalism and culture could and should sustain and enrich each other.

Max didn't dare interrupt his brother; he knew how important all this was to him. At moments he felt a strange envy for the burning passion, the intellectual torment his brother cultivated and nurtured inside him. As the wise, responsible man he was, Max could never allow himself to be excessively emotional, whimsical or original. He had never been able to give free reign to his dreams and desires, and thus had remained, since his boyhood, the noble prisoner of his role as heir and head of the family.

Around the rocks, meanwhile, the water had risen a few hands and the high tide continued to swallow up narrow strips of beach. From the port area a smell of algae and fish wafted sporadically their way, while the suddenly colder air beckoned them to return.

Aby stood up with the same resolve as Max, placed an arm around his brother's broad shoulders and clenched his jaw with a solemn look in his eye. The whispers of the waves seemed to reestablish a proper silence after all that declamation. Their feet sinking into the wet sand, the two brothers walked briskly now, looking far into the still glowing horizon. After a few minutes, Max broke free of that overly fond embrace with a laugh, pointing out to Aby that they were finally walking at the same pace.

6

THE RETURN OF THE GODS

The first years of the century proved to be strangely happy.

With the arrival of Marietta the house was filled with a cheerful confusion. First they had to choose the baby's room, and decided on one of those with a view of the olive grove. Then the wet-nurse arrived from a village in the Apennines. Then there were the arguments over the baptism, which was procrastinated week after week. Most of all there was Mary's gaze, radiant as a day in May.

And as Aby was trying to concentrate on the influence of the Flemish style on the Medici court, Max Adolf arrived too, blond and beautiful as a cherub in a Renaissance fresco. Although Mary's parents had put more pressure on them to avoid the Brit Mila, this time the two families sought to contain the usual disputes regarding the grandchildren's religious upbringing and surprisingly left it up to the parents. Max Adolf was a strange combination of Mary and Uncle Max; his features reflected a typical Germanic beauty, yet his character was clearly Jewish. Aby was very proud of him, and with that new feeling of fatherhood also came a desire to go back to Germany, to build a more solid future around the family and the Library.

He certainly loved Italy, its art and its people, but it wasn't the same; rejecting the religion of his fathers did not mean disowning his origins and the great cultural traditions of his native land. He continued to be a great supporter of the German

Empire; Wilhelm II's *New Course*, and his social reforms—which he had so feared at first—had come, with time, to seem more appropriate and astute; the new Chancellor, Von Bulow, had shown himself to be a statesman of great intelligence, and his success at stemming the new Socialist tide without harm to the aristocratic classes or to large protectionist industry made him the right person to hold the reins of power in so difficult a period. The Warburgs could only gain from this political situation: Max had given the M.M. Warburg Bank a new, dynamic, modern management, turning it into a real financial and political power, while Paul had turned heads on the other side of the Atlantic as the founder of the new American Federal Reserve System, gaining fame as a great international financier. At his age, Aby should have appreciated his brothers' successes and used them to his advantage in trying to reestablish himself in Hamburg. Yet his identification with the family was still a great psychological obstacle for him. He sensed, in the very notion of family, something coercive and limiting, and instead of simply passing over this feeling he would get stuck on it, reacting with the same muscle contraction that makes physical pain more acute and harder to bear.

When the family still used to gather in the Mittelweg house for the most important occasions, he couldn't control his transgressive impulse and quasi-adolescent attitude of irreverence. At the start of prayers he would take Marietta and Max Adolph by the hand, put them on his knees and begin to recite nonsense rhymes and slightly obscene tongue-twisters, while a disturbing sneer distorted his features. The children, awkward and frightened, would do as their father said, their voices trembling and their cheeks ablaze. At the end of the ritual, he would burst out in devilish laughter, which only added to the children's dismay and the adults' embarrassment.

He felt stifled when forced to assume those roles of model father, older brother, rebellious son ... Or perhaps it wasn't his role in the family that irritated him, but the price he had to pay to be part of the family. And yet the Kiddush prayers on the Shabbat had become shorter and shorter, and were barely whispered by Moritz, with Charlotte's half-hearted

encouragement. Recited partially in German now, so that the little children would understand, and interrupted by repeated distractions, those prayers represented more an homage to paternal authority than any real need on Max's and his brothers' part. Yet Aby would not tolerate even that. Mary, on the other hand, would look down and gracefully step back from the fray; she would let Marietta and Max Adolf follow the rules of the Warburgs when in their house, demanding only that in her own they give homage to her God. She so wished Aby would second her in that difficult but painless practice of tolerance, yet even the slightest mention of it would send him into a rage. For Christian feast days Mary and the children would go to church without their father and find a quiet peace among themselves. He felt that exclusion to be intentionally cruel, but for consistency's sake could raise no objection to it; the only way to vindicate himself was to collect the children after dinner and to tell them, in his own intense and passionate words, the most beautiful stories of Ovid's *Metamorphoses*.

<p style="text-align:center">*</p>

In the spring of 1904 he left Mary, Marietta and Max Adolph at Kosterberg and went to stay with Max in Hamburg, to look for a house. He wanted something large and spacious where not only the family but also the Library could grow without fixed limits.

After long days spent searching, he would allow himself, in his evenings of newfound freedom, sumptuous dinners in the old pubs of his youth. There he would meet with childhood friends and old university colleagues and lose himself in honest and lively conversation. He told them about the Italians, whose mannerisms and characters he could imitate with precision; he described life in Florence, the new fashion trends, the pleasures of eating well, the opening of the opera season, the fascination of women with eyes of fire. After dark he would walk to the St. Pauli Reeperbahn and wait for dawn and the return of the fishing boats. Those moments of waiting, poised between the end of the night and the start of the new day, filled him with a tremendous

sense of peace. With the collar of his jacket turned up, a cigar in his mouth and his eyelids half shut, he would breathe in that air scented with herring, spices and rum while the merchants and restaurateurs began to gather on the wharf, awaiting the return of the fishermen. Their subdued voices and laughter still muffled with sleep produced a comforting sound, occasionally drowned out by the screeches of the seagulls. At those moments he felt a new sense of hope growing within him: perhaps one day all the anxiety and delirium would disappear; perhaps he would soon recover his balance and stability and join his brothers in their success and social acceptance. On that quay slowly lightening with the first pale glow, with his face to the river and his native city lying protectively at his back, Aby tried to believe in some kind of future, some kind of change or miracle.

Heilwigstrasse was a quiet street to the north of the residential quarter of Hamburg. Beyond the great avenues of the Mittelweg and the Alsterufer, the city broke up into narrower, quieter streets; the trees grew denser and the Alster branched out into dozens of little canals. The townhouses of the Heilwigstrasse all faced onto the Leinpfadkanal, with terraced gardens full of weeping willows whose branches came to rest on the surface of the water.

The facade of 114 Heilwigstrasse, in elegant Art Nouveau style, was covered in a powder-colored plaster interrupted by the darker frames of the doors and windows; the slightly rounded roof gave a sense of the vastness of the rear, which reached toward the canal in a semicircle. The yard, facing south, had a great deal of charm: the grass was that intense green typical of humid northern countries; the willow branches lightly touched the waters of the canal, reflecting all the shades of their rich mane; and all the while a whispered splashing broke the surrounding silence at regular intervals. Looking out from the balcony, one could see to the left the little bridge joining Heilwig with Leinpfad, and to the right, in the distance, the outlet of the canal toward the Aussenalster. Aby understood at once that this would become his house, and he knew that Mary would wholeheartedly approve. Next to the cast-iron bench on which he had sat down to think, a somewhat sickly looking

little apple-tree was growing warily from the ground. Here and there on the branches were some withered spots and its yellowed leaves seemed about to fall right then and there, and yet there was something touching about the thing as a whole. It seemed to want to communicate something to him, a message of peace, a promise. He slowly approached it, touched one of its little flowers with the same gentleness with which he had first touched Marietta's cheeks, unthinkingly picked some of the more yellowed leaves and held them tight in his hand for a few minutes; then, turning back to the owner of the house, he made a gesture of affirmation and headed off toward the street.

<p style="text-align:center">*</p>

The following summer the Warburgs moved into 114 Heilwigstrasse with an enormous train of crates, trunks, boxes, and suitcases. Although Aby kept jokingly repeating that the Hamburg accent was the purest in Germany and Mary always retorted that the accent mattered little compared to the humidity and the rheumatic pains that the region had always inflicted on its inhabitants, both were in fact quite happy to be back in their native city and to see the same places and faces they had always known.

The task of putting the books in order was a long and arduous one. In fact Aby used the occasion of the move to change substantially the order of the Library. He worked out the initial set of criteria for arrangement, which was quickly replaced by another and then by a third; a few weeks later a new, more rigorous protocol made way for yet another which, in turn, engendered still another. With each new acquisition or delivery of books he would change the order, if not of the whole Library, at least of part of it, and he would not rest until each volume had found its most appropriate position. If the general criterion of arrangement was the evolution of human reason, the themes and subjects of each book were continuously creating new subdivisions and subsections, branching out into increasingly labyrinthine articulations. Whenever he ran out of room on one series of shelves, he became greatly irritated. He

would huff and break out in a fine sweat, abuse any objects that were lying about, breaking some and damaging others. When, on the other hand, the space was plentiful and well distributed, he couldn't restrain his great sighs of satisfaction and contented mumblings to himself. He would then take a sensual pleasure in touching the robust spines of those leather-bound or parchment volumes, would move them a millimeter or two to make sure they were perfectly comfortable in their assigned places, then would move them apart and back together again, substituting one or two positions with each other before returning with greater conviction to the initial ones. He would anxiously await the catalogue orders, rare books that often became the indispensable link joining two volumes. When these were late in arriving, he would look for momentary substitutions among the dusty volumes he used to find in the bookstalls at the market; or he would snoop around in every corner of the house or among the empty crates, hoping to find something he had forgotten about, checking and rechecking the order dates and re-tabulating the number of days or weeks he still had to wait. At times he would even get up in the middle of the night to reorganize a section, to put back some volumes that had been sitting too long on his desk, or else to set aside some others in a new series. He would climb up on a stool or stepladder, removing one ill-placed volume after another, holding them tightly between his fingers while anxiously looking around at the surrounding shelves. When he found a more appropriate place, he would re-insert them with physical pleasure, pressing down first at the base of the spine, then pushing on the central part with his index finger, so that the outer points of the cover would not suffer any damage. Touching them again from the outside, he would check to make sure that the bookmarks hadn't fallen out or gotten lost, and then he would finally, slowly slide back down to the floor with a stealthy, catlike step, his fingers still gripping the edges of the shelves.

Mary used to tease him good naturedly, saying there was something maniacal about all that arranging and rearranging, but he didn't care. She couldn't understand how important it was to bring that inert mass to life, to make it breathe, to turn

it into organic, moving, growing matter, how necessary it was to continually change its form and reorganize its structure.

In the summer of 1908 he hired a young professor as librarian and research assistant, and opened the Library to students. The large crowd of young people coming and going from the Heilwigstrasse, though certainly discreet and perfectly well-behaved, filled the house with a new vitality; even the children—who were now three with the arrival of little Frede— noticed the exciting, festive atmosphere.

At that time Aby came to the realization that he had unquestionably acquired a certain prestige and influence. He had many contacts with the intellectual milieu of Hamburg, and in fact was himself one of its prominent representatives. He was asked for specific advice concerning the foundation of the university, and was consulted about the new frescoes for the city hall. The requests to participate in conferences and conventions become more and more frequent, while the influx of people into the Library grew with each day, especially now that he had added a photographic archive. In recent years, in fact, he had collected a large number of photographs of sculptures, bas-reliefs, medals, tapestries, drawings, paintings, frescoes, engravings, calendars, edicts, and other things, from the fifth century B.C. to the late Renaissance. He grouped them according to iconographical themes, the better to illustrate each subject's origins and its stylistic transformations through history and context. This documentation grew even more rapidly than the Library had done, and would one day serve as the basis for a large project that Aby didn't like to talk about yet, but which he was gradually elaborating in his mind with great care and enthusiasm.

Amidst all that paper and all those images, he felt his passion for art history, now inseparable from the history of ideas, the history of man, and history *tout court*, grow and gain strength. History, for him, represented the social memory, the self-awareness, the rationality of humanity. Space and time, in the new philosophy he was formulating, flowed together in a single evolutionary dimension according to which man supposedly progressed toward a definitive break from the shadows of

irrationalism and fear through the understanding and mastery of reality—through science, in other words. And as a complement to this approach—and here his positivism was as innovative as it was original—the study of signs and symbols, far from impeding or obscuring this process, would in fact help bring it to light.

*

The new house, meanwhile, was beginning to acquire that cozy, lived-in character of houses that have been inhabited a long time. In this, he and Mary were in perfect agreement, for they both despised luxury and ostentation. They had each inherited a taste for simplicity from their respective mothers and had made it their distinctive personal style. Though he liked to travel in comfort, accompanied by a great quantity of baggage and portable furnishings, at home his needs were noticeably reduced. He thought the art collection that Felix had amassed in his New York home to be absurd; in fact the house itself seemed excessive to him, with its neo-Gothic style, elaborate mullioned windows and medieval portals giving onto Fifth Avenue. Worse still was their Tudor-style castle in the country, at White Plains. Frieda had insisted they maintain the same standard of living as the Schiff family, and Felix had complied by indulging in a plethora of pomp and waste. He bought horses, polo fields, race cars, and a personal yacht, and continued to fill his sitting rooms with Botticellis, Rembrandts, Sisleys, Turners, Monets and Renoirs.

Aby, on the other hand, had never had any desire to acquire works of art, despite the insistence of friends and the dictates of common sense. He continued to admire Mary's talents, though perhaps a bit distractedly, and he encouraged her to persevere in her career as an artist. But weighed down by family duties and frustrated in her youthful ambitions, she engaged less and less in that old passion, contenting herself with being asked for advice and criticism by artists more gifted than she. Even Alice, Max's wife, had far surpassed her by now and been invited on several occasions to participate in important group shows at the Kunsthalle. Mary did not envy or resent her, however,

and in fact remained always close to her, as her faithful adviser and sincere admirer. Mary in fact had never known feelings of rivalry or resentment toward anyone. At times Aby wondered whether she felt truly accepted by his family, whether her alienness to their culture made her feel lonely and isolated among them. He wondered if she had ever felt hurt by his mother's harsh glances or offended by his brothers' coldness. Yet he never actually bothered to ask her, perhaps out of laziness or cowardice. The woman, who was once treated like a princess in the Hertz household, had become distressingly self-effacing and introverted, and never dared translate those feelings into words, leaving them rather to shine through those beautiful, sad eyes. She never reproached him for anything: neither for neglecting her, for forcing her to live with his mental instability, nor for making her bear the entire weight of the family herself. She loved him unconditionally, or at least so he thought at the time. For his sake she had become a librarian; in a very short time she had learned the order of the books and was better than anyone, even him, at remembering it. She also took care of the correspondence, accounts, appointments and all the other necessities that had grown up around the new organization in their Heilwigstrasse home. Only when she had a free hour or two at her disposal, between her duties as wife and mother, would she take refuge in her little studio on the first floor and modestly attempt a drawing or two—perhaps an Italian landscape or portrait of one of the children—which often remained hidden in a drawer.

One day her brother John insisted they buy a little oil painting by Franz Marc, at the time an entirely unknown painter; Aby could not refuse this bit of friendly advice, and thus made his first and only investment in modern art. He was very fond of his brother-in-law, and probably hoped this act might make up for his failings toward Mary. When John later died, still in the flower of his youth, Aby suffered terribly.

With Mary's approval, he had hung every manner of reproduction on the walls of the house and especially in the library. Usually they were photographic enlargements which he would often study and think about in passing. Together with

the *Laocoon,* Ghirlandaio's Nymph, a photo of Nietzsche and an engraving of Goethe, there hung at the time, on the wall of the internal stairway, a large photo of the black man with the rope from the fresco cycle at Palazzo Schifanoia, who since the first of his many visits there had never ceased to torment him with his fierce, mysterious gaze.

In that summer of 1908, *La Sphaera,* by Franz Boll, was finally published. Aby had long awaited this essay by his friend and teacher, and now it was finally there, on his desk, fresh off the presses and with a personal dedication. The text was without question the most complete treatise on astrology ever conceived. In it, Boll had traced the development of the astrological and astronomical speculations of the Greeks through their refractions in Arab and Western medieval cultures. Now, sliding the paper-knife between the uncut folios was like unfolding secrets and mysteries to which he finally had access. Aby ran an attentive eye over the index and bibliography, the notes and references. Trusting himself once again to serendipity, he opened the book at the middle, to the translation of a text by the Arab astrologer Abu Ma'sar. This text was in turn based on an Indian version of a more ancient astrological text by a certain Varahamira, and it documented in great detail the signs of the Indian Zodiac and that of their lords, called "Decans" or "Ten-Day Rulers," under whose dominion are assembled the three groups of ten degrees that together make up the thirty degrees proper to each sign. These new astral symbols, of which he knew very little, aroused his curiosity. He read on and found that the first of these "Decans" was meticulously described as a man with dark skin, a fierce gaze, with a rope tied around his wrist, and a two-edged axe round his waist! He was Perseus, lord and master of the constellation that appears in the night sky in the autumn—around Ramadan. So he was right! His hypothesis now had a foundation: from a Classical myth, Perseus had been transformed into a constellation and survived the advent of Christianity; he had migrated east, where Indian and then Arab culture had hid him among the stars. Following this theory, he inferred that in Renaissance Ferrara, and in Cossa's representation, the myth had finally re-emerged and reacquired

its anthropomorphic features and ancient significance: that is, it once again embodied the hero who captures and kills the monster to save Andromeda, though in this case his courage and strength became a political metaphor for the good government of the ruling Este family.

Having found the key, he was finally able to open the majestic portal of Olympus and recognize the crowd of gods and heroes inhabiting the Hall of the Months in Palazzo Schifanoia. He went over those figures again in his mind, the same figures that had once seemed to him so enigmatic, and little by little unveiled their identities. Their classical origin was now clear, as was their correlation with their astrological signs—signs which for centuries had been their refuge in exile, safe havens of their survival. Thrilled by this new discovery, he now hailed "Pallas who protected March, the month of Aries; Venus, April and Taurus; Apollo, May and Gemini; Mercury, June and Cancer; Jupiter and Cybele together protected July and the sign of Leo; Ceres the month of August and the Virgin; and Vulcan, September and its corresponding sign, Libra."

He could now grasp the threads wound together in a single skein, and with them he could weave together a tight, coherent fabric. Those gods had come to Ferrara through Spain, yet their peregrinations had begun centuries before, in Greece, and then on to Asia Minor, through Egypt, Mesopotamia, Arabia, and India. In the late Middle Ages they had arrived in Italy in the form of folk figures in astrological calendars and the Tarot, and only in the blossoming of the Renaissance had they found their original names and faces again and gone back to being themselves, symbols of beauty, pathos, and freedom.

The correlation between paganism and astrology now became a key concept in his research: he began to follow paths previously unexplored and to enter a jungle of historical data, looking for traces that he knew existed but which had been obscured by time and different cultures. Little by little those paths emerged clear and well-defined, and soon they made up a new mythological geography where gods and heroes, symbols and signs intersected and overlapped with logical fluidity. In discovering these paths, he knew he had a chance to become the

first "cartographer of the gods," to retrace the most fascinating journey of the human imagination.

The following year he presented the findings of his studies to the International Convention of Art Historians, in Rome. It was a real triumph: a new discipline was born, "iconography," which would forever remain linked to his name; the *Kulturwissenschaftliche Bibliothek Warburg* was definitively baptized; and most importantly, he had won the respect and esteem of all his art-historical colleagues.

After the final applause on that hot autumn afternoon in 1912, Mary's eyes were bathed in tears. Never had Aby seen her so happy. Rising from the great dais he could now face the dense crowd with assurance and pride; he offered dozens of handshakes and made many bows, exchanged smiles and made witty remarks. By the end of his speech, the fire-red sunset had already faded and left behind a purplish glow. As he was leaving the Academy, he gave a start: that light, those colors were still there, only now they had been absorbed into the pores of the Roman stone, ancient as the world itself, which changes color at the close of each day. The city, from up there, was a play of soft curves described by the countless domes, while patches of silvery green counterbalanced all that architectural detail. The sky seemed to impose from on high the authority of the past and the solemnity of history, while in the immeasurable distance, vesper bells were ringing.

Surrounded by the crowd of convention participants, he had no chance to enjoy all that beauty but had experienced it inwardly, as a momentary mirroring of his state of mind. As a mild wind rose up from the west, the older professors began to head home while Mary, in a corner, furtively wiped away her last tears.

7

MELANCHOLY

He had always been irascible; in fact the outbursts of anger he began to have as a child became a reason for putting a distance between him and his younger siblings. Fritz and the girls were particularly frightened by these episodes, and Mother's strength and Franziska's patience were of little avail. Once he had given vent to his fury, he would carry on for hours, stamping his feet and punching the air, crying without tears and shouting childish insults in the large playroom.

He was especially grateful to the family doctor who—on the evening of April 2, 1873, declared him out of danger from his bout with typhoid fever—for the doctor had advised that no one, for any reason, should cross the sick young child any more. From that day on, protected by a clinical excuse, Aby resumed teasing his younger siblings and throwing every manner of tantrum.

Yet in adulthood those fits of choler became more difficult to manage. At every little instance of adversity he would feel an uncontrolled rage invade his body and mind, emerging from a lower region (perhaps the viscera, perhaps lower down) and taking possession of him, squeezing him until he exploded with sudden, brutal violence. He often wished he could check or channel that process, especially in the presence of loved ones; but when he did on rare occasions succeed in overcoming the beast, he was beset with a feeling of dizziness and nausea, a sense of darkness and damp and the slow, lucid awareness that depression was laying its hand on his head.

Then his eyes, usually bright and flashing, would darken and become veiled with strange shadows, passively reflecting an opaque, distant light. His usually tense, sharp facial features would droop and soften, the chin sagging toward his chest and the shoulders curving inward in a kind of semicircle. In that uncomfortable, humiliating position, he would realize he had no choice but to let his rage and bile overwhelm him, and to explode in a triumphant burst of energy. Anger, after all, was the most spontaneous, most genuine part of him; it was all that remained of his true nature.

At Kreuzlingen he had often tried to abandon himself to these frenzies, to free himself from depression's vice-grip by screaming wildly, stamping his feet and punching the air as he had done as a child, but the doctors punished him severely whenever this happened. He would pay for those moments of transport with long hours of isolation. Nobody understood how liberating and cathartic his rage was; the doctors feared it as they would a wild animal. They would frown at him like severe schoolmasters, shake their fingers at him, threaten him with incomprehensible utterances, then would take their revenge by forcing him into that stiff gray hemp straitjacket. Not even wise old Binswanger understood that at those moments he was struggling against his own loneliness, and that only in those moments could he feel his blood pumping and his body reacting; only then could he touch, grasp the world. Before or after there was only numbness and abulia. During those fits of rage he could actually see light—a cold, yellowish light which somehow illuminated his inner Hades like a winter sun breaking through leaden clouds. Later, when the sedatives began to take effect, the light would fade and at last die out altogether when that dark, damp grip had taken hold again of his head and limbs. Chin resting on his chest, shoulders curved in, eyes clouded, he would then be led back to his room, through stairways and corridors he no longer remembered, held up under his arms by an orderly whose name he did not know. Sedated and numb, he would go back to a place whose smell and temperature he scarcely recognized, and there his exhausted body would sink into a deep sleep.

*

He had studied melancholy from its beginnings as a subject and was following its development with dangerously intense interest. According to an anonymous treatise from the early Middle Ages, "in man there are four humors which are analogous to the four elements: they grow in different seasons and reign at different ages. The *blood* is like air; it grows in spring, elects childhood as its realm. *Anger* is like fire; it grows in summer and reigns in youth. *Melancholy* is like earth; it grows in autumn, and reigns in the mature years. *Phlegm* is like water; it grows in winter, and reigns in old age. To each of these elements correspond as many humors, characters, planets, and astrological signs, and thus to the sanguine character (permeated by a dark, damp humor) correspond the planet Jupiter and the sign of Libra; to the choleric character (permeated by dry heat) correspond the planet Mars and the sign of Leo; to the melancholic (pervaded by dry cold) correspond Saturn and Scorpio; and to the phlegmatic (pervaded by humid cold) correspond the Moon and Virgo. Man is in full health when the humors are right, whereas the alteration of the humoral balance (dyscrasia) generates different forms of physical and mental pathology."

The doctrine of the humors has a long and elaborate history. During the Renaissance, Marsilio Ficino shifted the focus to the melancholic, which became an independent typology as rich in case histories as it was in diagnostics. The melancholic type pervaded the history of thought and became, in a way, its central figure. Melancholic are the creative genius, the intellectual, the artist, anyone who in elevating himself to the highest speculative activities later falls back down into the depths of the human psyche; melancholic is the man who, under the influence of Saturn, oscillates between states of exaltation and gloom. Later on, and even in the modern age, the melancholic type becomes the misunderstood loner, the one different from the rest. Freud associates the melancholic type with the manic-depressive, Binswanger with the schizophrenic.

In 1514 Albrecht Dürer represented *Melancholy* as an angel with an ambiguous, intimidating femininity, surrounded by a

congeries of symbols, trapped in an impenetrable enigma. The head, turned downward, is circled by a crown of teucrium—that ancient fever remedy—while her gaze, beaming out from shaded face, is directed upward. The dress falls in thick, rich folds from the waist down; above the elaborate belt, from which hangs a set of keys and a *pouch à coulisse*, the bodice is equally sumptuous and topped by a bordered mantle. The angel is sitting on a low ledge, so that the knees rise up and dominate the foreground of the composition. The head is leaning on the left hand, which is closed in a fist, while the right hand is holding a pair of large compasses. At her feet, which are hardly visible under the full garment, the humble tools of *creative* activities—plane, nails and hammer—are scattered haphazardly, while above, on the wall of an unfinished construction, hang the tools of theoretical activity: hourglass, bell, scale, magic square. Also on the floor is a sphere and, behind it, a sleeping dog. On the left, opposite the angel, another series of forms and objects is arranged in striking, asymmetrical spatial relationship. A large polyhedron hides the bottom part of a ladder leaning against the building's wall; a cherub (also asleep) sits atop a stone wheel, and in the distance, a comet scatters its light under the arc of a rainbow, while a bat flies over a stretch of calm, stagnant waters bearing a standard on which is written *Melancholia I.*

In the months spent identifying the complex, fascinating symbolism of this image, Aby helplessly witnessed a process of identification with it; that sullen, gloomy angel seemed to press down on part of his body, there between the diaphragm and the stomach, and to increase its force of gravity, its specific weight. The more immersed he became in that deciphering, the more pressure he felt pushing him downward.

Just as the *Nymph* had represented the manic phase of his psychological vacillations in the state of overexcitement and hyperactivity, *Melancholy* represented the state of fear and sorrow. The physical lightness of the *Nymph*, her veil-like, streaming clothing, her impalpable flesh, her swift, airy movements, were now countered by the gravity of *Melancholy*, her bodily mass, static pensiveness, her dire omens. And just as the *Nymph* had accompanied him over the smooth heights of Olympus and the

tepid waves of the Aegean, *Melancholy* was now taking him into the burning rays of the stars and the dank wells of his psyche.

Nevertheless, he realized that Dürer had suggested a way to redeem the Angel from her age-old curse. He wandered through that jungle of symbols trying to find the proof of his hypothesis, and suddenly, with unexpected obviousness, the magic square caught his attention. Was it not said in the *Picatrix*, an essential text for the practice of magic and astrology, that the magic square is the sole means to invoke the beneficent intercession of Jupiter against the baleful influence of Saturn? And had he not discovered that two manuscript copies of this text were in the library of Maximilian I, in whose court Dürer was admitted and revered? That was it! That explained it!

But was it really so clear that Dürer believed in this sort of delivery from evil? What indeed was his real message? Whose side did he take: did he consider that Angel the bearer of a new annunciation or merely an illusory salvation? Or did that work represent the victory of *homo faber* and the intellectual over the forces of the irrational? Or did it represent the defeat of reason in the face of the mystery of the universe?

And why did he keep asking himself these questions?

Although he had always been one of those who could transform a question into a new enigma, this time he really did want to find a sure answer: the state of ambiguity in which Dürer had left his work was becoming a source of deep anxiety for him. Actually, this attempt to touch the ultimate meanings of a work of art was not the concern of the historian; this search for impossible answers to pointless questions was no longer part of the speculative investigation, but rather bordered on an existential need. But was it still possible to distinguish between the two? How to know where the study ended and the illness began?

With the study of *Melancholy* he wanted to move on to ever more esoteric fields. As he concentrated his attention on pagan divinations in the texts and images of the age of Luther, and on relationships between the Reformation, magic and astrology, his investigations seemed to trap him in a tight, downy web from which it was difficult to extricate himself. The more he tried

to fathom the unfathomable, the more those images seemed to secrete their filaments around his head like gigantic spiders spinning webs.

It was spring 1914 and he had become aware of a tremendous feeling of weariness and an ever growing sense of anxiety. While writing the short essay, *Luther and the Universal Flood Panic of 1524*, he began to suffer from real hallucinations. At night he would be prey to nightmares, fragments of which would resurface during the day and become confused with strange daytime visions. The idea of the universal flood had become superimposed with the idea of war, which he felt to be inevitable and more imminent with each passing day, and at night this would turn into images of destruction and horror. He would dream obsessively and repeatedly of a giant flood rising up from Germany and Central Europe and spilling over the entire continent, carrying myriads of human bodies in its livid waves. This would be followed by visions in which that liquid turned progressively redder until it became entirely human blood and those corpses assumed familiar faces and features. Once awake, or once the vision had vanished, he would try to understand the meaning of those images. He began to take notes analyzing these moments, jotting down hints of words or phrases, but before long his writing frenzy turned into mere raving and put him in a state of total confusion. Then he would try again to descend more slowly, one step at a time, from rational observations to more fantastical hypotheses. Once again, however, after the first steps he would find himself on slippery ground with nothing to grasp onto, and before he knew it he was already sliding toward the fathomless depths.

Finally he set his studies aside for awhile, mostly because his doctor had given strict orders to this effect. But he replaced that enormous mass of material (maps, calendars, almanacs, astrolabes, compasses, etc.) with an equally abundant mass of newspapers, magazines, reviews, and propaganda.

In June 1914, he would get up each morning more exhausted and anxious than the night before, and head into the dining room where, in front of a large pot of coffee and basket of fruit, he would spend hours and hours skimming the freshly printed

dailies, comparing news, checking information, commenting out loud on every detail of the political coverage. Alternating obscene curses with long hisses of disdain, he would shake his head as if to say "no," as if that gesture could alter the course of events or at least change the meaning of the news reported by the press. Then he would slip into the great armchair beside the hearth and continue to examine that pile of printed matter a little more slowly, until his fingers became so black with ink that he had to go wash them. Upon his return, he would concentrate his attentions on the few articles he had set aside, folding the page to the size of a book and immersing himself in his reading, with occasional whistles by way of commentary. In this fashion he would pass the morning hours, clinging to those articles and reports with a desperate tenacity. He would weigh every word, take apart every sentence, sometimes re-read the same line several times, looking for some sign, some hidden message. Oftentimes he would take the reporters' choice of words as a trick that said one thing but meant another; if the same news story was reported in slightly different ways by different dailies, he would compare the two or more points of view in search of a middle term, a common ground, and once he had found it, he would give it an overarching importance, no matter how inexact or misleading it might be. He would then go back and re-read the old articles in the light of this new discovery, starting over, from the beginning, that obsessive labor of deciphering and decoding.

In the news of the evening of July 10, 1914, however, there was nothing to interpret or decode: the story was clear and unambiguous on all the front pages. He gathered the family around him, and trembling like the needle of a broken compass, he solemnly read:

> "Mobilization of Germany imminent. Tonight or tomorrow. The excitement in Berlin is intense and frantic: everyone expects that Germany will mobilize in a matter of hours. The Conference that was held yesterday at the *Neues Palais* in Potsdam saw all the highest ranks of the military and naval

forces meet with the Imperial Chancellor and the Foreign Minister. This morning at the Foreign Ministry, no secret was made of the pressures from the military authorities to begin immediate mobilization. The decision now depends solely on the reply to the communiqué sent to St. Petersburg. There is little hope, however, that Russia will cease its mobilization: in such a case there might be a possibility of Germany's halting its own and an opportunity to proceed with a simple punishment of Serbia by the Austro-Hungarian forces. The Serbian delegation this evening received an official telegram declaring that the Austrians have started bombing the outskirts of Belgrade and are progressively moving toward the center. The Federal Government has been assembled for the last few hours awaiting the next decision . . ."

At these lines he paused a moment, trying to suppress his tremor. Then clenching his jaw, he read out loud, with sudden speed:

"Between today and tomorrow, it will be peace or war . . ."

All the tension that had been gathering inside him for months now exploded on the outside. That sense of cosmic menace had now assumed the form of a precise political vision: names and faces, formations and alliances now emerged sharply from that nebulous mental state. His "clairvoyant" abilities, in fact, always grew sharper in moments of greatest psychic instability. He could now imagine situations and consequences, causes and effects, with the lucid, precise foresight of a strategist.

At first his attention was taken up by the question of Italian intervention. The day after the assassination in Sarajevo, he didn't believe the Foreign Minister's reassuring declarations of the stability of the Triple Alliance; he realized that Italy would not follow her allies and thus hoped she would remain neutral, and he also knew that Italy—though a friend of Germany—might seize the opportunity to take back its northern territories from

Austria. Then there were the Socialists, an important force in Italy, who didn't hide their sympathies for France and England. Salandra had succeeded the pacifist Giolitti as prime minister, and Sonnino was the new Foreign Minister. What could be done to ensure that Italy remained neutral? How to prevent the taking of sides and formation of alliances, how to defuse that perverse mechanism that *would* lead to the destruction of everyone and everything? He started contacting the German Institute in Rome: if he could only manage to create, through the Institute, a pacifist propaganda center in the heart of Italy and put together a network of intellectuals, academics and scholars for the cause and support of non-intervention, then perhaps . . .

By late May of the following year, however, he had to throw in the towel. Italy's declaration of war filled him with indignation, and his resentment of the old friends and everyone else he had tried to convince with his imploring correspondence turned into vehement excommunications and vows of eternal enmity. Wavering now between moments of peaceful contemplation and urgent aggressiveness, he began to put pressure on his brothers in America, telling them they had to do something, to try to shape public opinion, to take the situation in hand.

Meanwhile the number and volume of newspapers he read was increasing, and he now needed someone to help him leaf through them, put them in order and select them. He had begun cutting out the more salient articles and collecting them in a "war journal," which was supposed to present a broad panorama of the situation and thereby offer the possibility of understanding and foreseeing what was happening. Thus he would recruit Marietta, Max Adolph and Frede, as soon as they got out of school, to come work in his study, at a pace that grew more and more frantic with time. Frede, the most sensitive of the children, caught her father's tremor, and during those hours of forced paste-up was often beset with fever. Max Adolph, frozen in an unnatural impassivity, would try to comfort everyone with wise observations and sensitive comments, and was impeccably precise in cutting out the articles indicated in the margin by his father. Mary, on the other hand, who usually withdrew to a corner, would look on that strange family gathering with sadness

and incredulity while a muffled hiss of bicycles slicing through the frozen snow on the street below rose up to the windows.

Once that task was completed, usually late into the evening, he wanted to be left alone, away from everyone. His discussions with friends irritated him terribly; nobody seemed to realize the gravity of the situation. They always accused him of contradicting himself: how could he be both patriot and pacifist, positivistic and conservative? All false charges! And anyway, what did consistency have to do with the war? How important could it really be to have coherent positions, when the situation was so urgent?

Meanwhile the war progressed with its death and destruction. He didn't even react when the United States intervened; withdrawing into his study, he would sink into despondence. He could no longer think, reflect, understand. In his head there was only a kind of hum, and in his ears a desperate refrain that incessantly repeated:

"It's the end. Total ruin, total collapse. The Empire is crumbling, and will take your whole world with it, and all of you, too."

Of the two years that followed, he remembered very little. Only the panic—the panic which had overcome him when he could suddenly and clearly foresee the inevitable defeat, the shameful end, the unconditional surrender that would throw the country at the enemy's feet, humiliating a noble, proud nation. In those days, his political acumen grew sharper as his anxiety increased. He then bought a pistol that he kept always with him, hiding it in the most unlikely places to prevent Mary and the children from finding it. At times he would aim it at imaginary targets to vent his frustration. He was convinced that this would be the only solution: he would let neither Mary nor the children fall victim to the enemy, if such a situation arose. He would take care of things all right! One day, however, while listening to a family argument, he was overcome with a shudder of fury and aimed the pistol at little Frede. Max arrived in a hurry, seized him by the shoulders and disarmed him. It was the last episode of this period that he could remember. After that there were only occasional flashes of an almost vegetable existence. His

physical needs had diminished to the bare minimum; ideas, feelings, studies all became confused with one another in dizzying, delirious fashion.

Then one autumn day, Mary left him at Kreuzlingen, uttering a barely-whispered goodbye as a secret sense of relief momentarily brightened her tormented, pale face.

8

BELLEVUE

The slamming of the door to the adjacent room announced Binswanger's imminent visit. Aby hurriedly tried to hide the pages of his lecture: he didn't want anyone to see how much care and worry had gone into those lines. Most of all, when speaking on the following day, he wanted to give his audience the impression that he was extemporizing, that he could still display the spontaneity of thought typical of his most brilliant lectures. He didn't want anyone to know that this time he would stick close to a written text and that this text would have rigorously logical conclusions and tightly knit arguments. The audience, in fact, would be different tomorrow: more demanding, more attentive, ready to criticize and make fun of him.

Ernest Abbe would certainly be there, ever ready to contest the most banal facts, with the typical arrogance of the doctor and sociologist; and so would Adolf Werner, so analytically punctilious, like the theoretical chemist that he was. And Charles Bally, with his literary snobbery and captious arguments, would probably come too. Too bad Nijinsky had left a few months earlier. He was really the only guest Aby would have liked to have as audience; that strange, inaccessible creature had so disturbed him, and yet he had felt an immediate psychological affinity with him. He hadn't really been able to get to know him well, but that was a question of chemistry. Nijinsky had been diagnosed as incurable from the very day of his arrival and kept for long months in isolation. As a result, to his already unusual

personality was added the veil of mystery that surrounded all the patients relegated to the "east wing."

And there would also be Rudolph Schroder, sitting in the front row, with his languid eyes and mannered poses. It was Rudolph, in fact, who had suggested that he come to Bellevue. He had become an intimate friend of the Warburgs, having built and decorated the homes of many friends, including that of Karl Melchior, Max's partner. Schroder's poetic aspirations had later opened the door of upper-crust Hamburg to him, and before long he was being invited to society parties and literary gatherings. Yet while his architectural style retained an appreciable classical element, his poetry was self-indulgently declamatory. Rudolph had stayed at Bellevue several times. Now he actually wanted to refurnish it, and to persuade Binswanger to consent, he had composed some new sonnets with such captivating titles as *Bellevue, Lake Constance* and *Kreuzlingen*, which he had recited, with tedious, emphatic accents, to the patients the previous week.

But Rudolph was not mistaken in considering Bellevue the clinic and refuge of Europe's finest aristocracy. It was a haven not only for intellectuals and artists of note, but also for personages of great political and social prominence. In a world where the mentally ill were supposed to be hidden and forgotten, Bellevue provided shelter and safety. Only today could Aby appreciate that this discreet, refined environment was more like a resort than a psychiatric hospital. The surrounding park was large and well maintained, the rooms clean and comfortable; the recreation halls were equipped with the most fashionable of games and the kitchen could satisfy a gourmand's every whim. For an average of eighty patients, the staff included four doctors and numerous assistants. Even the cleaning girls were nice-looking, and the chef was a pleasant fellow who played his role with great verve.

Upon his arrival, of course, the place had not seemed so attractive to him. Indeed, it had seemed more like a prison than a clinic, but with time and recovery, the walls had opened up a bit, the landscape had brightened, and the fellow patients began to seem more pleasant. Later on, he would actually look back on the place with a certain nostalgia.

Evenings, at dinner, the old guests would tell the new ones how Ludwig Binswanger's grandfather had founded and built *Praxis Bellevue* in the mid 19th century, when the town of Kreuzlingen numbered only a few hundred inhabitants and the hillside harbored only fir trees and silence. Ludwig's father carried on the family tradition, taking over the directorship of the clinic at a very young age. Later, he encouraged his son to follow the great master Freud, and sent him to Vienna before he had even finished his medical studies. The young Binswanger, however, wanted to look around a little more, to hear a few more opinions. From Vienna he moved on to Zurich where, having taken his degree under the guidance of C.G. Jung, he entered Eugen Bleuler's hospital as an intern. His degree in philosophy, with a thesis on the masters of existentialism, was to serve him well, for he was immediately recognized as not only a scientist but an intellectual as well. Many patients later were reluctant to leave him after their recovery, unless forced to do so in order make room for new arrivals. Others, after leaving Kreuzlingen, would return there periodically for brief stays, to exchange opinions and ideas with him. Schroder himself was always coming and considered the individual an entity who had to be understood in all the complexity and many facets of his totality. In joining Heidegger's and Husserl's ideas of *Dasein* with the concept of "being-in-the-world," Binswanger maintained that each individual develops his own way of realizing existence though the joint attainment of freedom and authenticity; if correctly combined, these two states, and only these two, could create the perfect balance between man and environment. As a result, for Binswanger, many cases of apparent mental illness (which other doctors would have called pathological "deviations" or "disabilities") became "forms of failure" or of "lack of success in human existence." On this basis, he founded existential psychoanalysis, a new concept and methodology that was supposed to use more elaborate and complex tools than those available to orthodox psychoanalysis and to the new Freudian theories. Another important postulate of his philosophical conception was that the individual, in his actions, is spurred by "motives" and not by "causes." Binswanger

believed in fact that motivations are the roots of human behavior, and that every action occurs because the individual is motivated, driven to achieve certain results. "Causality reigns in the world of things," he often repeated to his patients, "but motivations rule the human world." This meant, once again, the rejection of all those conceptions based on breaking down human nature and analyzing each single element.

Yet even when clearly rejecting Freud's theories and keeping a decided distance from Jung's, Binswanger maintained great personal intellectual balance. His revision of official psychoanalysis was more a personal necessity, a deeply felt conviction, than a theoretical battle. He always preserved a sacred respect for Freud and a filial affection for Jung and Bleuler, even though he knew he would have to distance himself irrevocably from them if he was to follow his own road.

Binswanger's strength and equilibrium were reflected in his voice, which always maintained a deep, calm tone and a slow, regular rhythm. A doctor's voice was very important for Aby: it had the power of attracting or repelling him, of making him open up with candid confessions or making him withdraw into distrustful silence. Binswanger's tone was inviting and discreet, and very clear in moments of confusion. He would often repeat the same words, emphasizing them not in their utterance but in their reiteration, to make them penetrate softly, in small doses. In articulating each verbal unit he would rest his gaze on his interlocutor, but gently, without harshness. Behind his large, round and slightly foggy spectacles, his eyes moved slowly, maintaining the same composure and stability as his entire body.

It was the power of his voice that had convinced Aby to agree to undergo analysis, but it had not been a swift or natural process. For a long time he had hated Binswanger, had mocked and disdained him. When Aby had first arrived, Binswanger wasn't even there, but was out roaming the world, indifferent to his new patient. Only a few months later did he arrive, with a haughty air and a false cordiality. He immediately thought it must be Binswanger himself who was behind the threats to his family, plotting kidnappings and vendettas. Aby couldn't even bear the

thought of meeting him, of sitting before him and talking about himself and his mental condition. How could he ever describe his feelings, his sufferings, to that perfidious enemy? How could he ever open up to such a despotic, invasive interlocutor? Only after an opium treatment did he agree to a weekly session with him, during which he would answer his questions with curt monosyllables. With the arrival of Dr Kraeplin, however, whom Binswanger had summoned for help, Aby felt the fury of his hatred transfer from the first doctor to the second as though the same demonic forces had migrated from one body into the other, freeing Binswanger from a veritable possession. Persisting in his animosity toward Kraeplin, he began to look more favorably on Binswanger. For the first time, his voice began to sound human, almost soothing. Seeing him there in his modest study, it was as though he were looking at him for the first time: he was a slightly aging youngster, tall and straight-shouldered, with ashy, curly hair cut short and closely shaven around the sideburns, a thin mustache separating his long, sharp nose from the too full lips, and high cheekbones calmly and precisely framing the other details of his face. Barely thirty-seven years old, Ludwig already exuded an aura of wisdom and authority. Six years earlier he had been mistakenly diagnosed as having a malignant tumor and given few years to live. From that day on, the look in his eyes became deeper, his voice softer, his movements as slow and prudent as those of someone much older, someone who carefully plans each day the number of gestures to make and carries out only the most indispensable.

They spoke for a long time during that first session; they discovered that their fathers had died in the same month eight years earlier, and this made a particularly deep impression on Aby. The pain of his father's death struck him that moment with the same intensity as it had eight years before.

Moritz Warburg had died just shortly after Aby's evening visit. He had been unusually gentle in taking leave of his father that time; he no longer had much to say to the sick old man, whose fragility he found more irritating than frightening. At that time he realized that his true bond was with his mother, for while his premonition of his father's death caused him pain, the mere sight

of his mother's suffering face tormented him deep inside. That strong, determined woman, so sweet and understanding, whose beauty was not physical but came from within, who had occupied his thoughts in such large measure and for such a long time, was devastated by age and sorrow. Her wrinkles, her white hair, her formless body cut into Aby's consciousness like so many splinters of ice. On leaving Mittelweg on that dark February afternoon, he had felt an overwhelming sense of cold which he couldn't get rid of, even at home, in front of the fire, with a glass of sherry in hand and his three children gathered around his armchair.

Encouraged by a gesture of consent from Binswanger, he then went on to tell how, on the day before the burial, he was overcome with anxiety at the idea of having to enter the temple. That night, between feverish chills and cold sweat, he had written a letter to Max, begging him yet again to take his place. In illegible handwriting, he had tried to explain that the School of the Torah had the right and obligation to pay their respects to his father, who had given so much to the community, and that although the Law stated that the firstborn son should preside over this ritual, he could not and would not accept this role. He would have felt all the burden of performing an empty hypocritical act, an act which, while observing religious convention, was unethical and therefore incomplete and offensive. He was, after all, a *Cherem*, an exile from the Jewish fold, a "dissident," as he liked to call himself, using the legal term that had been adopted after the 1850 Constitution. His non-participation in the Jewish community, the School of the Torah and the synagogue, in whose regard the Warburg family had so much influence, was a source of pride for him, in its free-spirited consistency; yet how could he ever explain this feeling—so odd, so foreign—to his grief-stricken, suffering mother? He could not, and would not, recite the *Kaddish* as the representative of the deceased's family, and he didn't even want to attend the public ceremony which was too incongruous with his own state of mind and intellectual convictions. Max was supposed to understand this and help him; he was supposed to become once again the first-born son and assume, not only before society but before God, the role that destiny had neglected to assign him.

Binswanger had continued listening to him attentively, scribbling on the cover of a medical publication that lay on the desk. He commented very rarely, and only to encourage Aby to continue his narration. His gaze inspired a feeling of trust in the patient. As of that moment, Aby had accepted not only the man but his analytical therapy, and soon he looked forward to those sessions. Binswanger, for his part, showed such great understanding of his interests and such great ability in finding connections between their different yet complementary fields of study, that their meetings soon became a source of mutual enrichment.

In the first months of that association, they had discussed such subjects as the nature and the origin of the symbol. While Aby was rereading Frazer's *The Golden Bough*, Binswanger would criticize and comment upon Freud; while he was gathering notes and thoughts on sheets of scrap paper, Binswanger was already working on his third book.

*

In the autumn of 1920, Ernst Cassirer, on his way back from a conference in Zurich, came to visit him at Bellevue, and the three of them had a long conversation. Binswanger debated Cassirer with his customary self assurance and skill; after a brief skirmish regarding Kant's distinction between the concepts of "beautiful" and "sublime," Cassirer diplomatically steered the conversation onto more general subjects, lightening his tone of voice and letting a hint of a smile show on his lips. They then turned the discussion to Goethe—his poetry, his philosophy, his symbolic universe. Cassirer was a subtle, penetrating interpreter of Goethe and his most enthusiastic admirer; his writings on the poet had been greatly appreciated by German cultural circles of the time, and Aby was well aware of this, perhaps even a bit envious. He wished he could direct the conversation himself, but didn't know how to insert himself into the intense dialogue between the other two; admiring Cassirer's face, he remembered Goethe's definition of classicism:

"Classicism is health," he interrupted, in a declamatory tone, "Romanticism is illness."

The other two avoided looking at each other, preferring not to confront their perplexity. Binswanger, quick-witted as usual, rushed to his aid:

"Of course, Professor Warburg, but do not forget that that pronouncement would have remained an enigmatic aphorism if Novalis had not explained and interpreted it, claiming that the essence of Romanticism is the transformation of a single event, or an individual event, within an absolute or general principle: for Schlegel and Novalis himself, everything was emotion; for Fichte and Schopenhauer, will; for Hegel, idea; and for Schelling, intellectual intuition . . ."

"Whereas Classicism," continued Cassirer, apparently anxious to conclude, "recognizes every principle independently of the rest and then connects and interrelates them so tightly, so organically as to make them an integral part of our spiritual universe . . ."

Seeing that the conversation was flowing smoothly again, Binswanger decided it was a good moment to take his leave. Quoting, with a touch of coyness, the last line of *Faust*, "What passes away is but a symbol; the unattainable is here achieved," he slipped away discreetly through the door of the *fumoir*, his smock a white blur behind the glass.

Aby was finally alone with his guest; he had been preparing for this encounter for months. Cassirer's moral and intellectual stature had always intimidated him; it was so rare that he felt so much respect and admiration for a living person, much less for someone younger than himself. Rational, methodical, and impassive, Cassirer represented everything he was not and would never be, everything he didn't have and would never have: his investigative ability and systematic consistency were on a par with the great masters of thought; the profundity of his speculations and the breadth of his knowledge were cause for surprise even in someone like himself, who possessed a vast wealth of erudition. But Cassirer was endowed with a solidity and equilibrium not comparable to those of the common man; they were superior gifts, perhaps divine. In reading

the first volume of the *History of Modern Philosophy*, Aby had immediately perceived the qualities of this young follower of Hermann Cohen. The Marburg School and the University of Berlin (where for years Cassirer was merely a private instructor) owed their prestige mainly to him; yet it was only that same year that the academies of Hamburg and Frankfurt, thanks to their progressive principles, dared to propose hiring the Jewish Cassirer as professor.

The gaunt face, broad forehead, and an impenetrable gaze gave to the man an air of unquestionable authority. One noticed, in his features, a will and commitment to life developed at an early age and encouraged by a family belonging to the highest level of the enlightened bourgeoisie. From a very young age, Cassirer was nicknamed "the Olympian" for his inborn tendency to keep a distance between himself and others, a detachment that stemmed more from respect than disdain, more from shyness than arrogance. He himself told how his teacher, Hermann Cohen, who refused to shake the hands of Jews converted to Christianity, had interpreted his coldness as a sign that he was one of them. That episode seemed particularly amusing to him, since in fact he had never questioned his faith or his Jewishness.

That day with Aby, however, Cassirer was expansive and attentive, and thereafter seemed a close friend on whom he could count.

Aby gave a forced cough and rearranged himself on his chair, waiting for the other to resume the conversation. After a few minutes Cassirer began to speak, confessing that the first time he had entered the Library on Heilwigstrasse, he was deeply troubled. In fact, he told Saxl that the place had seemed very dangerous to him: he would either have to carefully avoid it, or he would remain for many years its prisoner. The book he was working on, *The Philosophy of Symbolic Forms*, actually largely mirrored Aby's own ideas, and although it had a more solid philosophical foundation, he started from the same basic premises. He was therefore quite struck by the fact that another scholar—about whom he knew almost nothing at the time—had put together, in library form, the same theoretical itineraries

that he himself was traveling, and that he had found all the very books and documents that he, Cassirer, was looking for. As if by some strange instinct, he ran away from there his first time, but in time he returned and eventually became one of its most assiduous frequenters, gathering around him students, teachers, and intellectuals. And it was for this same reason that he had chosen the professorship at Hamburg over Frankfurt: having heard much talk about the Warburg Library, he thought he might combine teaching with the continuation of his research. Aby had already heard all of this from Saxl, during one of his more recent visits to Kreuzlingen, but he felt differently about it this time, hearing it from Cassirer himself. He no longer felt jealous of the activities that took place at the library outside of his control; now he exulted in that notion, as a young boy might bask in the praise of a strict schoolmaster.

In enthusiastically describing the Library's qualities, Cassirer had tried to engage him in conversation, often inviting him to comment. His skills as pedagogue and his ability to dialogue with students and colleagues were on a par with Socrates, but Aby could only waver between monologue and silence, and soon the exchange of ideas made him feel confused and frustrated. He would have liked to go on listening and talking for hours, but a sudden fatigue prevented him from carrying on a coherent conversation. He therefore tried to take cover in monologue and to explain his latest philosophical theory, that modern thought was born when Kepler shattered the traditional supremacy of the circle as the ideal form of cosmological conception and replaced it with the ellipse. But as he was about to support his idea with precise quotations and references, his memory suddenly failed him utterly: he stammered, temporized a moment, and then in humiliation, fell completely silent. Cassirer smiled at him reassuringly, pretending not to have noticed that profound lapse, and then himself cited the text and passages in which Kepler advanced, however indirectly, that hypothesis.

Of the rest of the conversation he had only a vague, confused memory, though he well remembered their goodbye. At the distant, resonant sound of the gong announcing dinner, Cassirer shook his hand long and warmly, looking steadily into his eyes,

without embarrassment or pity, and after a dry "See you soon," he walked away with regal bearing.

*

The door opened swiftly, with precision.

"So, Doctor, are we ready for the big day?" said Binswanger, in an encouraging tone.

"We're ready, we're ready," replied Aby, "I'm just waiting for the criticisms and comments of Professor Saxl, who should be here in a few minutes. On the other hand, I shall need your help to make sure that everything in the dining room is in order as requested. Please make sure that the panel of photographs is well attached to the wall and that the first row of chairs isn't too close to the dais. Please don't forget! You know how oppressive that is for me."

Binswanger nodded assent and leaned over toward Aby, unwrapping the blood-pressure pad. After carefully listening to the pulse in his arm, he continued:

"Our blood pressure's a little high, Professor. You should try to rest tonight, especially after the last insulin shot, which will be administered at nine. And no quarrels with Saxl, no bad feelings, all right?"

"Dear Doctor," Aby replied ironically, "you know how healthy my quarrels are, especially with Saxl, who for years has been trying to depose me, always plotting behind my back . . . But in all seriousness, Doctor, you know I'm no longer angry at Saxl. That was just a period of insecurity and confusion for me, but it's all over now. I can see now, and appreciate, how devoted and caring Saxl is, even if sometimes I don't agree with his initiatives. But at least let me say so, doctor! Let me scream it, in fact, to relieve my anxiety."

"Don't forget about tomorrow," replied Binswanger, with a hint of admonition in his voice. "I want to see you calm and serene; but mostly, I want to see some brilliant rhetoric. And now I bid you good night."

He felt reassured by that brief but very cordial visit. Once again he stretched his neck so as to see his face reflected in

the tarnished mirror over the hearth. He looked tired, and so ragged he almost frightened himself. He wanted to appear in top form the following day, as neat and well dressed as he used to be years before, with starched collar and bow tie, mustache well-trimmed, an ironic, piercing glint in his eye. The way he used to look when the young girls gathered round him, bold and garrulous, returning each day to the Library, asking somewhat pointless questions, and always appearing in the right place at the right time.

While not a philanderer like Felix, nor charismatic like Max, he still possessed formidable tools of seduction. He had the gift of speech, a sense of humor, and a taste for paradox; even in moments of ill-humor he was able to turn a terrible row into a mockery, a grimace into a smirk. He had an actor's talents, and his discussions, even in private, always had a dramatic touch of Greek tragedy in them. While he didn't like large crowds, he demanded an attentive, rapt audience, and when he spoke his eyes would light up like crystal prisms penetrated by a ray of light, and with their various reflections, they would illuminate the endless images evoked by his voice.

It was at such moments that he would sometimes sense, suddenly, that he had charmed a female heart. It was a feeling that, if too intense, became unpleasant. He didn't like overly forward women; indeed, he was afraid of them. At times he would dream of Italian women with their passionate eyes, yet in reality they were too voracious, too much like Furies or Bacchantes. Their femininity was sinful in its excess, and their desire seemed to contain a threat rather than a promise. A woman's charm was above all a question of balance, a cross between sensitivity and intelligence; but it also was something elusive, something that grows in shadow and cannot be discovered or violated. He had at times found that magical combination in young creatures who had the acrid, penetrating scent of musk and the fluid, slippery lines of Nymphs, creatures he wished he could love with a shameless, unbridled love. But it was not easy to forget that, in his experience, the woman had always represented firmness and authority. Sara, Charlotte, Mary, and then Alice, Frieda and Nina: these women were more like

Judith than like Nymphs; their scent was more like resin than musk. Tolerant and understanding, still they never gave in; they tried to persuade, but not to seduce, to assert themselves, but never to compromise. They knew how to show courage and loyalty, how to dispense affection and support, but they would never have sold their souls, not even for love.

Thus when he would try to come close to the other creatures and steal the taste of freedom with a kiss, his impulses would be stifled by an imperious sense of duty. There were therefore few occasions where he might have a chance to enjoy a pure pleasure, without the weight of memory. Now, of course, in that place of confinement, numbed by illness and drugs, he had long forgotten what pleasure even was. During the first years of his stay at Kreuzlingen, neither Mary's embrace nor Heidi's sinuous figure gave him any comfort. Lying there for hours on end, invaded by a damp fog and prey to his demons, he had known only suffering and despair.

With tired movements, he combed his thin hair, arranged the collar of his shirt, and with an automatic gesture cast a quick glance at his fingernails. He didn't want to look too unkempt for Saxl, or else he would be immediately reproached for it. He removed the objects scattered on his desk and put the few articles of clothing lying on the bed back into the armoire. Then he waited for Saxl to arrive.

From the half-open window, a gust of wind bearing the scent of spring entered the room. He breathed in deeply, as a thin veil of tears momentarily clouded his view of the garden.

9

Saxl à Vapeur

The first time Saxl entered the studio on Heilwigstrasse, Aby found his shabby appearance somewhat irritating. With two speeches to prepare by the end of the week, he couldn't afford to set his work aside for that untimely visit; but Wilhelm Waetzold, at the time his assistant and librarian, had so strongly insisted that he meet this new graduate—"who knew so much about astrology and art history"—that he could not get out of the obligation.

The young man had placed a worn-out straw hat on a corner chair, freeing his right hand to relieve the burden of a large, heavy portfolio he was carrying under his left arm. His long mustache hid thin, dark lips, while his heavy eyebrows tempered somewhat the ironic, curious look in his eyes. Of slight build and perhaps a bit too thin, Saxl clearly looked younger than his age. From his very first words of greeting, his voice had a clear, genuine ring to it, which made Aby more favorably inclined toward him. Taking his eyes off his papers, he slid slightly down in his chair, and with a decisive gesture, invited Saxl to sit down.

Silence and calm reigned in the room. The lamp beside the armchair shed a diffuse light. On Aby's large desk lay a great number of handwritten pages, index cards, and long strips of paper of the sort he used to cut from industrial reams for use as bookmarks.

During that summer of 1911, he was working on deciphering the frescoes of Palazzo Schifanoia and had just found in *La Sphaera* the key to many mysteries. It was, in fact, a moment of great intellectual euphoria for him; perhaps that young man might understand and appreciate the importance of his research and discoveries.

After a few polite phrases and an exchange of customary complaints about the climate of Hamburg, Aby picked up Boll's book and indicated it to Saxl, looking long into his eyes. In a slow, studied cadence, he then began talking about Palazzo Schifanoia and the *Sala dei mesi:* in describing the architectural structure, the layout, the technique of fresco, and the various restorations, his tone of voice slowly warmed up while the rhythm of his words accelerated. When he got to his favorite subject, the image of the black man with the two-edged axe and rope in hand, he paused a moment, raised his eyebrows, and in a single breath launched into a dizzying series of references, allusions, connections, hypotheses, and interpretations. He compared descriptions of the Classical Prometheus with the Deacon of Abu Ma'shar, evoked pagan deities and signs of the Zodiac, compared Greek astronomy and Medieval astrology, tied together Eastern mysteries and Western symbols, linked ancient myths and superstitious beliefs.

To catch his breath and allow his interlocutor a brief respite, he then grabbed a large, rolled-up map, unwound it on the desk with a conspiratorial air, fixed the four corners with small crystal paperweights, and began to explain its significance. This was the *Wanderkarte,* the first map ever drafted that traced the peregrinations and metamorphoses of the pagan gods from antiquity to the modern age. Marked in tiny, almost illegible lettering was an infinity of names and signs following one after another like notes in a baroque fugue and indicating everything from the columns of Hercules to Scylla and Charybdis, from the plateau of Anatolia to the palatinates of Bohemia, from the sacred waters of the Nile to the profane waters of the Tiber. He continued his explanation, carefully selecting his terms and definitions; he described in broad strokes

the face of Venus asleep under the horns of Taurus, Apollo's face sundered between the twins of Gemini, Mercury's face compressed inside the crab-shell of Cancer; he cited their names in the various mythological versions—Greek, Egyptian, Arab, Indian, Jewish, Spanish; he explained how the same stories and names underwent transformations in the different translations, changing their identities over the course of the centuries.

The timid Saxl, who at first had pulled out, with a certain pride, a number of mediocre reproductions, hastily reclosed his portfolio with a mixture of embarrassment and surrender. His shoulders seemed visibly to droop a few centimeters under the uneven padding of his jacket; his mustache, meanwhile, which upon his arrival had looked fresh and youthful, now seemed suddenly to have wilted. He hadn't had a chance to tell Warburg about his first astrological discovery regarding a statue of Mercury, nor about his studies of the planets carved in the pedestals of sculptures of the later Roman Empire, nor about his research on medieval woodcuts and manuscripts. In fact, he told him in a bewildered tone to take his material, since he would certainly make better use of it than he; indeed, by then he felt so discouraged that he actually felt like abandoning that vast, complex field and concentrating on Rembrandt alone, the main subject of his studies. But in response to Saxl's offers, Aby leaned back in his armchair, crossed his legs, and giving a hint of a smile, replied:

"No, no, dear Saxl. One does not solve problems by giving them away."

*

Now, however, he was thinking that there had never been a more eager, diligent assistant. His intellectual fervor, unceasing scholarly activity and tireless organization had made him a peerless help. Especially since he had been coming to see him at Kreuzlingen, his energy seemed to have increased twofold, and the nickname he had given him—*Saxl à vapeur*—fit him perfectly. Surely he was wrong ever to have borne him any rancor.

He no longer remembered the first time Saxl had come to see him there. He knew that Max had summoned him out of his retreat, right after the war. He was, in fact, just back from Italy, where he had spent his war service, on the Dalmatian front and in the Valsuga; even there, he had never ceased to study, write, and promote pacifist publications. When he finally returned home and was about to organize courses in public administration for recently discharged officers, he was urgently convoked to Hamburg and then to Kreuzlingen.

The year after Aby's hospitalization, Saxl started coming to Bellevue regularly each year. During the peaceful weeks of the Easter season, he would set up residence in a nearby cottage and appear at the clinic every morning with a new program for the day. Often they would go on boat rides, along the southern shore of the lake, which is more sheltered from the wind and has a more charming landscape. Even while rowing vigorously, Saxl still managed to maintain a surprising level of intellectual concentration, as well as an excellent sense of humor; he would speak slowly but with great conviction, while Aby abandoned himself to the sweet rocking of the boat. Saxl had become his window onto the world: it was he who kept him abreast of all the great changes of that period. Through Saxl, he had learned about the Conference of Paris, the territorial partition, the emergence of the Social Democrats, the Weimar Republic, and all the repercussions of that tempestuous, tormented postwar era.

Saxl was unable to hide his strong sympathy for the new socialist spirit in Germany and Austria, but he was not allowed to talk about it. Aby would not tolerate from a young man, who knew nothing of the past greatness of the Empire, to make comparisons or political judgments; he only let him give summaries of news stories and, of course, updated reports on the management of the Library. When, however, Saxl would try to insist, Aby would make him turn his attention to the salient cultural events of the time. And thus he would tell of the new artistic trends, of such avant-garde figures as Kandinsky, Klee, Munch and Ernst, or the developments of such groups as *Der blaue Reiter* and *Die Brücke*, or the emergence of Gropius and the Bauhaus, Le Corbusier, and Van der Rohe.

Each time he came to Bellevue, Saxl was laden with bibliographical curiosities—first editions of novels or rare essays discovered in small bookstores. Aby was never too happy to receive literature (except for the Italian), and when he got essays or contemporary theatre, he limited himself merely to expressing thanks. On his bedside table, he always kept Goethe and Hölderlin within reach, whom he read when in the mood for poetry. Hölderlin, for him as for so many others, had become a symbol of the defeated Germany, the voice of the German culture divided and dismembered by the Treaty of Versailles, humiliated and wounded in its deepest pride.

But most of all he loved Rainer Maria Rilke, because Mary loved him and because Rilke had been able to describe better than anyone the voyage into the land of the dead, into that same Hades where he himself had lived for so long. At times he would imagine Saxl as the Mercury of Rilke's poem "Orpheus. Eurydike. Hermes," and while Saxl talked and talked, he would recite in silence:

> "That was the deep uncanny mine of souls. There were cliffs there, and forests made of mist. There were bridges spanning the void, and that gray blind lake which hung above its distant bottom like the sky on a rainy day above a landscape. And through the gentle, unresisting meadows one pale path unrolled like a strip of cotton.
>
> Down this path they were coming.
>
> In front, the slender man in the blue cloak: mute, impatient, looking straight ahead. In large, greedy, unchewed bites his walk devoured the path; his hands hung at his sides, tight and heavy, out of the falling folds, no longer conscious of the delicate lyre which had grown into his left arm, like a slip of roses grafted onto an olive tree. His senses felt as though they were split in two: his sight would race ahead of him like a dog, stop, come back then rushing off again would stand, impatient, at the path's next turn, but his hearing, like an odor, stayed behind. Sometimes

it seemed to him as though it reached back to the footsteps of those other two who were to follow him, up the long path home. If only he could turn around, just once, then he could not fail to see them, those other two, who followed him so softly: The god of speed and distant messages, a traveler's hood above his shining eyes, his slender staff held out in front of him, and little wings fluttering at his ankles; and on his left arm, barely touching it: *she*.

She was deep within herself, like a woman heavy with her child, and did not see the man in front or the path ascending steeply into life. Deep within herself. Being dead filled her beyond fulfillment. Like a fruit suffused with its own mystery and sweetness, she was filled with her vast death, which was so new, she could not understand that it had happened.

And when, abruptly, the god put out his hand to stop her, he had turned around—she could not understand—and softly answered, with sorrow in his voice, '*Who?*'"

During the years spent at Bellevue he had often felt the desire never to return to the world outside. In Saxl's reports, he perceived an intolerable confusion, a deafening din: that excess of life troubled him, insulted him; in all that throbbing novelty and experiment he saw arrogance and vulgarity, and a disdain for death. He instead was coming from an inaccessible world, from which he could never again return as before, and not the same as before. Like Eurydice, he had attained a sense of depth from his Hades and could not see before him the path ascending steeply into life; he was not anxious to see Orpheus again or to follow Hermes; he didn't want to leave that land of shadow and indifference.

*

A soft, regular sound at the door unmistakably announced Saxl's arrival. Saxl didn't knock like everyone else: he drummed his fingertips lightly on the door near the handle, so as not to

impose any sense of intrusion that might come from a sound descending from above.

Aby rose slowly from the bed, cast another glance into the mirror over the hearth, and walked to the door with a tired but dignified step.

"Come in, come in, mein lieber Saxl. I was expecting you. Sit down wherever you like. We've a lot of work to do this evening, and a lot to talk about, too . . ."

Saxl came in smiling broadly, with two small books under his left arm and his hat, this time a finely made Florentine model, in his right hand. In the dim light cast by an oil lamp and an electric light, Saxl grabbed the back of the chair beside the desk and dropped into it without ceremony.

"Lieber Herr Professor, I find you in good form. A bit pale, perhaps, but serene . . ."

"Serene? I have never known such a thing as serenity, my dear Saxl. I have never had the privilege of experiencing such a state of mind. I am feeling relaxed, it's true, despite a few misgivings about my speech; I am at peace with my fellow man, despite some anxiety about tomorrow's audience; and I am happy finally to be leaving this place and going back to my family, my work, and the rest of you, despite the surprises that I am sure you have in store for me at the Library."

"The only surprises will be pleasant ones, dear professor. We are all very happy to see you again. You are our maestro, our spiritual father."

"Come on, Saxl! You know I can't stand that role. I've never been able to stand it. I've never had any ambition to be a teacher or the presumption to have disciples or followers. My work, dear Saxl, has always been a personal, intimate quest. My ideas and passions have always been mine alone. I have nothing to offer the world, nothing to pass on to posterity. I have lived and suffered from so much introversion that I ruminate on my demons to the point of madness, and it has been because I wouldn't, I couldn't, share them with anyone."

"Professor, like it or not, you are a teacher. Think of all those who are awaiting your return, who are eager to talk to you and learn from you."

"Nobody's waiting for me, dear Saxl, not even my wife, not even Max. And what can I say for my children? Will they even recognize me? Will they see this ruin of a man as a father, or just a friend? Before leaving them to go on this long journey, I frightened them, tortured them, and perhaps lost them forever. What does Max Adolph do now? What does he think? How does he imagine his father's return? And little Frede, so shy and reserved, what does she expect from the return of this defeated, humiliated warrior?

"What a failure I've been as a father, dear Saxl! What a poor example I set! What a shame . . . And yet, when they were little, those children were my only anchor to reality, a ray of sun among so many livid clouds. Poor Frede. I remember when I used to badger her to cut out articles from the newspapers for my 'War Journal'—all atremble, with her cheeks aflame and her heavy flannel dresses, she looked so awkward and sweet. And Max Adolph curled up on the floor, pale as a ghost, eyes in a daze, all engrossed in pasting, refinishing, numbering. Poor kids, what could they possibly have thought of their father? And if the day's work was not finished, or if some late-breaking news appeared in the evening editions, or if some propaganda pamphlet was left in the mailbox in the late afternoon, they weren't even allowed to go to dinner—nor was it possible for Mary to counter my irrationality with her common sense. How could I bring my own punishment down on Max Adolph's head? How could I do that to him? Do you remember, Saxl, when Mary had to bring him here? Poor thing, first he was thwarted in his artistic aspirations, then traumatized by his father's madness. Will he ever recover from it?"

"Let's not talk about those sad episodes any more, Professor. The war took its toll on all of us. Don't remind me of my days on the front. Think instead of your success tomorrow, after the lecture. The patients will be so envious of you! The doctors too. In fact, if you don't like the word teacher, think of yourself as the captivating speaker you are."

"Dear Saxl, I'm not impressed with these easy praises; they sound more like reproaches than encouragements, or at least like insinuations."

"It's you, Professor, who read insinuations into innocent bits of conversation. One doesn't need Binswanger's psychoanalysis to see that you're a bit too defensive in your attitudes."

"I'm not defensive, dear Saxl, but self-critical, as I have always been: aware of my own limits, even in my moments of greatest confusion. And anyway, as you so subtly implied, my success as a lecturer will, as usual, be inversely proportionate to my success as a writer, since the "Lecture on the Serpent", too, will never be an essay, but will only remain a string of spoken words, improvisation . . . Even though this time, I've a more finished canvas."

At these words, Saxl made a firm gesture of assent. He approved, almost thankfully, of Aby's plan to have a written text in front of him.

"You never know," he thought, "a sudden loss of memory or a moment of confusion, or some unexpected comment, and it might have been a disaster."

He smiled, and with a formal gesture asked if he could light his pipe. Aby paid him no mind, consented and went on:

"Yes, yes, my dear Saxl, you'll have a fine bit of writing to do after my death. I'm leaving you nothing but scattered pages, notes, and scribbles, all of it in the worst handwriting imaginable. The future is yours! I've always loved to read, but not to write. But why write, anyway? For whom? Yes, I know, the usual unanswerable questions, and yet if people read more books they would write less of them. Shall I have some tea brought up for you, and some apple pie? You'll need something to keep you going, after all this chatter . . .

"The fact is that I don't believe in *my* writing. What could I ever leave behind on paper? All those words to communicate ideas that should be grasped, seized through intuitions, through images. We are, after all, living in an age of images, of immediate, instantaneous communication. There is no more time for reflection, no more time for written transmission, no more time *tout court*. And that's what I'm going to talk about tomorrow, dear Saxl. This world has imploded, contracting in time and space; one can no longer think of a culture transmitted through writing. The culture of today is reproduced through

117

electrical impulses and magnetic waves. That's why we need memory, dear Saxl. Memory—as everybody knows—joins past and present and at the same time projects anticipations of the future; it keeps us in a state of suspension, and at arm's length, those moments of immediacy and lightning speed that are destroying man. And thus it is through symbols that memory re-establishes the space necessary for man's reflection. And here I shall say something new: that the symbol, in fact, does not directly recall to us an event, but is, how shall I say, its wake. That's it! The symbol as trace of memory, as mnemonic sedimentation, and in this respect, I must admit, psychoanalysis has helped us to understand a great deal. Don't forget, Saxl, that Freud and Jung unveiled the true origin of the symbol, and that from this point Binswanger himself has developed many interesting theories."

"I know, Professor, I know. Your admiration for Freud and Jung is much deeper than may appear. The fact that you never mention them by name or cite them in your public lectures doesn't mean you're not aware of them. How could you anyway, given your friendship with Dr. Binswanger?"

"My dear Saxl, I have never disregarded Freud's intellect, nor underestimated the import of his scientific discoveries; it's just that . . . allow me at least to have a few doubts about some of his recently developed theories. Besides, twentieth-century man can hardly be considered merely a savage forever chasing after the 'pleasure principle'! And I should like to say, without any presumption whatsoever, that it's Freud who should be interested in *my* theories. In fact, dear Saxl, I forgot to tell you that Binswanger did receive a letter from him in which he expressed real interest in me, not as a patient, of course, but as a scholar. Jung, on the other hand, has the fascination of a shaman, but some of his theoretical elaborations are very convincing. I am sure you know that he was the first, not I, to formulate the theory of the Archetype . . ."

As he was turned three-quarters away, Aby could not see the hint of a smile playing on Saxl's lips. The younger man, sipping his tea, started to prod him as if wanting to test him, to see if he really was in a condition to leave that place and return to

the ruthless world where, despite all the esteem and respect, a thousand traps would be laid for the aging Professor Warburg.

"But to return to memory, dear Saxl: What is the role of memory in our civilization? Starting with racial memory, or 'social memory', as they call it today? Why is there so much insistence in Judaism, in the Jewish community, and in the Jew as individual, on the theme of memory, on the practice of remembering, on the recollection of one's origins? Are the native land and the Scriptures themselves, perhaps not revelations of the Sacred but rather references to Tradition? Why, dear Saxl, does the Jew entrust his own survival, his own future, to memory? Because memory is the sole weapon against the extinction of the race—it is identity, it is the trace of a past that remains both in the common and the individual consciousness."

"In that regard, professor, you'd better be ready to face something perhaps unexpected that has developed in your country: anti-Semitism is slowly but undeniably on the rise. Sometimes I feel something terrible is happening; I sense a racial hatred beyond all political and ideological proportion."

At these words, Aby immediately turned pale and his entire facial expression changed, as though his mind had suddenly flown elsewhere, or had plummeted back into the depths of his illness. Saxl realized he had reawakened a ghost that Aby had not yet managed to conquer. After a long sigh, Aby began speaking again:

"Yes, dear Saxl, the forces of the irrational are always lurking below the surface. Man thought he had overcome this threat, defeated his atavistic fears with progress and science, but it is not so simple; we must continue to struggle and never stop, because the irrational is innate in man, as is madness, and death."

He took a paper-knife from the desk, clutched it in his fist for a few moments, then in a sad voice continued:

"I myself fell victim to this struggle; as a young man I considered it a theoretical entity, a matter for study. I didn't realize it was creeping inside of me and would become a condition of existence and, before I knew it, an irrevocable sentence. Irrationalism, fear, death . . . Don't think, dear Saxl, that I'm not aware of my imminent end. I am coming back to

your world, but only for a short time; I am coming back to say goodbye to you and to bequeath to you the little I possess: my library. When all has been taken care of, I shall be ready to leave once again, this time forever. That is the only way I can put an end to a conflict that has exhausted me beyond all human tolerance. I leave to others younger and stronger than I the task of waging future wars and battles, the struggle against individual madness and especially against collective madness. A wiser, stronger man than I should live his life thinking he is eternal but being, always ready to quit life at any moment . . . Anyway, dear Saxl, from a strictly personal point of view, I can say I have no great remorse: my rebellions, after all, were justified by my actions. I didn't achieve the same success as my brothers, I didn't carry on and strengthen the family tradition, I didn't amass money and wealth, but tell me, Saxl, tell me truthfully: aren't culture and knowledge more important than wealth? Aren't art and history more important than family honor? Perhaps I never really was of Warburg stock, perhaps I was a mistake, a joke of nature, a genetic mix-up, and had to pay the price for this: for I have known this lacerating split, this incurable schizophrenia, in all its horrible detail."

Aby's face now showed only great weariness. Fatigue had attacked him all of a sudden, like a carnivorous beast hungry for his lymph, taking advantage of his fragile convalescence. His speech was losing its initial coherence and the light in his eyes was fading like the oil lamp on the desk. Saxl felt great tenderness for the man, so brilliant and so devastated by life.

"But it's time we got to work, Professor! Let's have another look at the lecture, then we should get some sleep. You need a good long night of rest tonight. So cheer up!"

10

GHOST STORIES FOR ADULTS

Saxl was so absorbed in reading the lecture that Aby thought it best not to interrupt him. And so he let himself slouch down in his armchair and waited for his friend to criticize the text with his usual punctiliousness. He tried half-closing his eyes, to see if the faint reflection of the light would produce that glimmer that painters obtained with little touches of zinc white, and he stayed that way a long time, almost motionless,

He remembered Saxl as he was in that distant autumn in 1912 at the Rome convention, diligently taking notes. Having arrived a few months earlier on a scholarship with the Austrian Historical Institute, Saxl had anxiously awaited Aby's coming, and had organized meetings and encounters with the devotion of the perfect assistant. The day of the conference arrived, fraught with expectations. Saxl entered the hall of the Academia with a soft step; he sat down at the edge of his seat and pulled out his pen and notebook. Later, when it was Aby's turn to speak, Saxl followed his lecture with rapt attention, alternating between jotting notes and making emphatic gestures of assent. Aby had chosen him as his preferred interlocutor among the audience present, and addressed himself to him during the whole of his lecture. He used this trick often: rather than let his eyes wander from right to left, he would choose a face, any face, between the third and fourth row and slightly off to the side, and address himself personally to that face. It always worked because, as with those

portraits whose eyes seem to follow the observer everywhere, an individual in a crowd, when thus chosen, has the impression of being the speaker's sole interlocutor, so long as the lecturer uses a personal tone and manner.

The Rome conference, however, was the largest that Aby had ever participated in. He had always avoided big assemblies; crowded auditoriums bothered him, even frightened him sometimes. When possible, he chose the classroom format: a lecture for specialists, addressed to an audience that he would often select himself. At such small gatherings he could maintain his composure and display all his oratorical mastery. He had many tricks for winning over a small audience, most of which he would never reveal; his experience as actor, combined with a certain taste for games of seduction, only helped him to perfect his technique.

In his family, for example, his younger nieces and nephews called him "the magician": they actually believed he had magical powers, and were fascinated by his changeable, unpredictable character. At Mittelweg, where the whole family still gathered—and with greater frequency after Charlotte was left on her own—Aby played the star. Before or after reciting his blasphemous little refrains, he would drag the children through the corridors running around on all fours, make precious coins appear behind Carola's ear or in Gerald's pocket, tell marvelous stories of heroes and demons, or improvise imitations of friends or relatives, always with hilarious results.

Gisela and Bettina, Max's youngest and Paul's second, respectively, were crazy about Uncle Aby and remained fond of him even now. Gisela was the only one of his siblings' children to visit him at Kreuzlingen. At only thirteen years of age, she had begged Mary to take her there, and though her parents were against it, she managed to force their consent and followed her aunt to that faraway, mysterious place.

The older nephews and nieces, on the other hand, and his own children, those who had seen him when angry and violent, were truly terrified of him. They tried to avoid him, and when they couldn't, they submitted to him with cowardly obedience. Mary had never been able to calm him down during his fits in

front of the children, and in fact had often to take abuse herself for merely having admonished him. Those attacks of rage frightened everybody, even the adults, and only a few were able to bounce back and forget those scenes.

Karl Heise was one such person. Aby had always called him "Herr Heise," refusing to address him in the familiar form even after many years. He had mown him since boyhood, through their respective mothers, and since that time this generous friend had always given without ever asking for anything in return. Even when he became one of the most respected persons in Hamburg upon being appointed director of the Kunsthalle, he never ceased to display his deep respect for Aby, who for his part had always treated him condescendingly, showing kindness only when he needed to ask a favor of him. He was the first to admit it: Heise had tolerated his arrogance and abuse with Biblical patience and was able to forgive him his most regrettable episodes.

The very evening before the Rome conference, Aby had been tense as a violin string. Heise—who was sharing a hotel suite with Aby and Mary—had asked for warm milk to help him rest. Upon hearing this request, however, Aby felt a storm of rage rise up from deep inside him. He tried to repress it but immediately realized he had no choice: he couldn't give in to depression, not that night, not on the eve of the conference. And so he grabbed a paperweight and hurled it violently at a great pendulum clock against the far wall of the room. When finally the last wheel of that complicated mechanism had fallen to the floor, he looked at Heise straight in the eyes and in an acid tone said:

"Herr Heise, one must never disturb the help after midnight!" In those moments, Heise—like Mary—had learned not to react; it was most important to put up a passive resistance and to gain control of the situation with a calm, cool head. Yet with him, Aby could be even more offensive than usual. With Mary, he never failed to show respect, whereas he often used Heise as the butt of his most linguistically complex insults.

In the spring of 1911 he had gone back to Ferrara with Heise to look again at the frescoes in Palazzo Schifanoia. At one

point, while he stood there with head raised, immersed in his incomprehensible mutterings, Heise was leaning against a glass showcase that held old manuscripts. Perhaps from the pressure of his arm, perhaps because of a pre-existing earlier crack, the glass suddenly collapsed, making an unexpected, alarming noise. With a mixture of surprise and mortification, Heise assumed full responsibility and offered to pay for the damages, but at that same moment Aby exploded with uncontrolled rage: he called for the police, summoned the director, continued to accuse and insult poor Heise, denouncing him for God knows what crimes, calling him unworthy to be in such a place, to be in his company, unworthy even to exist. In short, it took all the victim's patience and devotion to bring that visit to a dignified end.

And Heise was one of the few friends who went to see him at Kreuzlingen. When he first came to Bellevue, in early 1920, Aby was still very ill. As soon as Aby saw him, he reproached him for not having sent the cyphered telegram he'd been waiting months for, which was supposed to contain a coded description of the situation in Hamburg and the condition of his wife Mary, whose life he believed to be in great danger. At the sound of his violent shouts, the doctors had come running to his room. When they finally succeeded in calming him down, he collapsed in his armchair and merely stared at an object on the bedside table, refusing to carry on any sort of conversation with his friend. Of that visit he had always retained a sense of bewilderment; he was unable to reconstruct what had happened, remembering only a great confusion of feelings. Visits from friends had often irritated him. Was he ashamed, homesick, embarrassed? He didn't really know.

But there were many other episodes from his early days at Kreuzlingen which he couldn't remember now. He had arrived there in a state of stagnant dementia, aware only of being somewhere else, of being different.

Of that period, he remembered only sensations. At night, when the darkness outside would coincide with the darkness inside him, he would find a kind of peace, a congruence that managed to pacify him, but no sooner would the sunrise invade his corner of Hades than anxiety and terror would take

possession of him anew. He would then vacillate between the "inside" and the "outside" of something, perhaps himself, and would become aware of having been in an "inside" only when he came out, when he found himself on the edge of nothingness. He would have liked to remain immersed in that amniotic liquid, but was always pulled out of it with the brutality of a premature birth and with the echoes of his inner screams still resounding in his ears. Sometimes he would try to stop himself, to remain immobile in one or another of those states, but then those dimensions would suddenly divide into others, or would overlap into a single one, sticky, viscous and mobile. He would then look for a center, a stable point, but once again, that center would expand and deepen until it fled toward infinity, or else it would split into another, narrow and stifling, solid and painful as the tip of a blade. In that exile, where he was unable to recognize a familiar face or feature, where space had no above or below and yet was cumbersome and stifling, he would try to grab onto something, some sort of anchor, but his body would not obey his will, his muscles remained stiff and contracted. Looking around his room, he would feel a tremendous sense of vertigo, and an intolerable hostility of which he knew not the origin but whose full menace he could feel. His body would then begin to feel very heavy, intolerably so; he would see his limbs lying inert and extraneous, his knees and feet beginning to assume monstrous forms, his flesh a flaccid, useless mass in a state of decomposition, abandoned to itself. At times he would hear vague, faraway sounds, and he would try to follow them until he realized they were syncopated bursts of laughter, disjointed guffaws, which intensified in volume to the point where they would reach his ears directly and violently, and only then would he realize that it was he himself who was emitting them. He would then try to transform those sounds into words, or perhaps into shouts, but they would continue to come out of him with no connection whatsoever with what he wanted to express. He would then try to stifle them but he couldn't stop, couldn't control his physical functions: his body, once again, would not respond to his will. He understood all this,

and for a few moments was aware that he understood, that he had "grasped" a thought, had made it his own and developed it. But no sooner did this occur than the thought stopped and became a passive entity, dead.

Thus once again, exhausted and terrified, he would let out a lament, a laugh, or perhaps a scream.

<p style="text-align:center">*</p>

He suddenly opened his eyes wide and focused them intensely on Saxl's head, bent in reading the text of the lecture. He didn't want to give the impression of having fallen asleep while Saxl was working.

"Has it ever occurred to you, dear Saxl, that 'pity' and 'patience' have the same root?"

"Hmm . . ." replied Saxl, who was on the last page now and seemed anxious to leave.

With a slight laugh, Aby continued to declaim in a low voice, ". . . Beneath the dark flutter of the griffon's wings we dream—between gripping and being gripped—the concept of consciousness . . ."

"Ah . . ." said Saxl, even more distractedly.

Having been given no satisfaction, Aby withdrew into silence, so the other could finish as soon as possible.

He remembered the period when his condition suddenly began to improve, beyond all hope, in that same room. The tranquilizers that Binswanger had tried at first were replaced by milder drugs and by analytical therapy. From that point on, he had resumed reading, going for walks, writing letters, and conversing with some of the other patients.

In times of good weather, an orderly would accompany him into town and up to the top of the hill where the finest restaurant in the area served fresh fish and crêpes à la crème. He would walk slowly through the little village streets lined with half-timbered houses which, in the contrast between the white plaster of their walls and the dark wood, created a play of lights and darks, lightness and solidity. The tiny balconies, decked with flowers in season, and the slate roofs—dark and

iridescent in summer, soft and white in winter—gave that corner of Switzerland a magical charm.

At the top of the hill the air was fine and fresh and he could finally let his eyes wander up into the sky without fear of losing himself. Up there he felt a new sense of confidence. For the first time in years he could enjoy nature. At last his body felt reconciled with the surrounding world. He breathed deeply the acrid odor of pines and the sweeter scent of buttercups, letting the sun's mild rays warm his forehead and hands. Not far from the bench where he customarily sat were some blackberry bushes. What a pleasure it was to gather the little fruits and taste their sweetness, to collect them in his handkerchief and save them for the evening, before bedtime. And what a delight it was to discover each day a new detail in the lakeshore below: an inlet previously unnoticed, a darker patch of green, a small, newly built dock. Then, when the evening's damp found its way up there and began to penetrate beneath his cape, he would politely ask his escort to accompany him home.

After those long walks, his whole being would radiate tranquility, and not even the annoying euphoria that spread through Bellevue at the hour of his return could alter that state. In the dining room, before dinner, there was always a disturbing electricity in the air: some would walk impatiently back and forth, glancing toward the portico; someone else might be playing the old piano with unpleasant incompetence;. another might be reading Schiller's sonnets or some philosophical aphorisms; others still would snoop about the kitchen to check the menu of the day and expedite service. The unset tables, which belonged to patients who on that day were not in a condition to come down for dinner, were used for games of whist and backgammon, while on the long benches at the back, people gathered for gossip and more intimate conversations.

In recent years Aby had managed to tolerate all that commotion; in fact, he saw it as a pleasant moment of socializing. It was at that very time of day that he had begun to form friendships with a few of the patients and to establish real human relations. He knew he had always been considered an egocentric. Ass a child his younger brothers often used to

exclude him from their games because of his constant need for attention and the abuses he would impose on those weaker than he. He wondered, however, if what he was accused of was even true—that is, of being "strong with the weak and weak with the strong." Perhaps it was, but today it no longer mattered so much; his ego and arrogance were by now part of his character and personality. Perhaps his brothers had managed to give more to the world: Felix helped poor Diaspora Jews, donated huge sums to Jewish organizations all over the world, founded universities and cultural centers, while Max helped Jews in Palestine and financed refugees and emigrants through his banks and their affiliates. But so what? He was proud of them, but that didn't change anything. He had always been the most difficult son, the "insufferable" one, but also the most ingenious, and in any case the one who had paid his debt to life most dearly. And if, by "life," one meant not only commitment and savoir-vivre—as Max and Felix probably thought—but also passion, then he certainly did have a more direct relation to life than they. Plato spoke of the three parts of the soul. If in fact they did exist, he possessed all three, and if they really did inhabit the head, the heart and the viscera, then he had them all in their right places, perhaps reserving a larger place for the last.

As Aby sighed deeply, Saxl firmly closed the folder with the manuscript, made a clear gesture of approval and got ready to leave.

"No criticisms or comments? Nothing that needs change or clarification? You're not being fair to me, Saxl. Your approval is insulting."

"Professor, it is very late and you need rest. The lecture is excellent; I have nothing to add to it. Don't worry, your panel of photographs will make a great impression on the audience. It will all turn out very well, you'll see. And now I must bid you good night."

Had he merely read it out of a sense of obligation? Was his approbation a pretence, a pitiful lie? Aby wondered, perplexed. Or did his writing really not need any fundamental criticisms? But he was too tired now to analyze it all; it was time for the insulin shot and a long, good night's sleep.

11

WARBURG REDUX

London, April 24, 1934

Fritz Saxl set his pipe down in the ashtray and, slouching slightly in the armchair, finished reading in a soft voice:

"The annihilation of the sense of distance threatens to plunge the planet into chaos; the shrinking of space and time through modern means of communication has done grave damage to the human mind, and yet myths and symbols, by re-establishing an area for reflection, a pause for contemplation, will restore the individual to his proper place in the history of civilization and will continue to stand as the restraints of conscience of which man is still greatly in need."

He then closed the folder and let himself drift away in a flood of memories. Exactly ten years had passed since Aby Warburg presented his lecture to the community of patients at Kreuzlingen—ten years since he bravely and heroically wished to show the world and himself that his illness had been defeated and his intellectual abilities recovered. Since then, he had chosen to define himself as a "redux," a survivor come back from a long war. And that was really what it had been: a war against darkness and the irrational, a daily struggle against human nature's most ferocious demons.

And yet that very difficult test still did not succeed in dispelling every doubt. It remained an enigma that he himself had pondered over for a long time.

Was Binswanger really convinced of his recovery, or had he merely succumbed to outside pressures and hurried his diagnosis, throwing caution to the winds? Had Mary really believed Aby could go back to being a husband and father, or had she merely wanted to protect the man during the last years of his life? Had the family sincerely wanted him to come home, or were they tired of shouldering the financial burden of keeping him in a luxury clinic? Most importantly, was Warburg himself capable of understanding all these ambiguities, or did he merely want to escape so he could die at home?

It was the first time a mental patient had secured his release with a lecture.

"My dear Professor," Binswanger had proposed to him one day, "if you can show that you are capable of giving a sound, serious lecture, of presenting it coherently and in its entirety to an audience, then you will have proved yourself fit to go home."

Certainly Bellevue was a vanguard institution and Binswanger a broad-minded doctor; nevertheless, that unusual case remained a subject of discussion and raised many questions for many years.

But Warburg had accepted the challenge. He had shown up punctually in the great dining-hall set up as an auditorium, looking dignified in a smart gray *grisaille* suit with starched shirt-collar and bow tie, his mustache just trimmed by the Bellevue barber, his watch-chain and his fine English shoes carefully polished.

With the years his face had grown sparer in its features: indeed, his whole body had thinned—not shrunk, as often happens in old age, but rather reduced to its most essential traits. The lips and eyelids, grown leaner and lighter, were sharp and delicate in their lines; the jaws, often pressed tightly together, stood out in relief against the slightly concave, vein-marbled temples, while the neck, short but slender, maintained the resilience and elegance of his entire bearing. The eyes, which at times were more glazed than bright, seemed livelier than ever that day.

With slow, deliberate movements, he had settled in behind the large table set up as a desk, and began to extract, from the pocket of his jacket, a surprising variety of pens and pencils. In

the front row, Mary squeezed her handkerchief apprehensively, wiping her brow and upper lip with it from time to time. Next to her, Binswanger rested his broad back against the too narrow chair and tried to find a balance between his crossed legs and folded arms. He, Saxl, had seated himself strategically in the last row in the corridor, so as to be able to oversee the situation without being noticed. Even Heidi was there, wearing a funny little hat made of rags and a pair of gloves that she never took off.

When the din in the hall finally subsided, Warburg cleared his throat and began to speak:

"The observations on which this lecture is based were collected in the course of a journey to the Pueblo Indians made twenty-seven years ago. I must warn you that I have not been able to revive and correct my old memories in such a way as to give you an adequate introduction to the psychology of the American Indians. Moreover, the impressions I gained were bound to be superficial even at that time because I had no command of the language of the tribes."

From the last row, right in front of Saxl's chair, a sharp petulant voice whispered:

"Well, if he is not able to revive his old memories or to give us an adequate introduction to the psychology of the Indians, what is he doing giving us a lecture on all this?"

"Quiet!" said someone else, "At least have the courtesy to let him begin!"

Warburg continued, unruffled, ". . . Nor could a journey limited to a few months produce any really profound impressions, and if these have become even more vague in the interim I cannot promise you more than a series of reflections on those distant memories . . ."

"Getting better and better!" whispered the voice again, loud and sharp, before being silenced again by the more understanding listener. Even Binswanger, in the front row, seemed momentarily impatient, losing his balance and having to re-cross his arms and legs in a new order.

Behind the table a large panel, prepared with obsessive care by Warburg in the days prior to the lecture, had been set up. On a canvas held in place by a wooden frame were hung dozens of

photographs that were supposed to represent the iconographic material of the lecture. During his speech, he repeatedly turned around to face the panel, pointing to details in the images with a thin wooden pointer.

"The Pueblo Indians," he went on, "got their name from the fact that they live in villages—'pueblos' in Spanish. This distinguishes them from the tribes of nomadic hunters who, until a few decades ago, led a warlike existence in the same area as the Pueblos, a region that includes much of New Mexico and Arizona. What interested me as a cultural historian was the fact that in a country that had made technological culture into a marvelous precision instrument in the hands of intellectual man, an enclave of primitive, pagan humanity could have survived so intact, engaging, with unflinching perseverance, in magical practices of the sort that we customarily condemn as symptomatic of societies trapped in an utterly backward state. Here, however, superstition remained in step with all the vital activities. Their superstition consisted of religious worship of natural phenomena, both animal and vegetable, to which the Indians attribute active souls which they believe they can influence, especially through their masked dances."

His tone of voice was growing more confident, exuberant, while his eyes and gestures began little by little to shine with the vivacity of his finest moments. Between paragraphs, he would turn his head toward the large panel, which only in those moments seemed to take on importance. Saxl was smiling behind his mustache, casting quick glances around the room to see people's reactions and comments.

"Typical of the style of the designs on Pueblo pottery is their symbolic representation of a figure's skeleton. A bird, for example, is broken up into its essential components, thus becoming a heraldic type of abstraction. It becomes a hieroglyph that should no longer be looked at, but read. We have here an intermediate level between realistic image and sign, between mirror image and writing. From this sort of ornamental treatment of animals one can immediately understand how such a manner of seeing and thinking can lead to an ideographic, symbolic kind of writing.

"Now, in this culture, the serpent stands at the center, as a symbol of lightning."

Abandoning his papers, Warburg began to speak off the cuff, confident of his oratorical abilities and in full command of his faculties of memory. His pages of notes had meanwhile slid to the edges of the desk, under his elbows, into his lap, and finally onto the platform below and into the first row of seats.

". . . My wish to meet the Indians directly, under the aegis of official Catholicism, was facilitated by a specific circumstance. I was able to accompany the local parish priest on an inspection trip to the village of Acoma. We traveled across a brush-covered desert for nearly six hours, until at last we saw the village emerge from a sea of rocks, like the island of Helgoland in a sea of sand . . ."

Mary had released her grip on the handkerchief, and Binswanger at her side reassured her from time to time with a pat on the shoulder. Heidi, meanwhile, was following everything with devout attention. Yet just when the initial heaviness and tension seemed to be dissipating, Warburg stumbled momentarily on his words:

". . . Steps and ladders outside the Pueblos' houses are a symbol of the conquest of ascent and descent in space, just as the circle—the twis . . . twisted serpent—is the symbol of time's rhythm."

But why did he choose that adjective! It doesn't imply circularity, but contortion, or worse yet, madness! And what a moment, what a place to have so telling a lapse! In fact it provoked general laughter and visibly confused and irritated him. He was incapable of laughing at himself, just when he most needed to, nor was he able to beg pardon for his lapse and his own irascibility. Suddenly everything seemed to be left hanging, poised between a breakdown of nerves and some disastrous conclusion. Mary squeezed her handkerchief again sullenly; Binswanger finally planted both feet on the ground and wiped the sweat from his hands, and Saxl slid gently to the edge of his chair, ready to intervene in the event of an incident.

Getting a firm grip on himself, however, Warburg quickly recovered: he cast a cold glance at the audience and, sighing

deeply, turned his head back to the panel of photographs. Without delay, he continued the lecture.

"About twenty years ago, in northern Germany, near the Elbe, I discovered something that proved to me, in a fascinating, vivid manner, how deeply the cult of the serpent has remained rooted in modern Western culture, despite the West's adoption of monotheism and Christianity. But it is the latter, in fact, that such a cult has found to be fertile ground for perpetuation, for the Bible itself has been its vehicle.

"During a trip to Vierlande, I once found, carved into a great crucifix in a Protestant church, a number of Biblical illustrations that had clearly been copied from an 18th-century Italian Bible. Here I found another Laocoon, with his two sons at the mercy of a serpent, but," and here he finally broke into a smile, "they were in the process of being saved by another Asclepius! And in fact, if we read Deuteronomy, we find that Moses, while crossing the desert, commands the children of Israel to procure a brass snake as a safeguard against the bites of the real snakes of the region. This is a typical example of the persistence of idolatry in the Old Testament."

Outside a heavy darkness had set in, and the rain had assumed a steady, monotonous rhythm. From time to time, a clatter of dishes arose from the corridor announcing the upcoming dinner, a sound that in the past had forced Warburg's talks to hasty and negligent conclusions.

The patients were starting to get distracted. Some had fallen into a peaceful drowsiness, while others resumed their somewhat inconsiderate bustle, raising an irksome din again in the hall. With a trembling hand, Warburg automatically turned the next-to-last page of the manuscript, which fluttered briefly in air and ended up between Mary's ankles. His voice sounded tired, enfeebled; he turned again to the panel of photographs, more to catch his breath than actually to illustrate anything: "Modern man no longer fears the serpent; indeed he banishes it, eliminates it. Having enslaved electricity, captured the lightning in a copper wire, man has created a culture that leaves no more room for poetry. But the question is: with what will he replace it? The forces of nature are no longer conceived as biomorphic

or anthropomorphic entities, but as endless waves that obey the touch of the human hand. But in this way, the civilization of machines is destroying what the science of nature, which itself sprung from myth, had conquered with such great effort: the sanctuary of devotion and the distance necessary to the development of thought."

Then, after a final glance at the audience, looking half fearful, half menacing, he concluded, ". . . and yet myths and symbols, by re-establishing an area for reflection, a pause for contemplation, will restore the individual to his proper place in the history of civilization and will continue to stand as the restraints of conscience of which man is still greatly in need."

Hearing these final words, Mary could no longer control herself and broke into a stream of tears. She always cried at the end of Aby's important lectures; the last time Saxl could remember her in such a state was in Rome, where she hid behind a column in the great hall of the Accademia.

Warburg rose from the table, leaning against a corner and momentarily supporting himself against the back of the chair. He was pale and exhausted. The ringing applause seemed to bother him rather than gratify him, and he wore a strange grimace on his stiff, somewhat livid lips. He cast a quick glance at Binswanger, who improvised a gesture of congratulations, then he walked slowly toward Mary, wiping the sweat from his brow. There in the back of the hall, Saxl too was moved; he went toward the center of the hall to gather the pages scattered under the chairs and around the table. As he looked up again, he saw Aby and Mary heading off to the adjacent room. Against the light, those two slender silhouettes looked unreal, like images about to dissolve in the blink of an eye. He felt great compassion for them at that moment, even though he knew their hearts to be full of hope.

*

Recalling that scene, Saxl was overcome with the emotion he had felt at the time: it was as though he could see Warburg's and Mary's slender silhouettes reflected on the window pane,

vanishing slowly into the river. Shuddering, he re-lit his pipe and let out a long sigh, turning again toward the window. From that angle he could see a stretch of the Thames, its current carrying the night's vestiges away from the port. With the morning's first breezes, however, the water's surface began to ripple and form little whirlpools that swept the small mess away naturally. Until midday the sky remained covered by a blanket of clouds that reflected its gloom onto the river's small waves. The London climate was not, after all, so different from Hamburg's, saturated with the same humid air. A rarefied light scarcely penetrated the darkness of that small space, which consisted of the leftover area between the two great rooms of the inhabited floor. They had arrived at the Thames House just a few weeks before, and the building, just built by Lord Lee to house offices and dependencies of the state bureaucracy, was still one-third empty. Between the freshly plastered rooms, they installed the 65,000 volumes and photographic documents evacuated from Heilwigstrasse. Many books still remained in the boxes and trunks in which they had arrived, while others had been stacked in tall piles in the corners of the rooms. The few shelves lining the walls of one of the rooms barely held the oldest of the books, those covered in their original parchment. The desks, binding presses and photographic equipment, however, were put in the larger room; hung on its walls, as a sign of respect, were the large reproductions that Warburg used to have in his elliptical room: the black man from Palazzo Schifanoia, the *Conspiracy of Claudius Civilis* by Rembrandt, Dürer's *Melancholy,* and the drawing of the snake given to him by little Anacleto Jurino.

Through the thin wall of the small room Saxl could hear the subdued conversations of Hans, Gertrud, Herta and Otto, as they tirelessly arranged and ordered books, catalogues, photos, and index cards. It had taken several weeks to recover from the physical and psychological strain of that journey, which had left Gertrud feeling devastated and Hans disoriented. He, meanwhile, was still struggling hard not to succumb under the weight of his own decision and responsibility for moving the Library to London.

Now that calm had set in, however, and the first signs of spring were emerging, everything seemed more acceptable. The ice of the prior months was beginning to melt, and with the arrival of the new tenants, the atmosphere of the floors above was starting to liven up.

He was glancing through a provisional catalogue—still bound in the Italian manner, with leather loops instead of the customary metal rings—to see how much of Warburg's material still had to be revised and corrected before publication in the *Journal,* of which he was preparing the English edition. He thought back on the attacks of anxiety Warburg used to have whenever there was any mention of publishing any of his writings or of re-arranging them so that they might be published. Until his final days, he refused to make his notes any more definitive or legible, even though they had so much to offer and teach. They all seemed to have forgotten or pretended to have forgotten this reticence of his, but it was all in good faith. It would have made no sense to deprive the Warburg Institute of the writings of its *chef d'ecole.* What credibility could such a headless creature have? Fritz and Gertrude had fought hard to save that treasure, and now they knew it was worth the effort.

*

During that damp spring of 1924, Warburg had returned home after a long, overnight train ride which, though spent in a luxurious wagon-lit, had exhausted him and put him on edge. Mary, in spite of his protests, could hardly hold him up, and in a soothing voice coaxed him to enter the house while the chauffeur was unloading the luggage from the car. Before her brief, last visit to Kreuzlingen, Mary had left precise instructions and taken all the necessary precautions to ensure that her husband's return would be as reassuring as possible. She had sent away all guests and students, explained to the servants what they had to do, and ordered special foods, wines and cigars.

Nobody knew how well Warburg actually remembered his own home, or whether he was truly happy upon seeing it again. His initial attention, naturally, was captured by his children:

Marietta, Max Adolph, and Frede were there before him, tall and grown up, with tears in their eyes but their heads held high. In a single movement, they surrounded their father as one and held him tight in their arms. Warburg, who until that moment had been clenching his jaw so tight as to cause himself pain, finally burst into a liberating flood of tears.

He was not ashamed of those tears, Saxl now remembered, looking out at the Thames; it was a true catharsis. After so many weeks of anxious expectation and the final hours of aggravated tension, that release seemed more than natural. He kept hugging his children, repeating that he couldn't believe his eyes. He looked at Max Adolph with an expression of tenderness and guilt, stroking his blond hair and pale cheeks, squeezing his narrow but very erect shoulders and turning him around, then he covered him with kisses. The girls awaited their turn, which came equally charged with emotion. How beautiful Marietta had become! Those deep, black eyes had grown a little larger, the face more refined, while her nose had stayed small and straight. And Frede looked so much like Mary! Even if her hair was darker, the eyes were blue as her mother's. And she, still so young and blonde!

"Poor Warburg," Saxl had thought at the time, standing back behind the entranceway to the house. Mary had indeed changed; it was only Warburg's eyes that didn't want to see her tragic, disastrous transformation. Only after looking again at the photographs of their honeymoon did Saxl realize how much Mary had changed! Since that time, her body had become almost formless, her face swollen, altered. The high cheekbones were gone, as were the lines of the eyebrows and the curving shapes of her hips and legs. And those eyes, which even in the photos seemed to emit radiance, had become gloomy and mournful. Dressed always in dark colors, without jewelry and in nunnish dresses, Mary seemed the humblest of creatures; it was difficult to imagine her former beauty, or even that she had once been young. Withdrawn, as usual, into a corner, she kept weeping in her quiet way, her tears more deep and intimate than Aby's, as a woman's often are, and as only hers could be.

After several minutes, after wiping his face and adjusting the collar of his shirt, Warburg asked if he could leave the company a moment. He had to check on something, and right away. The children made way for him, looking puzzled, and he headed straight for the garden. Pausing a moment at the entrance, he made sure the rain had stopped and then went up to the apple tree. What a disappointment it was to find that tree more spare and feeble than ever, its branches extending toward the railing like skeletons in a horrible tombstone sculpture! Then suddenly his disappointment turned into a fit of rage. Mary had foreseen this; she had known that for one reason or another Aby would explode into one of his customary tantrums. But she hadn't expected this; she had taken great pains to forestall all the various possible causes for anger, but that was one thing, alas, she real she really hadn't thought of: the apple tree!

Saxl tried to intervene before Aby's bile became directed at someone in particular, and sought to distract him with his favorite subject:

"Lieber Professor," he suggested emphatically, "aren't you curious to see your Library and all the work that's been done over the years? Let's go check and see if it's all to your liking."

Warburg, this time, managed to suppress his shouts and overcome the incipient storm. He looked back at the children, as if to beg pardon for that unfortunate moment, then clenched his jaws again. After a long sigh, he finally replied:

"No, dear Saxl, I'm not curious. I don't want to see my library. At least, not now, not right away."

12

POSSESSED BY ART

Years later, Mary said that Aby waited until late that evening to revisit his Library. She had already gone to bed some time before, and it was nearly the middle of the night when she heard him tiptoe to the large room on the ground floor. Aby had exhorted everyone to go to bed early that evening, using an unexpectedly paternal tone that nevertheless betrayed an anxious desire for solitude. Anyone could see, however, how difficult his homecoming had been for him: being reunited with persons very dear to him but a bit forgotten, returning to a house that for years was no longer his own, erupting unexpectedly in a whirl of different emotions. Max and Alice withdrew right after dinner, the kids slipped away whispering "goodnight," and Mary found an excuse for going to bed immediately.

Before leaving the dining room she saw him through the half-open door, still sitting at the table. That slightly hunched silhouette, the silvery head, the delicate white hands entwined around a glass of wine, the slight twitching from his irregular breathing, pierced her heart deeply and painfully. Was that person really Aby, she wondered, between sobs. Was that spent, weary man her beloved husband, father of her children? Was he the same man who, so many years ago, had told her about "the uselessness of action, of history, and the melancholy onset of the understanding of nature, where everything occurs without the determination of any will"? Was he the man who had held her

140

hand in front of the *Porta del Paradiso*, who had told her stories of gods and ancient myths in the shadow of Tuscan cypresses, who had squeezed her waist in the red brocade room at Wiesbaden and covered her with kisses between white linen sheets, who had made her laugh for hours with his funny stories and gossip, who had made her so proud of his oratorical powers and his worldly elegance? Was this the same man who had begged her to understand him, to accompany him on his descents into hell, who had terrified her with his explosions of rage, exasperated her with his childish tantrums, tortured and petrified her with his obsessions and his fits of madness, who had worn her out with his trips to psychiatric hospitals and clinics, who had now given her the joy of seeing him there again, in the bosom of his family? Was it really him, she kept asking herself, as she went up the stairs to her room, her legs trembling and hot tears streaming all down her body?

Yet when Aby finally joined her in the bedroom, he had an amused expression on his face.

"The surprise must have worked," she thought, relieved.

Upon entering the large library room, in fact, Aby had found something unexpected. There at the entrance, a large panel had been set up, similar to the one at Bellevue. On it were hung—following no specific plan or order—photos of all the works he had studied over the years. From left to right and from top to bottom, in quick succession, were the *Laocoon*, Botticelli's *Primavera* and *The Birth of Venus*, Agostino di Duccio's *Virgo*, a bas-relief from a Roman sarcophagus representing *Achilles and Skiros*, Masaccio's *Tribute Money*, Piero della Francesca's *Victory of Constantine* and *The Defeat of Massentius*, Buontalenti's watercolors of the costumes for the *Intermezzi*, illustrations of Flemish and Burgundian tapestries, *The Death of Orpheus* in a medieval rendition and in Dürer's version, portraits by Memling and Hugo Van der Goes, the *Mona Lisa*, the *Birth of Saint John* and the *Sacrifice of Saint Zachary* from the Brancacci Chapel, and farther down, Bocklin's *Naiads* and *Battle of the Centaurs*. In a corner to the left was a throng of "Saturns" drawn from medieval German calendars and Italian Tarot cards, in the middle of which sat Dürer's *Melancholy;* at the far right, a series of loosely

clad women, Maenads and Bacchantes alongside nymphs of every sort and three triumphant Medeas; farther down was the *Rape of Deianira* by Pollaiolo, horses in battle from a relief on the Arch of Constantine and from a watercolor of the studio of Piero dell a Francesca; next to this were Cossa's frescoes from Palazzo Schifanoia and a series of *Perseus* representations, including one from a Sufi astral catalogue and a Dean from the 15th-century *Picatrix;* lastly, at the center of it all was a photo of Aby in cowboy garb, with a large bandana around his neck and surrounded by a group of Pueblos.

Aby couldn't hold back a loud chuckle, which even Mary heard upstairs in bed.

"*Bravo*, Saxl!" he had exclaimed aloud. "Brilliant, just brilliant! The doors to my kingdom are open again."

The next morning he met with his collaborators in a more cheerful frame of mind, and he complimented Saxl for the first time in many years.

Late that morning, Gertrud Bing arrived. She slipped into the Library with a careful step and approached Warburg from behind, not knowing how or whether she should greet him. Saxl, at Kreuzlingen, had spoken to him many times about Gertrud, but Warburg, as usual, had reacted with suspicion. Saxl, however, would not give up, and had repeatedly spoken about that "young, intelligent, vivacious graduate" who had been formed by Cassirer and shown such competence in moving about the Library and understanding the order of the texts and documents that he himself had offered her a permanent position there. Little by little, Warburg came to accept this idea, and what at first had seemed to him yet another act of insubordination he eventually saw to be a very wise solution. A couple of times he even asked how Fräulein Bing was doing and what she was doing, showing an undeniable curiosity about that unknown young woman. Gertrud, for her part, knew Professor Warburg well, or rather, knew a lot about him, having read the few of his manuscripts available, absorbed the spirit of the Library, and listened to Saxl's stories, Mary's reminiscences, and the family discussions. And like the rest, she had patiently and faithfully awaited his return.

"Willkommen, Herr Professor," she finally said in a guttural voice. Saxl noticed an expression of astonishment on Warburg's face, as of a child caught in the act of stealing a cookie.

With an affected bow, he shook her hand, withdrawing his upper body in a slightly defensive pose, and from that newly balanced distance he began to scrutinize her as he might a painting. She let herself be observed, turning her head gently toward the wall and holding her breath momentarily. Her strong build and somewhat masculine frame gave her appearance a look of natural authority and deceptive rigidity, yet the light flannel dress she was wearing that day managed to soften these rather salient features. Her brown hair was cut in an unusual fashion and her eyes were perfectly almond-shaped; her lips, large and fleshy, had barely opened to utter her greeting. Warburg would have liked to appear at ease in front of the other assistants, but his agitation in this case was apparent. Gertrud withdrew her hand blushing and headed toward her desk, while Warburg continued to stare at her with voracious curiosity. Her way of walking had always been very much her own: slow and cautious, as if seeking a gracefulness that her physical shape could not naturally give her, yet it was this very same awkward bearing that gave her a particular charm. Warburg then let his gaze slide down her strong, round hips and then further down, around her buttocks and thighs, all the way to the calves sheathed in the soft leather of her boots. Fritz pretended not to notice, but he continued to watch with apprehension a scene he had tried many times to imagine: the first meeting between the two. And while Warburg was still in search of some specific meaning for it, Mary entered smiling, with a large tray of *krapfen* and coffee.

*

He rose from the armchair to look for some small boxes in which to store the scattered sheets he had on the desk; until the books were arranged in the little bit of available space, there was no point in putting the archive of documents in order. Saxl couldn't stand the chaos; he had always had an instinctual

attraction to order and organization, and much of his professional success was due to this natural aptitude.

During the period of Warburg's absence, he had proved to be a conscientious director of the Library; he had worked tirelessly on its development and success. Now he felt a certain pride about it, or more simply, thought back on it with pleasant satisfaction. When Max Warburg, the most charismatic personality in Hamburg, had offered him full command of the *Kulturwissenschaftliche Bibliothek Warburg*, he felt incredulous and flattered. The task promised to satisfy his highest aspirations and represented the great challenge of his life.

He immediately devoted all his time to that commitment, even taking a series of initiatives that very soon bore precious fruit. He remembered how tenaciously he had begun to develop relations with the recently founded university, and how insistently he had begged the newly arrived professors to come to Heilwigstrasse to visit the Library. At first he invited them to informal gatherings, then to lunch or dinner, then for a lecture or brief seminar, and before they knew it, they had already been appointed collaborators at the Institute. He remembered the suspiciousness of Ernst Cassirer and Erwin Panofsky the first time they entered the Library. They had maintained a guarded silence throughout their visit, but he knew how to win them over: he took them around those rooms with an air of nonchalance, then courted them and finally invited them to make brief public appearances, until they finally succumbed to the charm of the place. And a few months later, in fact, Cassirer went to see Warburg at Kreuzlingen, while Panofsky took up again the theme of *Melancholy,* working together with him on what would become the first book to be published by the Institute. During those years there were never any slowdowns or unnecessary pauses, and with the success of each new initiative, he would immediately develop new ideas, draw up new plans, solidifying newly established relations by intertwining them with still newer ones. By the early 1920's there was already talk of a "Hamburg School," which brought together such scholars as Otto Kurtz, Ernst Kris, and later Edgar Wind, as well as a great many other Jewish intellectuals who saw the Library not only

as a point of theoretical reference, but as a meeting place where the exchange and dissemination of ideas became an everyday practice. Another shrewd move of Saxl's was to convince the dean of the humanities faculty and the university to publish, at their expense, abstracts of the lectures held at the Warburg Institute, which soon became the *Studien* that he was now trying to keep alive under the equivalent English title of *Studies*.

What a euphoric time that was—he now thought—but what a tremendous effort too, especially during the long trips through Europe. He was now convinced, however, that if he hadn't begun that work of dissemination then, there would not have been as much chance later on of fleeing to safety. In England, where the University of London was planning to institute a chair of art history, they had learned of the Institute's existence with delighted interest; in Italy, where Warburg had left so many friends, they responded with promises of future participation; in Germany, where the Library's fame was by now well established, they began to consider the new institution as a valid alternative for specialized instruction.

But the greatest problem was one of finances, and once again good luck lent a hand. Felix and Paul, from America, had never ceased to keep abreast of their older brother's fortunes, and considered Saxl's directorship a guarantee of the safe continuation and development of the Library's activities.

Between 1921 and 1924, during the period of economic crisis and postwar inflation, Felix and Paul had displayed great generosity and a strong sense of civic responsibility. Though he did not have any direct dealings with them, he had followed their every move through the official reports and the accounts related to him by Max, with whom he was in daily contact by then. At the start of this three-year period, Max was experiencing some difficulties: while fighting for the survival of the M.M. Warburg Bank, he also had to contend with growing anti-Semitism and obvious political hostility directed at him. Felix and Paul offered their help not only in saving the family bank, but in sustaining a large part of the entire German banking system. Through their diplomatic proposals and political initiatives, they thus became two of the leading figures in the ratification of the Dawes Plan.

In October of 1923, Max and Paul had suggested that a new coin, the *Rentenmark*, be minted, which would be guaranteed by the combined assets of the German economy and issued by a new institute independent of the State, the Rentenbank. This provision proved so efficacious that it managed to keep the Weimar Republic alive, at least for a while, even though by now the currency had fallen to 4 million Deutschmarks to the dollar. In the first months of 1924, with the full application of the Dawes Plan, part of the German economy managed to pick up again, and the banking system revived with the issuance of new securities and bonds. The M.M. Warburg Bank squared its accounts and actually gained a great advantage over other banks, placing in long-term investments the fortunes made on German speculations on inflation and on fluctuating exchange rates. In a brief telephone conversation on Sunday, the 3rd of April of that same year, Saxl learned that Max was finally out of danger and had regained command of the ship. With an unusually cordial tone, Max even invited him to celebrate Pesach with the family at Mittelweg, but he politely but promptly declined, imagining the display of scorn Aby would have made upon learning of such an episode.

Paul, meanwhile, had left his father-in-law's Kuhn-Loeb firm and gone out on his own, whereas Felix had remained with the Schiffs and accumulated one of the more outstanding personal fortunes in the United States. And while Paul was complementing his banking activities with a series of financial operations at the government level, Felix had become a key figure in the movement of support for a Jewish state in Palestine. He embraced the cause of Israel wholeheartedly, and even formed a close friendship with Chaim Weizmann. In fact, before Weizmann eventually became president of the new state of Israel, he had promised him his total support for the foundation of a university in Jerusalem and a research institute to be established near Tel Aviv, whose directorship was to be assigned to another great friend of Felix, Albert Einstein. His wealth and magnanimity had by now become legendary: he was one of the most prominent men in America, and through him, the Warburg name became even more prestigious and

powerful across the Atlantic than it had been in their country of origin.

All three brothers, therefore, had vied with one another in helping to finance the Warburg Institute during those difficult years. While Max was allocating funds for new pedagogical initiatives, Paul and Felix—who at Saxl's suggestion had become stockholders in the Institute—acquired their shares in exchange for sums earmarked for research.

Yet whenever, on his visits to Kreuzlingen, Saxl tried to tell Aby about all these developments, the teacher would see only dangers, insults and attempts at usurpation in all of it. He therefore quickly decided to present him only with budgets and balances on his visits, which he did with the dullness of a bank employee. There was no way to share with him the satisfaction of those years, to tell him of the successes in which he had taken part and of which he was often the architect, and he felt deep regret at this.

And even though in early 1925, a few months after Warburg's return home, the Institute was in excellent shape, the atmosphere between the two of them became immediately tense. The accusations that Warburg began leveling at him no longer sounded like the fantasies of a persecution complex, but they still had a disarming arbitrariness about them. Though he had come home harboring only good intentions, Warburg's feelings toward Saxl remained somewhat confused. He had succeeded in turning a private library into a functioning, prestigious cultural center, but this had happened without the authorization or awareness of its founder. It was therefore hardly surprising when Warburg refused to accept decisions made earlier or to approve policies not determined by himself. Though he did not want to appear ungrateful, his claims of ownership and control made him averse to any delegation of authority. Saxl, too, did not want to appear greedy, yet he knew that the method and discipline he had brought to the Institute must not be endangered by a sudden shift in style.

During his long arguments with Warburg, Gertrud would watch the two rivals attentively, agreeing sometimes with one, sometimes with the other. Mary, on the other hand, always

supported her husband, without, however, ever expressing herself very emphatically, and as a result, Saxl never knew what side she was really on. Max rarely got involved in such arguments, even though his role as financial supporter was essential; Aby, in fact, had noticed a change in him, and this time it was not some impression brought on by psychic disturbances, but a feeling of out-and-out betrayal. Max and Paul had, in fact, become particularly close to each other in recent years; business and politics, Olga's death and Aby's illness, the war and the economic crisis, and the friendship between their wives and daughters had made them more united than ever before. Max thought of Paul as his alter ego, and Paul loved Max more than a father. Olga's suicide, in particular, had brought the two close together in a kind of guilty complicity. Even if nobody wanted to talk about it, that episode remained the great shame of the family: the awareness of having been unable to help the dearest, weakest member of the Warburg family. When Olga fell madly in love with Jimmy Loeb (Nina's brother), everyone considered it a scandal. The parents would never have allowed a third child to expatriate to America; Nina herself was against it (fearing perhaps that it would force her to move to Hamburg); and even Aby—usually uninvolved in matters of this sort—expressed his disapproval, having known Jimmy rather well and having recognized in him a psychological imbalance frighteningly similar to his own.

Thus when Moritz and Charlotte forced Olga to marry Paul Kohn-Speier, a common businessman, they deprived her of her only chance of finding love. Later, when Olga, sick and in the middle of a nervous breakdown, finally collapsed, she asked Max and Paul, the brothers closest to her, for help. They failed to understand the seriousness of the problem, and unknowingly consigned her to her fate.

For the rest of the family, the mutual understanding between the two brothers was by now taken for granted; for Aby, however, it was a mortal wound. Henceforth, despite the gratitude he owed Max, he tried to forget those sacred moments of his childhood when the bond between them had made him so happy and proud. He never again mentioned the pact they

had made under the great fir tree on Mittelweg or the walk on the beach at Helgoland; nor did he wish to remember that soft, sunny gaze, and the secret devotion he had felt for the one he considered his own "older brother."

Perhaps this was why—Saxl thought now—Warburg began to get closer to him. But unable to express feelings or appreciation verbally, he had concocted a theoretical rapprochement, embarking on the study of Rembrandt. Saxl's love and study of the Dutch master had never ceased, not even during his period of total immersion in astrology, and when he learned that Warburg had devoted himself to analyzing Classical influences in the early Rembrandt, he couldn't help but feel great satisfaction.

The second step the teacher took that revealed his intellectual esteem (and perhaps affection) for Saxl was to embrace and actually develop the idea of the large panel of images that he had found in the Library on the night of his return. For little by little, those images had begun to generate theoretical ideas of his own.

*

In April of 1925 Warburg gave his first lecture since his return home. It was a moving celebration and memorial for his friend and inspirer Franz Boll, who had died the preceding month at Heidelberg. In the two years that followed, he held classes at the University of Hamburg and in so doing recovered so much confidence in his oratorical abilities that the lecture he devoted to Rembrandt in late 1926 kept the audience glued to their seats for three uninterrupted hours.

But he made a special effort for the lectures on Jakob Burckhardt, putting all of himself into them and their preparation. Only then did Saxl understand his teacher's method of study: a total immersion of the man into the subject, an absorption, a symbiosis of the one into the other. Private and intellectual life, theories and sentiments, all went up in a great bonfire of agitation and exultation. During those months of work, Warburg admitted seeing in Burckhardt not only a master—that is, *the*

master of his formative years—but someone who also shared his own visionary qualities. Burckhardt, in his opinion, was one who had sharpened his senses to the point of transcending reason, to the point of possessing a broader, deeper vision of the world, such as a sage or madman might possess.

Before each lecture, Warburg, in the presence of Saxl and sometimes Gertrud Bing, would expound upon the themes he was to set forth for his students. Aware that his two assistants would understand him better than his class, he would often let himself get carried away by the stream of his words, all the while gazing intensely at Fritz and Gertrud. In the rehearsal for his final lecture, his eyes looked more fervid than ever as he ventured to draw a parallel between Burckhardt and Nietzsche:

"Both of them," he declared to the audience, with a wild look in his eyes, "are very sensitive seismographs whose foundations tremble when they must receive and transmit the waves. But there is one important difference: Burckhardt received the waves from the regions of the past, he sensed the dangerous tremors and he saw to it that the foundations of his seismograph were strengthened. He felt how dangerous his profession was, he was a man whose vocation means *suffering,* having been a necromancer, with his eyes open . . ."

Hearing these words, Saxl had remembered what Warburg had said on the eve of the "Lecture on Serpent Ritual," to which he had given little weight at the time. It was, obviously, a recurrent idea in his thought during that latter period: Warburg had pointed out to him the common origin of the words "pity" and "patience," but he hadn't named their common root, the very same *pathos* to whose artistic representations he had devoted so many years of study. Nor had he even mentioned another term of the same origin: *passion.* Had this been a lapse of memory, brought on by his weary condition, or an intentional theoretical omission? And it was also strange that, with Burckhardt in mind, Warburg should have identified only with the suffering of the profession and not also with the "passion" for it.

"Nietzsche, on the other hand," he had concluded, suddenly focusing his gaze on Gertrud's face, "is the man whose salient character is an unconditional devotion to a faith in the greatness

of the future, and this is why he became victim to his own ideas in the course of attempting to put them into action."

Saxl's heart sank upon hearing these words: the manner in which Warburg had addressed himself to Gertrud had something intensely sensual about it, something at once provocative and imploring. He had never seen his eyes flash that way, or Gertrud blush so deeply. It lasted only a moment, but the tension he felt between the two made him shudder in fear. Was this perhaps the reason why Warburg had omitted the word "passion"? Was he perhaps afraid that the mere sound of it might suggest a state of mind already too much in evidence? Had he perhaps omitted so that he could use it in a different context, at another time, perhaps when alone with Gertrud?

Even with the wisdom of hindsight, he had never been able to understand what happened between Warburg and Gertrud that evening. Nor did he understand what had happened to himself: was he more jealously possessive of Gertrud or of Warburg? From whom did he fear betrayal more: from the woman he had loved from their very first encounter or from the teacher he would always love and remember? With whom should he have competed? With whom should he have allied himself? He was, by then, the odd man out, or at least, as of that moment, had felt himself to be such.

There was, however, one thing he did understand at the time: that passion is a force that one does not acquire or conquer; rather, it is innate, and only in very few human beings. Whoever has passion receives passion, and he—he had to admit—would never possess or receive passion. Tenacity perhaps, consistency, enterprise and perhaps many other things, but not passion. Aby Warburg, instead, could only be remembered as the man who had formulated the theory of *Pathosformel* and had found, in the concept of *Pathos*, the final fusion of all his conflicts.

13

116 HEILWIGSTRASSE

In a corner of the little room he finally found the boxes he was looking for: small and stout, covered with labels handwritten by a Florentine sender and addressed to Professor Aby Warburg, 116 Heilwigstrasse, Hamburg, Germany. He still remembered the date on which the first stone of 116 Heilwigstrasse was laid: it was August 21, 1925, but the occasion was not so much an inauguration as the conclusion of a long period of research and effort.

When Mary, in 1909, convinced Aby to purchase the lot abutting their own property, neither one of them had any clear idea of how to use that space. Its dimensions—too limited on the side facing the street, too great in back—presented many technical difficulties for the construction of a real building. Meanwhile, however, the number of books kept growing and by 1920 had already reached approximately 25,000, not counting the photos and documents. Books were overflowing into all the rooms: into the foyer, the stairway, the bathrooms, the cellar, the billiard room. The shelves, made to measure by a local craftsman, were each different in dimension, depending on the space in which they were inserted; they had thus come up with no less than forty different lengths of shelf for a total of 189 meters of books. The Warburg house was therefore no longer a real residence, but neither was it a real library. During Warburg's absence, moreover, the seminars and lectures that Saxl organized with religious zeal always retained a familiar,

non-academic flavor; they often ended with sumptuous dinners or long tastings of Chianti, and the coming and going of students deprived Mary of any sense of domestic intimacy.

During his visits to Kreuzlingen, Saxl had often enumerated all these inconveniences for Warburg, but the more he spoke to him about them the more the older man reacted with skepticism and postponed any decision. At his repeated suggestion that they rent a large, commodious space in the center of town, Warburg had always stubbornly replied that, "though it may serve the public, my library must remain absolutely private in nature." Perhaps, in the future, they might think of using the lot next door to this end.

And so Saxl floated the idea of bringing in some of the great names in architecture of the time—such as Gropius and Le Corbusier—arguing that they would certainly have accepted a commission for a public building that would not be restricted by the imposition of current tastes or inhibited by slow governmental financing. Such ingenious minds, moreover, would resolve in brilliant fashion the spatial problems presented by the lot itself.

But Warburg had replied: "What a peculiar idea! *My* library can't be turned into some artist's experiment. It would risk becoming famous because of its architect instead of its function."

Thus one day, Saxl appeared with plans by a certain Felix Ascher, a perfectly respectable architect with a somewhat less commanding name.

"But Ascher hasn't understood a thing!" Warburg exclaimed.

"Just look at these plans, dear Saxl, this system of little rooms, without a center, without a focus . . . It's all dispersive, inorganic. And then the connection with the house—that's exactly what we want to avoid! And what are these idiotic arches between the two entrances? And two floors aren't enough, it's a waste of space, it makes no sense. Look at the façade. It's too modest, it's boring. Agreed, it should be consistent with the front of the house, but we need some imagination here, some inspiration! Anyway, what's the big hurry to start building? Why,

dear Saxl, are you oppressing me with useless plans and maps that I'm supposed to approve with eyes closed? I have to think about it, I have to be there on site, to know how and what to build. And I really don't care about the building's architectural style; classical, deco, Bauhaus—who cares! What I care about is the interior, the heart of the library!"

Only months later did he realize that Warburg actually had something specific in mind, and that as he continued to discard Saxl's ideas, he was trying to define his own. During one of his final visits, in fact, he spoke to him of the "elliptical room."

"Elliptical room?" Saxl had remarked incredulously.

"But professor, with the lot's dimension, it will be a miracle if we merely create enough space to house the existing volumes. How are we going to fit an elliptical room in there? At best, we might give the ground floor walls a certain roundness, and maybe a small circular room for your study, but . . ."

"My dear Saxl, you don't understand! It's not roundness or circularity I'm interested in, but the *ellipse*. The ellipse contains a sense of direction that the circle doesn't have. The ellipse has two poles, two spaces, two differentiated areas, and this bipolarity releases energy, movement. In the ellipse, opposites coexist in contraposition and conjunction, just as the Renaissance contains in itself the contraposition of different epochs, fusing and embracing the extremes of classicism and the Middle Ages. The ellipse contains the idea of cycle, of balance between space and time: wasn't Kepler's ellipse perhaps man's first attempt to gain knowledge of the cosmos, to gain knowledge tout court? The circle is instead based on a constant instability; it is constantly running through itself, over and over; it has no points of reference. My library, dear Saxl, has to have a large, elliptical room where the energy thus released will enrich those who work inside it, and where the books themselves will be arranged in a fluctuating, free-flowing order, not static or permanent. And actually, there will not only be books, but problems, questions around which the books will flow, so that each question will be answered by a new enigma, and each book will refer back to another book, so that they will all animate one another with a life of their own.

After hearing this passionate, suggestive explanation, which had very little practical sense about it, Saxl had to suspend any attempt to begin such an undertaking by himself. The project would have to wait until Warburg's return home.

A few months after his homecoming, in fact, he began thinking again of how to build an extension of the Library in the lot next door and after much correspondence with his brothers in America, in which he sought financial support, he arranged an emergency meeting with an old friend of Max, Alexander Schumacher, who had just returned from Cologne, where he had been working for a number of years as an urban planner. Warburg didn't want anyone to know about the Library project.

"That would confuse matters and roil the waters," he said, looking circumspectly at the other.

"The project must remain a private, family matter, and anyway, God only knows what we'll manage to put up with only 100,000 marks!"

Indeed, the financing he had managed to obtain from Felix and Max fell far short of his expectations, which grew from month to month and from one letter to the next. The proposed estimate was therefore only partly covered by the sum deposited, but he did not give up.

In mid-December of 1924, Schumacher presented his first drawings. Preserving the same fundamental design as that proposed by Ascher, he had distinguished the two facades by leaving the internal one in a residential style and proposing that the external one be in "lower Saxon" style, in red brick, like the civic buildings and public schools of Hamburg. The number of floors was increased to four, with two of them to be mansards, while the elliptical room was to occupy much of the terrain of the current garden.

"But this room isn't really elliptical" muttered Warburg, upon first seeing the plans.

"I'm afraid, my dear Mr. Schumacher, you don't know what an ellipse is! And all those useless ornaments, these wastes of space! As for the facade, I can understand the civic-style austerity, but in the back, you could have allowed yourself a bit more grace, a little more drama. Perhaps we could get rid of

the ugly diving-bell of an elevator and widen the windows of the upper floors. No, dear Schumacher, I'm afraid we haven't understood each other at all . . ."

But before he could finish, Schumacher had resigned and resentfully left his position to a young architect, "not terribly experienced," he warned, with a sneer of satisfaction, "but full of understanding and good will."

Thus was the twenty-five-year-old Gerhard Langmaack pushed into the doorway of Warburg's study on a cold afternoon around Christmastime, much the same way the Christians were once pushed out into the arena of the Coliseum.

At the start of the New Year, Langmaack appeared with his first two plans in hand, which were immediately rejected. A few weeks later he presented the next three, which were also flunked at a moment's glance. In February came the sixth, seventh, and eighth plans, in March the ninth, tenth and eleventh.

With each new plan, however, Warburg would make corrections and suggestions that the young architect began work out technically. His ability to listen and learn, to ask questions and determine the preferences of his client, became winning cards, and before long a fruitful relationship of collaboration was established between the two. Saxl, meanwhile, had himself played a part in the success of Langmaack's proposals, having conducted prior research into the libraries of Europe. In the preceding months, in fact, he had visited the libraries of Oxford and Cambridge, the Leipzig library and, naturally, the great British Library, and he had to admit to the professor that almost every one of them had, as central element, a large oval room— which was not even to mention the libraries in Washington and Boston, which—as Eric, Max's son confirmed—maintained an elliptical structure throughout the entire architectural layout.

"You see, dear Landmaack," Warburg explained, "ideally speaking, a library is a bit like a sacred place, and like any church or synagogue, it must have an apse. A library is, in fact, very similar to a synagogue: a place for study and for meeting, where the librarian, like the rabbi, guides the reading, encourages study and at the same time presides over social encounters and gathers the faithful around himself. The Library, however,

must also be able to transcend this idea of holiness and become a center of ratiocination, a laboratory, a place of research where ideas are discussed, compared and tested. It is also a link in a chain, an element of conjunction with other libraries, with similar, complementary places, and therefore it needs branches, subsidiaries—just like a bank."

Taking a paper-knife in hand, he pointed it at the center of one of the designs and continued, "If, then, we concentrate our attentions on the focal point of the Library, my dear Langmaack, on the elliptical room, that is, we shall see that this must fulfill a number of different functions, and from a practical point of view, this complicates the problem. As a consultation room, it must contain the texts most in demand, which should be on continual, and continuous, display; as a reading room, it must facilitate concentration but also encourage conversation; as a conference room it must have good acoustics and allow the audience to gather round the speaker, not just in front of him; and as a reception room, it must have a personality of its own; it must mirror, in some way, the mentality of its owner."

Young Langmaack, from across the desk, followed these explanations with eyes bulging and notebook in hand. He took notes, nodded in assent, exclaimed his approval, and at last, on March 24 of that year, he presented his thirteenth design, which was approved with great enthusiasm, signed and immediately acted upon.

Pleased and satisfied, Warburg wanted the execution to go as fast as was humanly possible. He took on thirty laborers, whose number included masons, carpenters, plumbers, electricians and two interior decorators. Every morning, with a mixture of anxiety and childish excitement, he would go down to the garden and onto the work-site to encourage the laborers and urge them to work faster, to maintain their rhythm, to ignore the bad weather, to avoid lingering and taking useless breaks, to keep from talking to one another too much. At first his exhortations were friendly and full of good humor, but soon, as the season advanced and the work slowed down, his usual sullenness came out and he began to mistreat engineers and masons alike, showing no consideration whatsoever. It took all of Mary's sweetness and

patience to keep the laborers from quitting during that long, harsh winter.

*

On May 1, 1926, the building was finally completed. The event was memorialized with a historic photograph: in the street, in front of the redbrick facade, Warburg stands with hands on hips in a humorous, general-like pose, visibly admiring the new building, while on the roof of the house, lined up like soldiers in a somewhat ragged army, the laborers and architects, with arms raised, enthusiastically salute their patron.

What a day that was! You could feel the euphoria in all the rooms still fresh with paint, in the garden adorned with new flower beds, in the kitchen where Mary prepared the inauguration lunch, and even up in the attic, where Gertrud and Hans had begun to bring down the first crates of books.

That same day, before dinner, the mayor of Hamburg came to the Library for its first private visit. As he stepped out of the car, Warburg had him stand a long time outside the new building, explaining the philosophy and reasons behind the architectural choices made. That man, in any case, was well aware, like many others in town, of the travails the project had gone through, but at that moment he seemed to have forgotten it all, and displayed an expression of great surprise.

Then with a deep bow, Warburg invited him to come inside, and after detaining him a few more minutes in the entranceway, dragged him toward the elliptical room, gesturing emphatically. Its walls lined with solid mahogany panels, the room had ultimately taken up a smaller part of the garden than previously planned by Schumacher, its proportions finding their harmony in a balanced relationship with the other spaces of the building. The flowing lines and absence of "useless ornaments" gave it a superb elegance, the lightness and strength of a theoretical assumption. Possessing only a few, wide windows and lined all around with shelves, the room had a glass and metal roof, a splendid cross between late Art Nouveau and early Deco, through which filtered the peaceful light of the Hamburg sky.

It looked like a great seagull brought there in the morning by a fishing boat moored at St. Pauli. In the gallery above, a row of mahogany chairs fitted into the wall conveyed the feeling of an auditorium, while the books, at last arranged in proper order, preserved the atmosphere of a library. The desks and chairs, down in the room, were very sober in design, and a sophisticated system of retractable screens accentuated the rigorous style of the entire space.

Still leading the old politician along by the arm and checking up on Saxl, who was following them in silence, Warburg continued to extol the quality of the construction:

"Please note the building's details, Herr Bürgermeister. With so little space at our disposal, we had to use every little corner, organize everything as rationally as if we had been building a boat. Here, for example, we have the file drawers; all the stationery needs are already laid out on every table, and then up there, you'll see the staff offices, the mailroom and the periodicals section; then we have the photo archives. But come see what we've made of the attic: a plein air reading room where one can enjoy the river breeze and admire the view! But the most important aspect of this splendid project, if you'll allow me, is the level of technological sophistication we've managed to attain. Scientific progress is very important to us, you see; it is part of the very meaning of the Library itself. We alone know how to use this complex system; our collaborators of course could never learn it all. It would take too long, and might even create problems. To give you an example, we have twenty-eight telephones on our internal system alone, a pneumatic dispatch service for rapid communication with the outside, as well as book-elevators that travel much faster than those built for people.

"And as you probably know, Mr. Mayor, the cost of building the Library turned out to be four times the original projections. But we'll talk about that another time. In any case, my American brothers are well aware of this, and perfectly satisfied with it all."

There seemed to be no end to Warburg's ebullience, not even after two hours of detailed explanations. The mayor, on

159

the other hand, had begun to show signs of weariness. Following Warburg breathlessly up and down the stairs, he couldn't help but give a little shout of enthusiasm at the suggestion that he stay for dinner, especially after Warburg had said for the third time: "I *really must* explain the order of the books to you, but I think we ought to put something in our stomachs first."

*

Sighing deeply, Saxl thought back on the endless effort he made, during Warburg's absence, to rearrange the Library's books. The order he had found them in upon his arrival had seemed too inconsistent; in prior years Warburg had kept shifting and changing the arrangement so frequently and swiftly that it became impossible to catalogue, and therefore to find, anything at all. Only Warburg himself, with his prodigious memory, could find a book upon request; but once he was no longer there, not even the most experienced librarian could have found his way amidst all that arbitrariness. Saxl had therefore formulated, together with Gertrud, an ordering system based on color: he had placed on the spine of each book three strips of paper, each a different color, and a number. The first color indicated the principal category to which the book belonged; the second, the more specific subject or discipline; the third, as well as the number, referred to any subcategory in question. Dark green was used for philosophy, light green for comparative religion, brown for art history, red for history, purple for Eastern history, dark blue for anthropology, black for archaeology, yellow for natural sciences, and orange for periodicals. *The Mysteries of Mithras*, for example, bore a light green strip indicating that it belonged to the category of comparative religion, a red strip referring to its historical nature, and a purple strip indicating its geographical purview; lastly, the number 25 referred more specifically to the Persian origin of the subject. *The Book of the Stone Ring* by Al Farabi, on the other hand, had strips of dark green, brown, and red, and the number 10, which referred to the Arab context.

Upon completing this vast task, he had felt rather proud of himself. The great advantage of his system was that one could

immediately recognize the nature of a text upon seeing it, and the principle behind it all was actually much simpler than it might seem when explained verbally. The order it followed was like the structure of a tree bifurcating into smaller branches from the trunk. New acquisitions did not alter or upset the prior order, and it was perhaps the only way to deal with the rearrangements Warburg would surely make upon his return. When, however, it came time to register the changes in the card catalogue, things became a bit more complicated; the colors, moreover, as Gertrud had noted with a smile of alarm one day, had already begun to fade, and to keep them from changing they would have to keep the Library in total darkness.

But when the move from 114 to 116 Heilwigstrasse took place, Warburg gathered the whole staff together at the entrance of the new building and with clenched jaw and fists stated in no uncertain terms:

"My library must follow the order I have for it in *my* mind, and therefore the volumes will be rearranged according to *my* directions. And common sense and functionality be damned! That is how it must be, dear colleagues, whether you like it or not."

Thus, amidst the chilling silence that had fallen over the librarians and their assistants, the movers and Warburg himself resumed the merry-go-round of the crates and boxes, replacing those originally destined for the third floor with those left on the first, those slated for storage with those destined for the elliptical room, those designated for public use with those reserved for employees only. For days on end those still half-empty rooms echoed with breathless shouts at times shrill or alarmed, asking now for confirmation of a title, now for the name of an author, requesting a book by its number and being answered with a color, triumphantly announcing a book discovered or lamenting a book feared lost.

Yet despite all the chaos, on the day of the mayor's visit the Library was in impeccable order. After a dinner of boiled meats with sweet and sour mustards, Warburg resumed explaining the current system of the books' arrangement and the reasons behind it. The general rule of this arrangement, he

explained, might be termed the "good neighbor rule," that is, the same by which humans choose the neighbors with whom to live in peaceful coexistence. It was therefore impossible to give a detailed explanation of the arrangement, just as it was impossible to understand the various reasons why people choose the neighbors they live with. And as sometimes happens in human society, there were even cases of arbitrary communion and apparently inexplicable preference.

"My books, however," he went on, "follow a highly sensible general system of subdivision, if you know the organization of my own mind. To put it simply, the Library is subdivided into four sections that correspond to the four floors of the building: the first section is devoted to the Image; the second, to the concept of Orientation; the third, to the Word; and the fourth, to Action."

After ascertaining that the mayor had grasped the concepts expressed, he went on to explain, slowly and a bit pedantically, that the first section contained all the art; the second brought together all the texts of astrology, religion and the natural sciences; the third had literature, poetry, and linguistics; and the fourth featured history (with a special section on the Great War), politics, and sociology. In the gallery of the elliptical room, finally, were the reference books and periodicals.

"As of today, mein Lieber Bürgermeister," he concluded with great satisfaction (due probably more to the rich meal he had just eaten than to his interlocutor's rather inane expression), "the Library contains exactly 43,889 volumes."

From that same period dated one of Saxl's fondest memories of Warburg, a moment in which he felt deep affection for a man not easy to love.

After the official inauguration on the following day—where a panic was caused by the insufficient number of chairs and the lack of a coat check area (which they had, alas, failed to consider)—the Library held its first great social event on the evening of June 13, 1926.

Mary prepared an enormous sachertorte and opened up some of the finest wines from the cellar. In the garden a brackish wind rustled the leaves on the willows and the sunset cast a

golden light on the waters of the canal. Inside, the crowd of guests began to pour in under the curious eyes of the librarians and employees gathered about the gallery, while at the entrance Max and Saxl busied themselves with the rituals of reception and introduction.

Aby Warburg turned sixty that day. Indeed it was his first birthday to be celebrated in a very long time, after so many mere rememberings and even forgettings, the unnoticed passing of the years, the progress and decline of a lonely, sick man. That night, however, more than three hundred people came to express their affection for the friend and render homage to the distinguished scholar. Their number included the most prominent representatives of German culture and business: scholars, academicians, intellectuals, bankers, industrialists and politicians. And then there were Marietta and Frede with their husbands, Max Adolf with his fiancée, Max and Alice with their children Eric, Lola, Renate, Anita, and Gisela, Paul with his daughter Bettina, Fritz and his wife Anna Beata, Louise and her husband, Aby S. and Rosa, the young Sigmund and the even younger Edward, and so many others, whom neither Warburg nor Saxl could remember.

After toasting and shaking hands for more than two hours, the guests, upon a discreet sign from Saxl, were asked to stop talking, and in that pregnant silence, Ernst Cassirer rose from his chair with the authority of a high prelate and approached Warburg. Gazing intensely at him, he handed him a freshly printed book and said:

"My dear, illustrious friend, the work I am giving you for your sixtieth birthday was originally supposed to be a personal expression of the deep friendship and devotion I feel towards you. I could not, moreover, have ever completed this work had I not received constant help and encouragement from that community of scholars for whom your Library serves as spiritual center. Today, therefore, I can no longer speak only for myself, but must also speak for this community—for those, that is, who have long honored you as a master in the field of research in the history of the human spirit. Working quietly and tenaciously, the Warburg Library has striven for three decades to gather

research material in the history of the spirit and the cultural sciences. But it has done much more than this too: with a clarity rarely encountered before, it has never let us lose sight of the rule that must guide such research. In the manner in which it is constituted and in its spiritual structure it has embodied the idea that all spheres and all currents of spiritual history work together to constitute a unity of method. Today, on the day in which the Library's development enters a new phase, when the construction of its new home broadens the sphere of its activities as well, we who have worked in its fold can publicly say exactly what it represents for us and how much we are indebted to it. We hope and know that beyond the new tasks that the Library must presently carry out, our old tradition of friendly collaboration shall not be forgotten, and that, indeed, the spiritual and personal ties that have kept us united until now shall grow ever stronger. May the vehicle of this research in the history of the spirit, which you have created with this Library, continue to raise ever new questions for us for a long time to come, and may you, as you have until now, continue to show us new ways to answer them."

With jaw tightly clenched and a light veil of tears over his eyes, Warburg took the book from Cassirer's hands and carefully read the title. Wiping the sweat from his brow, he clasped his friend in a tight, heartfelt embrace. It was not difficult for those present to appreciate the tremendous gratitude and acknowledgment behind that gesture.

Whereas Mary liked to remember her Aby as he was at the moment of applause after the Rome conference (as she herself admitted), Saxl for many years cherished the present image of his mentor: Aby Warburg in a warm embrace on the day of his sixtieth birthday. It was an image in which all the scholar's authority and his humanity shone through, where Warburg looked as great in intellectual stature as he was fragile in his physical being: a fascinating, intractable man, passionate and arrogant, and in any case deserving of all the respect he was being granted at that moment.

In early 1927, the Institute returned to operating full time. Warburg had urgently pressed for the resumption of all the

activities that had been suspended during the first few months after his return, and organized a staff of eight permanent librarians (two per floor) plus two outside collaborators assigned to special projects. Gertrud Bing was appointed his personal assistant, while Saxl was named chief editor of all publications. Herta von Eckardt, originally assigned to the fourth floor, was to handle administrative questions.

Herta had arrived at the Library a few months earlier very well trained in her field. She showed such quick-wittedness that she was soon made part of the Institute's management before even becoming fully familiar with it. Her physical appearance, generally more attractive than Gertrude's, lent her a seductive air rather unusual for such an intellectual milieu. Warburg was immediately taken with her. Yet while Mary had resigned herself to Gertrud's presence, and in fact at times felt grateful to her for her obvious devotion to Aby, she was unable to keep her usual composure in the case of Miss Eckardt, that "cheeky, ill-bred girl," as she called her.

Using every sort of feminine wile, the three women thus began to compete for Warburg's attention. Having never been so assiduously courted, he became inflated with childish vanity. Although their responsibilities were precisely defined and separate, the three women often ventured into each others' territories in order to make themselves appear more useful and diligent in his eyes. And while Gertrud and Herta were liberated women, Mary was too reserved and weary to outdo them. She therefore soon quit the field of competition and entrusted Gertrud with the task of total assistance.

But aside from these moments of pleasant flattery, Warburg had begun to suffer again from fits of nerves and cardiovascular problems. Entering his study unannounced one day, Saxl found him in a state of extreme prostration, collapsed in an armchair with a book on his knees and cup of herbal tea in his hand. Seeing Warburg in that state, he gave a start, upon which the old man whispered to him, by way of explanation:

"Yes, dear Saxl, I should never have imagined it would be so difficult to come back into the world. It's like trying to build a haystack in a thunder storm"

165

And the more his condition deteriorated, the less attached he became to the Library. After three years of tenacious control of its management, personnel, and acquisitions, and after repeated, imploring requests for funding from his brothers, he suddenly threw in the towel. Saxl then understood that his energetic encouragement of new activities and the increase in personnel had all been an unconscious preparation for succession. In October of 1927, moreover, he instituted a *Kuratorium*, a board of trustees that included his four brothers, his son Max Adolph, Peter-Paul Braden (Marietta's husband), his nephew Eric, as well as Ernst Cassirer, Adolph Goldschmidt, Erwin Panofsky, Gustav Pauli, Wilhelm Waetzoldt, and Saxl. Warburg was thus safeguarding the Library's future by leaving it in the hands of rich bankers and prestigious academics. He could now make his exit at any time without fearing that his dream might vanish with him.

14

MNEMOSYNE

Gertrud stuck her head quickly inside the door to get Saxl to come: the others were also about to leave and it was already dark outside. He, however, wanted to put those documents in order; they were too important to be left unattended overnight. When, at last, he had put away Warburg's first notes on *Mnemosyne*, he decided to leave the others in their original folders.

"Who really deserved the credit for the Mnemosyne project?" he asked himself with a mixture of modesty and presumption. That panel of photographs that Warburg displayed in the great hall at Bellevue for the *Lecture on the Serpent* had actually been *his* idea. Fearing that Warburg might get lost in digressions, he had suggested that unusual outline as a way of guiding and condensing his brilliant rhetoric; then, having witnessed its success on that occasion, he had arranged for his mentor to find the same panel, though in larger, more elaborate form than its predecessor, in the study on Heilwigstrasse as a welcome home greeting. From that moment on, Warburg had begun to study the panel with ever increasing interest. Little by little, he started changing the order of the images and increasing their number, drawing liberally from the photo archive that had continued to grow in size with the Library. After a few months' time, he multiplied the number of panels, and perfected their structure by using a thicker hemp for the backing and a very light wood for the frames. As these became his "indispensable tools of methodology," he began to take

them around to the conferences to which he was invited, and after having set them up at various colloquia, such as the Franz Boll conference, the Orientalists conference, the convention of the Association of North German Libraries, and the Chamber of Commerce convention, he decided they were no longer merely a complementary element of his profession but the nucleus of an independent entity. Forgetting their origin, he christened them "his last work," called them *Mnemosyne*, and nicknamed them (with his customary sense of humor), *Ghost Stories for Adults*.

While it is true that Saxl had always been a convinced supporter of the use of images, especially for didactic purposes, and that he had in fact made photography a second profession, Warburg's sensitivity to the very concept of image was clearly superior to his. And although the archive contained many photos taken by him, it was Warburg who had given every one of those images its precise classification and reason for being. Who, then, deserved credit for the idea of Mnemosyne?

He himself conferred too sentimental a significance on photography, and sometimes forgot its theoretical aspects. For him, photography represented youth above all: his experiments with the old Leica his father had given him, the small remunerations at school and at the university, the relationship with the woman who, before he knew it, had become his wife, and who, though a highly talented photographer and the first photojournalist in Europe, had also been the source of much unhappiness for him, unaware even of the tragedy of her own son.

But photography had also been the thrill of a snapshot in the trenches and the opportunity to take refuge in a sanctuary, the desire to capture a moment or record a detail. For Warburg, on the other hand, photography was an iconographical datum, a historical testimony, and even in old family photos it was the importance of the document, rather than the flavor of the past, that he most appreciated.

Yet hadn't Saxl's most intimate links with Warburg been forged in the realm of image, the real protagonist of that association? Had it not been this shared sensibility, this common

conviction which had made Warburg and Saxl teacher and disciple and, at times, disciple and teacher?

One day in autumn, toward evening, Warburg summoned his collaborators into the elliptical room, and with a weary but dignified expression asked for absolute silence and undivided attention. Slipping his hands into his pockets and standing with his legs slightly apart, he announced:

"This work will represent an immense 'atlas of memory' illustrating the two fundamental themes of my research and study over the years: the peregrinations of the Olympian gods and the flux of *pathosformel* in the history of the figurative arts in all centuries and in all countries.

"In these panels," he continued in a solemn tone, "I will give—indeed, we all will give, since this will be a group effort—a general view of the basic concepts expressed in the history of art. In each of them, we will make plain the contrast between images; we will emphasize the conflicts between them. Through the general themes of Orientation and Expression—and all their subcategories—we shall thus retrace the path of man, no longer in books this time, but in images. But let this be perfectly clear: this will all be expressed from *my* point of view, following the organization of *my* ideas, and whoever wants to understand will understand, whoever wants to follow me will follow me. I have no intention of inserting long, elaborate captions between these images; rather, I will make only brief indications, hints, suggestions. The images will have to be confronted alone, left to express themselves. Some of you, I think, can already imagine what I have in mind."

And here Saxl noticed the penetrating look that Warburg cast at Gertrud upon finishing that sentence.

"What I mean," he went on, "is that there is no need for writing in a work of this sort, because it must span the theoretical dimension, as traditionally understood, and elicit an immediate, intuitive visual comprehension."

This candid declaration, thought Saxl, was clearly a stratagem for freeing himself once and for all from the constraints of writing. The work would be the creation most consistent with Warburg's needs and least in conflict with his phobias. It would

be a way to get around an insurmountable obstacle and give his thoughts free rein.

Having then hastily chewed a piece of candy he had taken from his pocket and hidden in his left hand (he often ate candies during that period, for fear of hypoglycemic crises), Warburg continued:

"We shall start with the idea of Memory, with the fundamental element that imposes on man the detachment necessary to an understanding of reality. And memory—or better yet, the *mneme*—will be the thread tying all the main themes together. And though at times it may not be evident, memory will remain deposited in natural fashion at the bottom of the work, like the flora of a submersed landscape. And from there we shall proceed, with the help and collaboration of all."

Upon these words he cast another meaningful glance, this time at Herta, who seemed at last satisfied that she too had won some small recognition of her own.

"We shall proceed with the breakdown of each subject, and anyone with good suggestions will be welcome to present and develop them. It will be a long, difficult task, my dear colleagues, yet before my next trip I would like to define its structure. During my absence no one will be allowed to change or alter a single comma in these panels. And don't forget: no leaking of information. This is our project—that is, *my* project—and it will not be announced until it is completed."

Saxl knew that the project would keep Warburg busy for a few months, distracting him from his health problems. Indeed, he had no doubt that it would be the best of medicines for all the mentor's ills, starting with his loss of interest in the Library. During those first weeks, Warburg got down to work early in the morning, animated by intellectual enthusiasm and an incredible physical energy that sent him running up and down the building's stairways—from the photo archive to the elliptical room—with surprising speed. In this period he even refused to meet with students, fearing this might slow down his work rhythm and cut into his commitment to the project. When he finally felt the work was at a satisfactory stage, he decided to leave for Baden-Baden, where Mary and their daughters were

waiting for him. There he intended to go on a serious diet and try to regain his health.

The evening after his departure, Saxl had stolen into the elliptical room to have a look at the project's latest developments and to reassure himself that all was in order.

There in front of him more than forty panels were spread out, bearing thousands of photographs, prints, engravings, maps, and reproductions of every size and shape. The overall effect was one of a gigantic mosaic whose movement, variety, power and suggestiveness made one think of a musical composition, a triumphal symphony.

The first panels, leaning against the wall on the left-hand side of the room, contained representations of the cosmos alongside geographic maps on which were marked the places where pagan tradition had been preserved or spread (clearly reminiscent of the Wanderkarte). Then, in an almost contrapuntal sequence, came a series of alternating images of the relationship between macrocosm and microcosm, between man and the Zodiac, between archaic deities and the gods of Olympus. These were followed by representations of the most extreme forms of pathos: sacrificial rites and cathartic practices, triumphal marches and funeral processions, displays of degradation and ceremonies of edification, all in a swift, tight interpolation of faces, figures, and symbols.

At the center of the room reigned the Renaissance, broken up into details in strident contrast with one another. Leonardo's image of the human body within the circle was set off against medieval representations used by barbers in bloodletting; Piero della Francesca's silent portraits contrasted with the tumultuous drawings of Pollaiolo; the ascending lines of Michelangelo's crucifixions were juxtaposed with the descending lines of his soldiers fallen in equestrian battles. Then there were the Nymphs, each reproduced in a series of progressive photographic enlargements until single details were isolated—a veil, a sandal, an arm—in a kind of futuristic film sequence. Babylonian bas-reliefs were arranged together with Mithraic reliefs and Arabian pottery from the 1st century A.D.; monsters from Italian folk calendars were juxtaposed with

171

those from Dürer's early engravings; and images of Perseus and Mercury, in their various age-old aspects, vied for space in the panels that followed.

And amidst all these images were just as many signs: musical notes, word-plays, lines of verse, neologisms, arrows and expressions at times illegible yet so suggestive! On the right-hand side of the room, between two windows protected by heavy velvet curtains, stood the panels devoted to Judith and Salome, the "head-huntresses." And here unfolded a splendid arrangement of the most beautiful faces of the period from the works of such figures as Lippi, Botticelli, Donatello, and Ghirlandaio, an array of gazes sweet and perverse illuminating that dark corner of the room.

He had to step back toward the exit; that swirl of images was making him dizzy. He stood looking at the door for a few minutes just to rest his eyes and to try to understand the whole phantasmagorical vision. At that moment he understood that, even if the original idea had come from him, the manner in which the work had been executed belonged entirely to Warburg.

Having begun as a kind of scherzo, that work had now built up to a grand finale. It was the only way Warburg could make his exit. And truly enough, it was made not only to be read and looked at, but above all to be "felt."

*

Upon his return from Baden-Baden and from a brief visit to Florence, where the Warburgs met with old friends (not those, of course, to whom Aby had sworn eternal enmity following Italy's entry in the War), relations between Aby and Saxl seemed to have definitively smoothed out. Warburg had been officially commissioned to curate an exhibition at the Planetarium. It was the idea of the director himself, Fritz Schumacher, who wanted to reawaken public interest in an institution that had fallen for some time into a state of near neglect. Warburg accepted the assignment with initial enthusiasm, proposing to Schumacher an itinerary, in images, of man's intellect in the face of the great mysteries of the universe. The central theme would be

the journey from mythic thought to mathematical thought; in other words, from astrology to astronomy. The modern part of the exhibition could be assigned to Albert Einstein, who would illustrate the new science of astrophysics and win the attentions of the younger people.

Yet the more the plans for the show progressed, the more the problems multiplied. The city authorities refused the funds requested; the director of the Planetarium himself reduced the amount of space to be made available; the museums of other cities declined to lend them many of the needed materials. In short, so many obstacles came up that Warburg, in a fury, assigned the entire project to Saxl, suggesting at the same time that he use Max as political mediator.

But Max Warburg had other things to do in that summer of 1927.

On those rare evenings when he was invited to dinner at Heilwigstrasse, Max had tried to make Aby and everyone else understand the delicacy of the historical moment. He explained how the dizzying, illusory economic growth that had spurred the country at the start of the preceding year had, in fact, been created by a series of complex maneuvers by bankers all over the world. The exchange rates had become fixed and seemed guaranteed by the direct or indirect convertibility of all the major currencies into gold; and thanks to the play of loans, international business had grown very rapidly and investment banks had become so attractive that they came under fierce competition from the commercial banks. Equally encouraging, at least in appearance, were all those American loans distributed throughout the industrial sector: the banks had increased the volume of loan monies to 25 million dollars as compared with 1 million dollars before the War. It was certainly a good sign that Luther had become Chancellor and Stresemann remained Foreign Minister, and even more reassuring that Carl Melchior, his partner, had been appointed German representative to the Finance Commission of the League of Nations (into which Germany had just been admitted). It was also true that the new Anglophilia that had recently emerged in Hamburg would help bring in and circulate new foreign capital. An opening of

this sort had been encouraged by the Thyssen and Siemens dynasties who, newly re-established in their economic fortresses in the Ruhr valley, were anxious to use American loans, either by taking advantage of the Dawes Plan accords or through direct channels with Wall Street. And it was precisely here that Max played an important but risky role. Obviously nobody had better access than he to the world of New York finance, and in fact he had already obtained, in early 1927, a loan of 5 million dollars for the city of Hamburg and 10 million more for German heavy industry. He was the only man, after Stresemann, to be employed by the German government as a financial liaison with the United States, especially since December of that year, when he convinced Paul to establish, by means of a merger between two large American banks, a new source of financing for rich German stockholders.

Having said all this, however, Max warned his listeners that all this economic euphoria was becoming dangerous, that the inflated economy and generous handouts of loans would not last forever. The market would shift and the creditors would become furious, and a political situation that seemed to favor the moderates over the Nazis and Communists would all go up in smoke.

After this crystalline exposition, Saxl refused to involve Max in the Planetarium project. He would not have had the time or energy for it, and for once Saxl wanted to allow him the right not to interest himself in his brother's affairs. Aby flew into a rage over this: he began to accuse everyone—and Saxl in particular—of obstructionism, passivity, and laziness. During that summer of 1928, Saxl suddenly felt the full weight of all those false accusations; he felt deeply offended, tired and frustrated. On one particularly hot day, for the first time in his life he shut the door to the elliptical room without using the doorknob, and he would really have liked to slam it in anger.

The following week he left for London, where he remained for a few months. To honor his commitment to the Library he sent official reports to Warburg at the end of each week. In them he mentioned the curiosities he was finding in antiquarian bookshops and hinted, rather reservedly, at the results of his

research. Furtively, however, he was also writing long letters to Gertrud, which he secretly hoped would be discovered by Warburg.

*

Owing to that same complex web of economic interrelations between America and Germany, Felix and Paul spent the entire summer of 1928 at Kosterberg. Mary described the period as the last moment of peace among the family. Even Aby managed to find a tranquility of sorts.

Felix's children were too involved in New York society to spend the summer in a small town on the banks of the Elbe. Yet while Gerald, the third born, was a very talented cellist and always busy with musical engagements, Edward, the youngest had a great deal of admiration for Uncle Aby, and his sporadic visits to Kosterberg were really a pretext for spending some time with him. Considered the black sheep of the family, Edward had embraced the cause of avant-garde art—an "entirely incomprehensible form of expression," in the opinion of his father Felix—and in his unrestrained desire for transgression he had squandered money promoting such unknown artists as Pablo Picasso and inviting to the United States such odd characters as Georges Balanchine.

Max's daughters, on the other hand—Lola, Renate, Anita and Gisela—were models of good behavior. Musical enthusiasts themselves, they had formed a string quartet considered one of the country's main attractions. Often summoned to Berlin by that city's philharmonic orchestra, the four young women had succeeded in balancing their musical commitments with their household duties, and lately it was they who performed on the warm summer evenings at Kosterberg. The prettiest of the four was clearly Lola, who also had a great deal of charisma. Blonde like her father and slender like her mother, she had an inborn elegance and irresistible charm. Already married now for some years to Rudolph Hahn, she had achieved economic well-being and social prestige through that marriage, but her ambitions led one to believe that this would not be the only

instrument for continuing her social ascent. Renate and Anita remained overshadowed by Lola's personality, though they too were strong, determined women. Gisela, the youngest, lived in a world all her own, in which all the Warburg character traits remained nevertheless distinct.

After dinner, which by now had dispensed with all strict kosher observance and featured instead classic French dishes, the four young women sat down in a semicircle around their music stands, and upon Lola's cue began their recital. Husbands and fiancés exchanged glances of mutual admiration, while Max and Alice sat up straight in their chairs and Felix continued his flirtatious chatter with the other daughters-in-law and young ladies invited for the occasion.

At the end of the first movement, Eric and James slipped silently out toward the portico to enjoy their Havanas in peace. Between Eric and Jimmy—the eldest sons of Max and Paul, respectively—there was a bond of deep friendship based not only on their close work relationship (which their fathers also had), but on a deep affection as well. An introvert like his father, Jimmy had graduated from Harvard and counter-balanced his obligatory work as financier with his semi-clandestine pursuits as a writer, producing short works in many different genres: plays, short stories, brief economic treatises. Eric, on the other hand, like his father as well, had taken his role as banker quite seriously, and felt the weight of his family's destiny and his responsibility as firstborn. On those warm nights at Kosterberg, the two used to talk for hours and hours; their future appeared more certain yet less heartening than their fathers', while their private lives were menaced by a gradual breakdown of traditional values.

In the great country house that year there was a strange silence in the air, despite the Schubert sonatas, a silence more mental than physical, and seemingly impossible to dispel. Even Uncle Aby seemed to have stopped flying into his customary rages, and he no longer had the strength to tell the little ones his marvelous stories. He often chatted with Eddy and Gisela, though usually remaining a bit distracted. He tried to follow the stories of the children's activities in New York, but often

confused names and relations, and he resolved to devote more time to his own children—whenever they came for a short weekend—but after a few exchanges of ideas he was always unable to suppress his usual paternal authoritarianism.

By mid-September, after the first autumnal storms, parents and children, uncles and aunts, nephews and nieces were all ready to go back to the city. While getting in the car, Mary realized that this year nobody had climbed up into the arms of the great beech tree, that the little theatre in the park had fallen into a state of neglect, and that the kiosk under the portico had become no more than a little pile of wet wood.

15

THE APPLE TREE

Through the slightly open door, Saxl glimpsed Gertrud's dark head as she entered with a firm step, impatiently asking again if they could leave. With her overcoat already buttoned up, she set a small pile of books onto a shelf and decisively picked up a typescript that had been lying nearby. She looked determinedly at Saxl, as if to say she would wait no longer.

Since they had been living together she had become more attentive, almost maternal, in fact. Or perhaps it was merely a question of age, and that at forty-two she had lost some of the stiffness of youth and acquired a more mature solidity. Her features had relaxed somewhat, and her eyes, which once seemed to hold inaccessible secrets, had now softened with a shadowy sweetness.

He had never understood what sort of relationship Gertrud had had, deep down, with Warburg, nor would he ever have wanted to know. Gertrud's devotion and respect for the maestro were more than comprehensible, and Aby's attraction and affection for her more than justifiable. Beyond this, he didn't care to uncover secrets; he didn't want to suffer. He did know, however, that his own attachment to her had grown simultaneously with hers to Warburg, even though between 1927 and 1929 they had spent very little time together. Having begun with an immediate, mutual attraction, their relationship had not weakened upon Warburg's return, but rather had been forced to find a new balance between duties and personal interests.

He had suffered from this—there was no denying it—yet at the same time his own marriage was falling apart. His mongoloid son was absorbing much of his vital energy, work was often difficult to manage, and he no longer had the time to give it sufficient thought and attention. Human relations at Heilwigstrasse had become difficult in the last few years, with Herta acting against Mary, the staff continually in competition with one another, and Warburg, Gertrud and he involuntarily involved in undeclared *ménage à trois.*

Upon Warburg's death, however, all those conflicts ended naturally; tensions vanished and friendships were reaffirmed. Gertrud again grew close to him, more spontaneously this time, and a few months later they decided, without false moralizing or useless institutionalizations, to spend the rest of their lives together.

What bound him so deeply to her was her utter freedom of thought and inexhaustible intellectual curiosity. Gertrud, too, had never felt much sense of belonging to her culture or religion, her origins or country, and this had helped lend them the necessary courage and impetuousness to run away and start over. At the same time, the desire for knowledge and discovery had provided for both the stimuli necessary for feeling at home no matter where they might be. There was no question that Gertrud had more in common with him than with Warburg, even though he knew that likeness was not always the most important factor in a relationship.

He recalled the intense, precise work Gertrud used to carry out for Warburg: there was an understanding between the two that had always filled him with jealousy. After his return from Kreuzlingen, Warburg had wanted Gertrud beside him to transcribe his dictations, and that was the way it remained until the day of his death. She could follow his speech better than anyone; she always knew exactly what he meant, knew how to write it and annotate it, how to finish his unfinished sentences, how to find more appropriate words, how to clarify complex thoughts that at times, out of laziness or impatience, he found unnecessary to explain. When Warburg was dictating, she would watch his lips closely to grasp the nuances and verbal

connections he was omitting or slurring. When he declaimed, on the other hand, she was always able to cut things down, to preserve the tight logic of the arguments, to keep from losing her way amidst his irrepressible tale-spinning. During those sessions, while Gertrud's eyes concentrated on Warburg's mouth, his would slide swift and hot along her features, settling now and then on one detail or another of her figure: the part in her hair, a fold in her neck, or some more solid part of her body well protected under heavy layers of flannel. Gertrud was also better than anyone at finding material on request: texts, reproductions, photographs; she would head straight to the source, remove from the shelf or archive the document requested and hand it to him with a pertinent question or witty comment.

After Warburg's return from Baden-Baden, their rapport seemed to grow stronger than ever. The two would spend many hours coordinating materials for *Mnemosyne*, putting the finishing touches on the Planetarium exhibition, or organizing some new lecture.

Once this work was finished, however, Warburg plunged back into his customary leaden mood. The latest diet enforced by the family physician had deprived him of meat and seasoned foods, making him not only melancholy from the involuntary fasting, but suddenly physically weak as well. During those cold winter months he went around bundled up in layers of clothing and overcoats like a homeless person, moving restlessly and sorrowfully from one room to another between the two buildings. He almost never entered the elliptical room any more, but would wander from floor to floor to check up on the staff's diligence. Downstairs there were "too many people," he kept bitterly repeating to himself, "too much confusion, a constant coming and going." At the end of the day, he would flee exhausted to the little room on the second floor that used to belong to Mary, and there he would manage to calm his anxieties. He knew he was near the end. He would say so too, in a half serious, half facetious tone, so as not to frighten anyone, but also to sound out the reactions of others and perhaps simply to accustom himself to the idea.

Then one day in November of 1928, he announced he was leaving for America.

"America?!" they all exclaimed in unison.

"America, now, in your condition?" Max asked, with impatient surprise.

"Don't even think about it," said the family physician, Doktor Heinrich Embden, apparently putting an end to the discussion.

But this prohibition made Warburg even more obstinate.

"Not just to America," he said, "but to dwell among the Pueblos, in New Mexico, and . . ."

"Impossible!" was everyone's reply.

Mary, finally, in a tone that combined shrewdness and supplication, suggested he return to Italy. But to Rome this time, and to Naples, and not with her or the family, but with Gertrud, who certainly needed more classical culture based on on-site experience, and with Franz Alber, who could look after his health.

The suggestion proved to be a brilliant one. Warburg welcomed it enthusiastically and immediately made preparations for departure, despite the great quantity of luggage. Indeed, this time he had decided to bring *Mnemosyne* with him, more than forty panels with hundreds of photographs attached!

*

Whenever Gertrud spoke to Saxl about that Italian sojourn, he could never suppress a feeling of profound unease, and when she said that she never wanted to go back to Italy so as not to ruin her fondest memories, he could not forgive her for it.

"Rome was bathed in a golden light on the morning of our arrival," Gertrude had said with a dreamy air, "A scent of wet earth hinted at the storm of the night before and created a sense of tremendous calm. The streets and piazzas, still immersed in silence, were blossoming before our eyes like the body of a woman who awakens still full of desire at her lover's side. The streets along the Tiber cut through the dense foliage of the trees, whose amber color was reflected in bright splotches

on the surface of the river. The Sant'Angelo Bridge, in that atmosphere of suspense, seemed to echo with the tragic notes of Tosca, while Michelangelo's dome, in the distance, dominated the entire city."

On the ride from the station to the hotel, Warburg was overcome with an uncontrollable feeling of euphoria, and as Gertrude was echoing his sentiments with repeated exclamations, Herr Alber, seated behind them in the car, chimed in now and then with his usual discreet comments.

Franz Alber, a stylish, handsome young man, had been hired by Mary upon Warburg's return from Kreuzlingen. A trained nurse, he had also worked as a personal secretary for some of the best families in the country. Alber had a hundred different duties in the Warburg household. Aside from assisting Aby in all health-related matters (shots, diet, and massages), he was also responsible for part of the correspondence, for organizing travel, and for every other technical matter concerning the Library.

At the Hotel Eden, where the three had taken lodging, Alber oversaw the preparation of Warburg's meals, having them cooked directly in the suite, and consulted daily by telephone with Dr. Embden, to keep him up to date on Aby's health.

In the same suite, the photo panels had been set up and a great quantity of books piled on furniture and on the small shelves ordered from the hotel in advance.

The panels actually proved very useful when Warburg was invited to the Biblioteca Hertziana to give a lecture on his latest research. The preparations for this presentation were, however, long and laborious: the screens had been set up in the sitting-room, but their original sequence changed daily until, on the day of the lecture, that rotation turned into an out-and-out merry-go-round. Sunken in a great armchair of damasked velvet, Warburg shouted stentorian orders at Gertrud and Mr. Alber to establish a final arrangement for the following day:

"Yes, yes, that one there . . . Yes, that's right . . . No, no, not that one, the first over the third, then take out the fourth. But what's Dürer got to do with it! Nobody said to move the Botticelli! You just don't understand . . . Now let's put back the Nymphs. And next, here, the Sistine Chapel. Excellent . . .

Now there, Raphael . . . No, no, not the *Mass at Bolsena*, what's that got to do with anything! It's *The Sacrifice of Lystra* that goes there. Good. Then, on the other side, there at the end, put the Tarots. And where is the *Picatrix*? Ah, there it is! And there's the Cossa, and the Piero . . . Good, good. Now put the twelfth where the fifteenth is. No! Take the fifteenth away . . . Now bring back the Flemish—no, not the portraits, the tapestries! Wait a minute, wait! Hold onto Manet! Manet is supposed to come last . . . Why can't you understand? It's so simple . . ."

On a morning with the north wind blowing, the panels were loaded into a small, somewhat dilapidated truck and shipped off to the Hertziana. Early that day, Gertrud and Mr. Alber carried the materials downstairs, while an indolent porter in the street loaded it slowly and incredulously into the van.

On the sidewalk in front of the hotel, groups of young students in black shirts were marching in orderly fashion toward the sharp declivity of Via Capo le Case, hugging a long wall covered with political posters. In the distance, three elderly women were returning from their morning shopping with great baskets of fresh bread, while through an open door at street-level a radio broadcast speeches by Il Duce, interspersed with sentimental songs.

The lecture turned out to be one of the longest Warburg had ever given. Indeed he had summoned up a surprising reserve of energy that day. In the years that followed, Gertrud often repeated to Fritz how surprised she had been at Warburg's achievement on that occasion, the lucidity and ingenious insights he was able to come up with during that stay. Theories and ideas that had seemed long extinguished and which he had obviously guardedly preserved in his memory during the last period in Hamburg, poured out of him anew like water from a mountain spring. Perhaps it was the city's atmosphere that revived him: the direct contact with antiquity, the faces so full of pathos, the echoes of a past still so alive. Though debased by the gloomy mediocrity of fascism, Rome still managed to preserve its historic identity, its vigor and vitality. The co-existence of different historical periods, the overlapping of architectural styles and the mix of cultures stimulated a rapid, eclectic thinking process in

Warburg; it was as though the world outside reflected, in reality, what he had been trying to reproduce in *Mnemosyne*. Or perhaps it was she, Gertrud, who with her youth and insatiable curiosity had brought the youth back out of the old Warburg, prompting the return of the sensual historian and brilliant orator he had once been. The attentions he lavished on her became more subtle and gratifying each day, while the excitement he felt in her presence was hard to conceal.

Having come finally to *Dejeuner sur l'herbe*, Warburg breathed a long sigh; he was nearing the end. He had dictated the notes on Manet to Gertrud just the night before, and she had transcribed them in great haste during the night. Now she was hoping he could follow them and remember everything that had been jotted down in a rather approximative manner.

Warburg's rapprochement with modern art was a recent development. After supporting it enthusiastically in his youth, perhaps more out of a spirit of rebellion than out of real intellectual interest, he had shut himself up in the Classical and Renaissance periods as if wanting to flee everything that represented the "new." Especially during his illness, that period of innovation and experimentation left him more than indifferent: it frightened him. Now instead he had begun to appreciate contemporary art. When one day Gertrud had found him examining and taking notes on a work by Paul Klee, he had explained to her with a smile that at his age all that mattered was the simplicity of the stroke, the essentiality of the work, since there was no time left for all the rest. And it was strange, she thought now, that he had never given in to the temptation to become an art critic. From so assertive a personality always ready to make the most pitiless judgments in the various other areas of everyday life, one might have expected consistent evaluations of works of art and artists, but his intellectual formation was that of the historian, and in this he was always impressively consistent. His gaze on the past, though spurred by an exhilarating curiosity, always remained focused, precise and attentive, like that of a philologist. Though intuition had always played an important role in his research, the process of investigating nevertheless followed a rigorous, methodical pattern. His flights of fancy,

which were for the most part "flights of pursuit," always ended up landing on sure ground, amid documentation and proof.

The audience was beginning to show signs of great impatience. Warburg had kept professors and colleagues bound to their chairs for almost four hours, and though armed with good will, they were on the verge of exasperation. His continuous movement between one panel and the next had, moreover, dragged things out longer than expected, and the Roman audience, already undisciplined by nature, had repeatedly expressed surprise and amusement at this unusual presentation. It was time to bring things to a conclusion. Gertrud began to convey subtle messages to him, which he immediately understood and executed.

That evening, strolling about the back streets of the city, Warburg confessed he was ready to go back home and say his last goodbyes to everyone. He said these words with a big smile, ready to lighten his melancholy pronouncement with a quick wit that provoked a bittersweet laugh in Gertrud.

"You see, my dear Bingia," he said, taking her hand, "I am the perfect sort of person for one of those commemorative portraits: you know, the fellows about whom they tell so many anecdotes and write so many fine obituaries. It's only a shame I myself won't be around to take part in the reminiscences!"

"But let's imagine," she replied, "that you could return among us, as a reincarnation or whatever you want to call it. Who would you want to be? Or rather, if you had been offered another chance before birth, who would you have wanted to be?"

"Nobody else," he replied more seriously, "Believe me, Bingia, nobody else. I am happy this evening, because I am with you, but especially because I have now ended my cycle of lectures, a cycle that has lasted a lifetime and given me immense pleasure in its every word and pause. Yes, it is time to make my exit. The long, perhaps too long finale this evening was my last goodbye to my Italian friends—a goodbye from the pulpit, which is how I have always wanted to take my leave."

Slipping along the walls of Via Gregoriana, they arrived under a streetlamp that cast a metallic glare onto the pavement. That unexpected light seemed to interrupt a conversation that

had become perhaps too intimate and chased Warburg's smile back behind a pall of reserve. A few moments later, however, Gertrud felt a fragile, warm body beside hers and the light trembling of an arm seeking to rest, out of affection or fear, on her sturdy hips; and she heard that beloved voice speak to her again. In the newfound darkness she suddenly felt all the power and fragility of the man, and all the pain of his tortuous conflicts. She didn't want him to die, but neither did she want him to suffer, to meet his end in an undignified manner. She returned that search for support with an embrace, helping him, without calling attention to herself, to climb up the steep hill of Via Sistina.

What happened afterward was something Gertrud never spoke about and Saxl never asked her about. When, upon their return, Mary asked her with a combination of curiosity and jealousy to tell her of some episode of their journey, Gertrud had her anecdote ready. Flashing a broad smile, she told about the day when Professor Warburg had wanted to organize a little goodbye dinner for his friends and hoped to bring them together at the Hotel Eden's restaurant, which had a splendid view of the city. But that day turned out to be February 11, when Mussolini was supposed to sign the Concordat. The city's streets, from early morning, were teeming with people. An exultant, triumphant public waited hours for news, singing Fascist anthems and bursting out in delirious support for the beloved "father of the country." Warburg that morning had gone out earlier than expected without having told Gertrud of his plans for the day. After hours of waiting, Gertrud realized he hadn't returned for his customary afternoon nap. Nor did he show up before dinner, not even for his appointment with his friends. Around ten, she and Alber, convinced something terrible had happened, asked the police for help, but they had their hands full with other matters and paid little attention to the supplications of these foreigners. Finally, shortly before midnight, Warburg returned looking happy and satisfied. When asked what had ever happened to him, he replied:

"My dear colleague," which was how he called her officially, "you are well aware that for all my life I have been fascinated by

the survival of paganism and by every kind of feast and pagan ritual. Today I had the opportunity of a lifetime: I was able to participate in the "repaganization" of Rome. How can you complain that I stayed to enjoy it to the very end?"

Mary laughed heartily at this story. She was quite familiar with her husband's assertions of independence, the sudden disappearances in search of some trace, clue, or hypothesis—dropping everything, even his "dear colleague" Gertrud, when it came to testing a theory!

The final days of the trip were devoted to Naples, a city toward which Warburg had mixed feelings. While he loved the Naples of Taine and Stendhal, of Vico and Montesquieu, and even more the Naples represented in a pearly light in early 19th-century gouaches, he hated the real thing, the city and its people. After a few hours of visiting churches and monuments he began to inveigh against the tangle of smelly streets and the teeming crowds of disheveled, ragged humanity. He said that in all this vitality he saw a force more electric than biological, more rooted in neurosis than in culture. The very same gesturality that he had learned and adopted so many years ago was too excessive here; it became a grotesque pantomime, a carnivalesque masquerade. The aristocracy, for its part, preserved the purity and elegance of the Italy of another age. But the commoners—my God!—flaunted their dreadful misery. When the irritation became too unruly, Gertrud would take him down to the seaside promenade. There, at sunset, the profiles of Vesuvius and the islands evoked strange forms of sirens and dreams against the reddening sky. The steamboats heading out to sea from the Mergellina port left rainbow wakes in the water behind them while kiosks selling mussels and almond milk enlivened the seafront with a festive air. Finally calm, and almost embarrassed at his earlier complaints, Warburg would resume his fascinating monologues, which he interrupted now and then with declamations of Homeric verse.

The excursion to Pompeii was particularly memorable. Warburg was once again able to relish the role of guide, while Gertrud enjoyed those qualities in him that had never failed to win a woman's heart. At Pompeii his gaze burned again

with the passion that only the pagan world could instill in him. Taking her by the hand, he sought out sculpted Nymphs like an excited satyr, squeezing her arm while explaining the minutiae of the mosaics, hugging her round the waist as he whisperingly described every detail of the purple frescoes. He had them recite, in a comic vein, the chief passages of Jensen's *Gradiva*, obliging Gertrud to play the part of Zoe while he himself played an awkward and amusing Norbert Hanold. She now understood what the ancient world really was for him: an umbilical cord that had never been cut. "The survival of classical antiquity in the modern age" was no longer merely the formula that the old scholar used to repeat as the motto of his studies, but expressed the knowledge of a world to which he had truly belonged, a world that seemed to span all subsequent epochs indiscriminately and become actual experience in his evocations.

The quick wit that Warburg displayed in the company of Benedetto Croce at the end of their stay won Gertrud over once and for all. Upon entering *Palazzo Filomarino*, in which the philosopher lived, Warburg confessed to her that he felt a bit nervous about that meeting. As with Cassirer, Warburg experienced an avowed inferiority complex in the face of one who had been able to realize a philosophical system so coherent and all-inclusive. Though for his own part a stranger to all idealistic positions, he nevertheless had a great fascination for them, feeling somehow spellbound in the face of such majestic visions and aesthetic concepts that could rise so much higher that his own research, which was based on minute details. Croce, like Cassirer, represented what he would have liked to be, the part of himself that he had never listened to because he was so stubbornly attached to his principles and whims. Croce was able to look at art with a philosophical eye and at history with a serene detachment, whereas he struggled between the two disciplines with a visceral involvement. While it was the Dionysian principle he had always pursued, the Apollonian calm of such minds had always aroused his envy. The imperturbability and audacity that allowed them to aim so high, had this not perhaps been his real and ever unattainable goal?

But when the eminent philosopher received them in his library, Warburg forgot all his fears and hesitations. He plunged into the vast, and yet warm room, like a fish that had been too long out of water. Skimming those shelves lined with as many as two and three rows of books, he burst into inspired eloquence while Croce, clearly flattered, tried to turn the conversation to broader-ranging subjects. Between various courses of southern specialties, the conversation shifted to the question of whether it is "God," "the Good Lord" or "the Devil" that "hides in the details," and this popular saying led to the most elegant and subtle of philological skirmish. Croce calmly insisted that the origin of the proverb was simply "Gott ist im Detail" ("God is in details"), whereas Warburg, growing somewhat heated, maintained that it was "Gott steckt ('God nests' or 'God hides') im Detail". To Gertrud they both seemed right, and she didn't know whose side to take. Their outpouring of quotations was so amusing that she didn't feel up to prompting them to resolve the issue. The conversation then turned to Cassirer, whom Croce was reading at the time, and Gertrud noticed that Aby seemed deeply touched when, calling him "one of my dearest friends," he told the story of the book dedication on the occasion of his birthday.

The time passed so pleasantly that day that nobody noticed when the streets outside had fallen into the torpor of the afternoon siesta. After a few brief and bitter comments on the Italian political situation, Croce and Warburg (who were exactly the same age) both displayed an obvious desire to retire.

*

As soon as he was home, however, Warburg fell back into his dark moods. The Italian interlude faded quickly as a dream, and waking reality resumed its torment. During the last days of the summer of 1929, the situation in the family was tense. Max, Felix and Paul feared the imminent collapse of the world economy. Paul was trying to persuade Max to sell everything he owned on the stock market and to make his financial decisions very carefully. Max also feared some impending international

catastrophe, but was determined not to abandon ship and to stay at the helm as long as was humanly possible.

Aby, who was even more aware than the others that something monstrous was descending upon them, tried to concentrate his energies on the Library, his sole wealth and the only inheritance he had to leave behind. On the evening of August 21, at the end of a particularly muggy day, he called together the members of the *Kuratorium* to make an appeal to their sense of responsibility and loyalty. He reminded them that the *Kulturwissenschaftliche Bibliotek Warburg* must continue to support, even in an uncertain, menacing future, the role of the past, the spiritual role that it played for all who believed in culture as enlightenment, as a progressive journey away from darkness and fear. The Library must remain above all an instrument of education and orientation, steering man along the path that leads from myth to science, from magic to mathematics, from individual memory to social memory. The persistence of classical civilization in the modern age would remain the Ariadne-thread holding together the entire Library, whose coherence and *raison d' etre* lay not only in the studies conducted within but in the very evolution of humanity. The work thus far completed thanks to the ironclad solidarity of the Library's few but devoted collaborators had shown that it could not survive except with the support of all of all those who believed in this institution.

Then, unexpectedly raising the pitch of his voice, he turned toward Saxl, gazed intensely at him and, pointing his finger at him, said:

"Professor Fritz Saxl, a dear friend of mine for over twenty years, has given and will continue to give the Library the best that his formidable intellectual and didactic talents have to give. Future projects, such as the *Mnemonsyne Atlas* and the Planetarium exhibition, will depend on his commitment and good will, as will the survival of the Library itself, both as a public institution and as a link with the other libraries of Europe. I ask you, gentlemen, never to lose hope, and always to support the *Kulturwissenschaftliche Bibliotek Warburg* financially and spiritually. If you do, I promise you that in a very short time it will become

190

a universal tool for all who believe that the path of informed research leads to the truth."

Warburg had finally declared him his successor, had finally acknowledged his worth and responsibility! Saxl was surprised and pleased; he approached him and accepted his warm embrace, not knowing it was to be the last. Shortly thereafter Warburg discreetly withdrew, slipping away in silence and leaving the guests to continue their conversations. It was late for him, already time for bed. During that period he often skipped dinner and retired very early to the little room on the second floor.

In those last two months, as in the final days at Kreuzlingen, the uncontrolled anxiety of the mornings was followed by a lucid calm during the afternoon and a total passivity in the evening hours. News of the country's and the family's economic difficulties filled him with an urgent need to communicate the instant he woke up: he would phone his brothers, request information from the offices of the municipal authorities, try to contact stockbrokers and financial experts, but then in the afternoon he would give in to a feeling of detachment from the world that grew and grew until he silently slipped away into the bedroom where everyone and everything was forgotten.

On one of those evenings Aby called Mary upstairs to him. He needed her, needed to speak to her. Gertrud, on the ground floor, kept working in the dining room, as was her custom one day a week. Through the half-open windows an unusually warm air was blowing in, and the sky, though moonless, had an odd lightness about it.

Mary and Aby spent many hours in the little room on the second floor, more than they had for years. Through the door came a constant murmur so hushed and reassuring that no one dared disturb them. Shortly after ten, Gertrud thought she heard a voice or strangled cry, but a few minutes later the tender, indistinct humming resumed its regular rhythm. Franz Alber, in the next room, was dozing quietly, and thus Gertrud thought it best to leave without disturbing anyone.

Mary reappeared several hours later. It was dawn on October 26, and the light outside was already beginning to filter into the

house in bluish shades. There was no need for Mr Alber to ask any questions; the expression on Mary's face announced that her husband was dead.

Gertrud was not surprised when she arrived early the next morning. She had heard, had sensed the exact moment of Warburg's death. Ordered to gather all the children and siblings, she began making phone calls and sending telegrams with swift efficiency, just as the Professor would have wanted; the final details she later finished up with a cool, calm head, as was the family style. Mary was asked no questions regarding the specifics of Aby's death. She was left absolutely free to speak or remain silent on the matter, and thus, closed in on herself, she slipped silently from room to room to see that the instructions for the imminent ceremony were being carried out.

During the day, while preparing the body, Mary made an astonishing discovery. Having stepped out into the garden for a breath of fresh air, she noticed that the little apple tree, always so sickly, was dotted with buds; the branches, once stiff and gray, had turned green with life, and so late in the autumn at that! She raced back into the room where Aby had spent his final hours and grabbed the diary in which he had jotted down a few things shortly before dying. There she found written: ". . . who will sing me the paean, the song of thanksgiving, the praise of the apple-tree that blossoms so late?"

What did he mean by this mysterious question? It was certainly prompted by his discovering the tree in bloom, yet why had he not mentioned it to anyone? Why did he write it in his diary like a last goodbye? The little notebook, moreover, had been kept by Aby himself in a parchment box together with the last will and testament, in which he asked—with no chance for appeal—that he be cremated and that Mary be named guarantor and executor of this will.

She thought back on that final conversation, trying to find a deeper meaning, something that may have eluded her earlier. Aby had still wanted to talk about his fears, the fear that had never left him and had re-emerged in violent, uncontrollable form during the final hours. The shadows that he had tried for so many years to dispel with the power of reason and the

scholar's self-awareness came back, looming menacingly over him:

"Monotheism's fear of paganism," he had said near the end, in a faint voice, "is it not the same as Christianity's fear of Judaism? Aren't the Jews banished the same way the Olympian gods were? Forced to hide, to camouflage themselves, always in exile, always wandering? Isn't fear the most indelible mark of the Jew, is it not perhaps the *shadow* of his flight? Whether he be a believer or not, does he not carry inside, deep down, a *black spot*, a bottomless well at the edge of which he is sooner or later forced to stand?

But is that spot fear, or is it guilt? Or is it an existential condition? I don't know, dear Mary, I no longer know, I am too tired . . . Mary, dear wife, beloved colleague, faithful companion . . . stay close to me, so close . . ."

Recalling these words, a flood of tears blinded her swollen, sorrowful eyes. She tried to repress the sobs, swallowing tears and saliva, breathing deeply and wiping her face dry. She felt an abyss open up inside her, a long, deep crevice that rent apart her vital organs and gaped all the way up to her throat. She pressed her hands hard on her stomach to prevent that vortex of emptiness from expanding further, then quickly massaged her throat to let the air through. She had often wished for Aby's death, but how could she have? How could she have conceived such madness? And yet when seeing him suffer so much, when seeing him through the eyes of others, seeing the mocking sneers masked by polite smiles, the embarrassment and impatience of his brothers—that was when she would have rather seen him dead. Still she now understood that it had been an ignoble wish. Now she knew she would rather have him at her side: mad and suffering perhaps, old and infirm, but alive! But it was useless to pity him now; she should have thought of it earlier, should have helped him, fought beside him instead of withdrawing as she had always done, especially in the final period. Frightened and frustrated by his illness, she had felt incapable of intervening, of pushing herself beyond the limits of patient assistance. Yet now she felt she should have entered the Hades from which he begged for help and dragged him out like

a strong, determined Orpheus. She had always thought of herself as the victim, as the one who suffered more; in fact she had been only stupid and cowardly, unable to understand or alleviate his suffering. It was true: "the woman who loves always surpasses the one she loves, because life is greater than destiny." But what meaning could these beloved verses of Rilke have for her, if she had never really understood them? What meaning her patient waiting in sanatorium antechambers, or her long visits to Wald Park and Bellevue, when she merely left him there in the end, abandoned to himself, while she went back home and into the world? If only she had been more persistent, more tenacious, at least she could have, or would have.

But after a few minutes of this despair, she clenched her fists, tightened her jaw, as he used to do, and returned with her head held high to the large room on the ground floor. It was time to get ready.

16

ESCAPE FROM HAMBURG

As he was about to leave, he was overwhelmed by a flood of memories of the final period, the closest, most anguishing period of all.

Three days after Aby's death, the Warburg brothers received the news they had been expecting and fearing for some time. On Wall Street, the market had crashed. In a few hours sixteen thousand stocks had changed hands and the market lost thirty billion dollars in value. The repercussions on the European markets would soon work their terrible damage. As usual, the women of the family tried to stem the panic that was taking hold of the Warburgs young and old from New York and London to Hamburg and Berlin.

From that moment on, Saxl discovered another side to Max Warburg, not the wise and generous brother but the nearsighted and stubborn politician. Even though Max had given him carte blanche in managing and administering the Institute, the madness of some of Max's decisions risked destroying the Library.

The crisis, meanwhile, had reached Europe, and the M.M. Warburg Bank began its rapid decline. Max had asked for, indeed demanded, help from Paul and Felix, and they had responded by depositing, between debenture bonds, controlled shares, and cash a total of nine million dollars into his banks. For Paul it was a very trying experience; he did not resist, like Felix, nor did he get indignant like his son Jimmy. He was the brother closest to Max, and had halved his own patrimony to help him.

"What good is money," he had screamed one day at Felix, "if you don't uphold the family honor? What good is my wealth if I can't help the man I've loved most in the world? . . ."

In late 1930, while other banks with names like Goldschmidt and Wassermann became the favorite targets of Nazi threats, Max was actually managing to survive; his fame for having unlimited access to American capital and his role as principal international negotiator had thus far protected him. As an influential member of the Reichsbank, he had, moreover, succeeded in having Hans Luther, the former Chancellor, appointed its new president, and in late 1931 he went to New York to explain to his brothers that there really was nothing to fear in Germany. Felix, on the other hand, exasperated by what he saw as irresponsible behavior on Max's part, demanded that he merge the M.M. Warburg Bank with other banks or change its name, and that he think about getting at least his family to a safe place. Once back in Hamburg, however, Max continued to be surprised at all this alarmism.

"Yes," he had said one day to Saxl, "the Jews are beginning to find themselves in a bit of trouble, but it's not the first time in history this has happened. And anyway, in Hamburg they can't touch a ruling class without whose support no government party is in a position to assert itself. Even Hitler, when visiting the city this summer, toned down his anti-Semitic rhetoric and told Wilhelm Cuno, the new head of the HAPAG, that he had no intention of getting rid of us, but only of reducing our economic power."

In late 1932 Paul died of a heart attack, leaving the rest of his fortune to Max as a final token of love. Amidst the silent disapproval of the entire family and the unambiguous resentment of Jimmy, who had tried up to the end to convince Felix and his father that the M.M. Warburg Bank was already dead, Max continued his activities as an important financier, investing a large part of his remaining capital in real estate market.

Even when, on March 5, 1933, the Nazis obtained 44% of the vote and Hitler was elected Chancellor, he continued to believe it was a momentary phenomenon, a temporary confusion that would soon be worked out. Finally taking

note of the rampant spread of anti-Semitism, however, he developed a two-sided attitude that Saxl was no longer able to follow. On the one hand he felt that his people should not run away or openly display cowardice, but on the other he became one of the most active organizers of the Jewish exodus into Palestine. In a few months he saw to the financing of thousands of refugees and had a hand in the Haavara Accord between the Jewish Agency and the Nazi government, which helped the first Jewish refugees to overcome the export boycott and provided incentives for the adoption of German machinery abroad. This accord, however, which was promoted by the Paltreu Organization, soon proved to be not only difficult to implement, but a total political paradox, since after the escape of about 50,000 people, Jews began to disappear into the concentration camps instead of among the outflow of emigrants. The following month Max was expelled from the Council of the HAPAG, the German-American shipping company founded by his dear friend Albert Ballin. This position, of all the Warburgs' representational appointments, had always been a source of pride (Even Aby had worked for them for several months, during the war). Just a few weeks later, that expulsion was followed by many more. He was shut out of the Administration Councils and banking affiliates he had founded himself, and barred from private societies and clubs. At Kosterberg, where for so many years the most illustrious names in politics and finance used to meet, the dinners and parties were suddenly deserted, and reservations at the Hotel Eden at Baden-Baden inexplicably refused. Still too carried away by his role as leader, Max continued not to react to these monstrosities. Considered all over Germany as a kind of new Moses, the man who would lead the Jews out of the hecatomb to safety, he then began to formulate a new form of Judaism, a religion above all the others which would overcome the conflicts between Jews and Germans and between Jews and Zionists. He dreamed of a Palestine populated by two-thirds of a German nation and by all the Russian emigrants who continued to pour out of the Soviet Union; he continued to believe in the possibility of a dialogue between Nazis and

Jews, which would take place through representative groups such as the Reichsvertretung, recently formed in Essen under the leadership of Leo Baeck.

But history was indifferent to his dreams. On March 23, Hitler opened Dachau; on April 1, the S.A. began boycott operations against Jewish businesses; and on April 7, a decree was issued ordering that all Jewish employees be fired from public administration and university positions. In mid-May, Nazi party functionaries placed his house under strict surveillance, taking note even of occasional visitors. In a few short weeks the last clients of the M.M. Warburg Bank dispersed in a great hurry.

Alice, who for months had been begging him to open his eyes, wanted to get some of the family out of harm's way and sent Renate and Anita off to their American cousins. Lola and Gisela stayed behind, while Eric was still shuttling between Hamburg, London and New York, trying to save what there still was to save.

*

Saxl had tried at first to support him in his absurd political expectations and his gestures of assistance to Jews, but as time kept passing, their disagreement was supplemented by an unbearable tension. Max's blindness risked ruining everything, while Saxl felt a moral duty to salvage what he was responsible for and overcome his forced subjection to Max once and for all.

In July the Gestapo evacuated the Bauhaus, expelled director George Heise—Aby's good friend—from the Kunsthalle of Hamburg, and did the same with Ernst Cassirer and Erwin Panofsky at the university. The same treatment was in store for Saxl, but he was informed of this a few hours beforehand and thus was not in his honorary professor's chair when the time came; rather, he hid in the elliptical room of the Library. The government had already suspended all the Library's activities at the beginning of May; it was no longer allowed to be associated with University initiatives, could no longer hold

its own seminars, nor house students and researchers. The Nazi periodical, *Volkische Beobachter*, called the courses given at the Institute dangerous and useless, "typical expressions of Jewish thought," while the research findings published in the *Studien* were reviewed as "empty reflections of pseudo science about science."

A few days after the book-burning at the University of Berlin and the seizure of thousands of volumes from the library of the University of Hamburg, Saxl found threatening letters under the front door at Heilwigstrasse in which the *Kulturwissenschaftliche Bibliothek Warburg* was called a "nest of Jews" that kept "dangerous materials concerning doctrines such as witchcraft and other mysterious devilries."

It was time to make a decision. But how to convince Max? And above all, where to go? Who would take in a cultural institute with 65,000 books and hundreds of thousands of documents? America was too far away, although the consul general himself, George Messersmith, had tried to save the situation by stating that the Library was an institution financed in part by American capital and therefore had a right to be transported to the United States. Italy—the natural site for the Library—was mired in a political situation similar to Germany's. Holland had welcomed the Institute but had not offered enough financial support. In England, however, Council of Academic Assistance had been formed to examine the situation of academics in exile; Edgar Wind, moreover, had in previous years established fruitful contacts with the Courtauld Institute, and these two events conspired in creating a favorable predisposition for the Library. Thus in late autumn, one of the Council's founding members, C. S. Gibson, and the director of the Courtauld, W. G. Constable, came to Heilwigstrasse to look into this unusual request for asylum.

Convincing Max that the Library had to leave Germany for its safety seemed impossible at first, but Saxl's tenacity had by now turned into desperation, and after a few weeks of exhausting arguments he finally succeeded. That same day they received a letter from Lord Lee of Fareham declaring his willingness to house the Warburg Library for a period of three years in his

new Thames House building, and stating that the Courtauld Institute would see to its financial support.

The problem now was to obtain permission and authorization from the Nazi government to leave the country. Questions of this sort, however, had been left in the hands of the local state authorities based in Hamburg—rather than with the Reich authorities in Berlin—and it was the former, in particular Wilhelm von Kleinschmidt, who handled the case. Some people in the meantime had argued that the books, if correctly distributed, could serve the new Nazi "cultural centers"; others argued that it would not be possible to integrate the group of librarians within the government apparatus "for reasons of a philosophical, religious and racial nature," and suggested that the volumes be donated outright to the government, which would do with them what it wished. After weeks of bargaining, however, in which Max finally offered all his resources as a negotiator, the government at last sent a signal, letting it be known that the authorities would not officially approve the transfer of books out of the country, but would in any case ignore it. They would also see to it that the press remained silent, and make sure that the Library's personnel could leave the country undisturbed.

Saxl left for London in late November to finalize the details of the move. At Heilwigstrasse, Herta von Eckardt, Hans Mayer, Edgar Wind, Gertrud Bing and Otto Fein began getting the crates ready for the transfer. At night, by candlelight and with the windows barred, five shadows moved about in haste and silence, emptying one by one each shelf and room that Aby Warburg had had built with such care and precision.

When he got back, everything was ready: the *Hernia* and the *Jessica*, two solid steamboats with ample holds, landed at St. Pauli shortly after midnight. It was December 12, 1933, and the Library, hidden in 600 crates, was about to leave its own country. By one o'clock, Herta and Gertrud had few packages left to seal, Hans and Otto few photos left to take care of, and Edgar and Fritz lent a hand here and there to whoever was in need. Six communist laborers had volunteered to assist in the transport of the crates. Had they been caught, they would have

had little to lose, since they stood to be persecuted for one reason or another in any case.

In those hours of darkness and frantic preparation, each person kept his feelings to himself, with the dignity and reserve typical of the German temperament. Fear and euphoria, excitement and regret remained hidden behind those stern faces, and if perchance a sigh or exclamation escaped from someone's lips, it was immediately swallowed back down, lost in the swiftness and efficiency of their movements. Saxl, for his part, tried not to feel anything at all, to suppress all emotion by pushing his body to the limits of exhaustion. All the doubts and fears he had coldly, rationally examined in the last few days now came back to him in the form of nightmares and torments. He would run up and down the stairs, seize a box or gather papers or tie some string, and at times he would just look at the Gertrud's strong, powerful body, which seemed to inspire a sense of security. Although he was used to making difficult decisions, the responsibility for this flight weighed more heavily on his shoulders than any before, for in this case he had decided not only for himself and the management of the Institute, but for five other lives as well, and for more than fifty years of work.

A little while later, as planned, Max came by to say goodbye. He looked very tired and his blue eyes bore an expression of deep sadness. He embraced Saxl with feeling and shook the others' hands with unprecedented warmth. Then he wanted to be left alone a moment and stood silently in the entranceway, as if in meditation or prayer. At last he left, his eyes wet with tears, and slipped quickly into the darkness of Heilwigstrasse. Mary went in and out of the small kitchen brewing and serving coffee, and helping with the packaging, comforting the others with the affection and wisdom of a tutelary goddess. With her swollen, ravaged face illuminated by a candle she held tight as if it were her last hope, she looked around in the darkest corners to make sure nothing had been forgotten. She had grown very fond of the laborers and gave them double portions of *krapfen* and large cups of black coffee. When everyone was finally ready to leave, they all gathered in the foyer to say their goodbyes to

those staying behind. Mary was all choked up; she would never again see Saxl, Gertrud, Edgar, Herta, or Otto. After so many years of friendship and solidarity she found herself alone again, like an islet of ice broken off from its iceberg, abandoned to the water's cold currents. And she remained like an islet of ice for hours, floating in the vast, deserted elliptical room, in which even her own heart produced a melancholy echo.

*

Before dawn the steamboats set off from St. Pauli laden with 65,000 volumes and thousands of photographs and documents, as well as chairs, desks, lamps, card-catalogues, binding presses and photographic equipment.

They sailed for the entire day between the broad banks of the Elbe, partially protected from the winter cold, which spread its icy wings once they reached the open sea. Inside, succumbing to their utter exhaustion, Fritz, Gertrud, Herta, Hans, Edgar and Otto fell into a deep sleep.

For the whole next day the boats advanced slowly against a hard, hostile wind. To port, the Dutch coast stretched its tongues of sandy land between the waves of the North Sea. A briny smell penetrated inside the cabins and clung stubbornly to their hair. The women, dressed like men and wrapped up in heavy sailors' jackets, looked numbly out on that colorless landscape. The men, still exhausted, smoked pipes or read, alternating between sleep and consciousness at irregular intervals. Around sunset, the wind died down and the city of Oostend, with its great lighthouse, announced that they were about to cross the Channel. On the other side, the English coast promised shelter and protection.

After a modest meal of canned herring, hard-boiled eggs and a robust red wine that Max had hidden in the hold, the small group of passengers fell back into the silence of fatigue. The cold outside entered relentlessly between the cracks of the rotting doors and scattered the precarious warmth of an oil stove.

From time to time they heard a groan, but no one had the energy to look into its source or cause. The rhythmical rolling of

the boat was occasionally broken by more abrupt movements, forcing those forlorn bodies to regain a precarious balance.

After leaving the coast of the continent and plowing through the long, regular waves for a number of hours, the two steamboats, with Dover to port, entered British waters. As they headed toward Cape Foreland, the sun was swiftly setting behind a blanket of gray clouds. Herta, alone in a corner, had started weeping silently; a combination of despair and seasickness had got the better of her, and all her usual brashness vanished behind her sorrowful expression.

At dawn the mouth of the Thames opened up before them, broad and safe like a long arm held out to them, a great hand ready to grasp the little boats and their heroic passengers. Then finally, after a peaceful stretch of sailing between the river's banks, the port of London greeted them with a festive air. It was the morning of December 15, and from afar the city's rooftops bristled with their snowy chimney-pots spouting sooty smoke. To starboard, in the distance, the Tower of London soared elegantly above the low-lying blanket of fog while closer by, to port, the austere, powerful mass of the Parliament building rivaled the smaller Westminster Abbey in beauty. All six passengers rose at once to look out their little portholes, which were so fogged up that the sight looked like something from a fairy tale. Herta, who had stopped crying some time before, resumed weeping more audibly, and was soon joined by Gertrud and Otto. Hans had seized a rag to wipe the portholes, while Saxl began to express his excitement in exultant, descriptive exclamations.

Then, after a few minutes of suspense, they all embraced and formed a circle of interlocked arms. They remained that way, with heads down, for several moments, celebrating, as in a silent, motionless *hora*, their "rite of passage."

*

Gertrud came back into the small room, opening the door wide, and making a decisive gesture to Fritz. Without hesitating this time, he rose from the large, black leather armchair, which had once belonged to Aby, emptied his pipe and joined his

companion. Once out of the Thames House, they were assailed by the paperboys selling the evening editions. The persecution of the Jews of Germany was continuing apace; each day hundreds of families were deported and resistors killed. A few days earlier, Max had written him a letter saying that he still wanted to stay in Germany to "defend his fortress." The only person left with him was Lola, who had also become a kind of hero of the Jewish cause. That very isolation, however, put them in great danger.

By mid 1934, the number of refugees arriving in London had fallen to 100 per month, compared to 300 per month throughout the previous year. The government, however, felt it necessary to centralize the immigration organizations and to impose new limits.

It would therefore become more and more difficult for Max to escape to safety, but by this point Saxl could no longer worry about him. He would have to carry on alone now, along the trail that he had blazed for so many years in the company of important and generous companions. He knew that Felix would continue to support the Institute, even while unreasonably insisting that it be transferred to New York.

His struggle had only begun, yet he knew that his tenacity and determination would once again come to his aid. The lights of the streetlamps reflected wanly on the wet pavement, while the shutters of the few stores still open began to close one after another. After walking along the Thames for a short stretch, they arrived in Trafalgar Square, where a swarm of pigeons was besieging the broad rim of the fountain. Fritz squeezed Gertrud's hand tight; they each knew what the other was thinking, and that tender awareness filled them both with hope.

Post Scriptum:

The Warburg Institute

Between 1934 and 1936, Fritz Saxl reopened the doors of the Library, now officially known as The Warburg Institute, and re-infused it with the same vitality and intellectual ferment that had characterized it during the 1920s.

In late May of 1934, the arrangement of the books was finally complete, and soon afterward scholars such as Henri Focillon and Johan Huizinga began a series of conferences and seminars. Ernst Gombrich and Otto Kurtz became part of the permanent staff; Frances Yates and Hugo Buchthal regularly frequented the Library and the photographic archive; and Edgar Wind and Rudolf Wittkower became directors of publication of the *Studies.*

At the end of 1936, the lease with Thames House expired, and the University of London offered to house the Library at the Imperial Institute with a ten-year rental contract. This solution, however, was never fully exploited. At the outbreak of war, the order was given to many London libraries to save whatever could be saved. The Institute was again dismantled and relegated to a warehouse outside the city.

When finally reconstituted in the spring of 1943, it was officially invited to become part of the University of London, which this time offered a permanent base, to replace the expired contract with the Courtauld Institute. The Warburg family accepted the offer on the condition that the Library was to be guaranteed total independence and freedom of choice. The

merger was made official in December of 1944 and the press headlined the event: "The greatest Christmas gift to England comes from Hamburg."

That same year Felix Warburg died in his New York mansion, and his wife Frieda donated the building to the Jewish Museum, which established its permanent home there. Max, who had managed to escape from Hamburg on the very last ship leaving the country, had joined the rest of his family in New York, where Felix's and Paul's sons were carrying on their fathers' tradition of magnanimity and social commitment. Sigmund, in London again, had meanwhile become head of the Warburg S. clan, whose political and financial power would yet play an important role in that country's history.

When Saxl died in 1948, Henry Frankfort took his place, and after him Gertrud Bing became Director of the Institute until 1959. After her death, Ernst Gombrich carried the Institute to the height of fame and prestige, creating a series of international relations and expanding its disciplinary interests.

The Warburg Institute today counts more than 300,000 titles, 2500 periodicals, and 300,000 photographs. A survey in the late 1980s showed that 40% of its titles are not available in the British Library. Yet the Warburg Institute's uniqueness lies not so much in the number of volumes as in their ordering, an arrangement that respects the wishes and intentions of its founder.

The books, moreover, are not kept apart from the public as in most modern libraries, but are freely accessible, so that they "will lead you not just to the book you are looking for, but to the book you need."

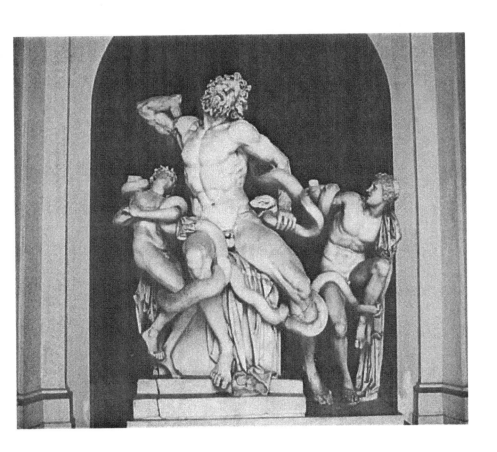

The Laocoon Group
The Vatican Museum, ROME

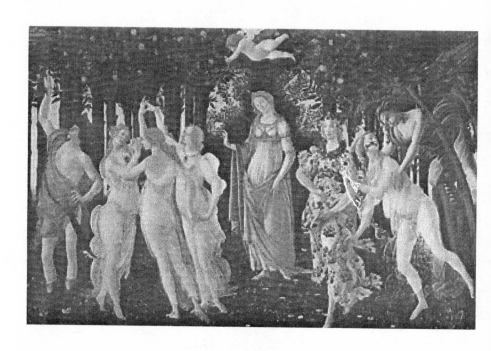

Sandro Botticelli—*La Primavera*
The Uffizi, FIRENZE

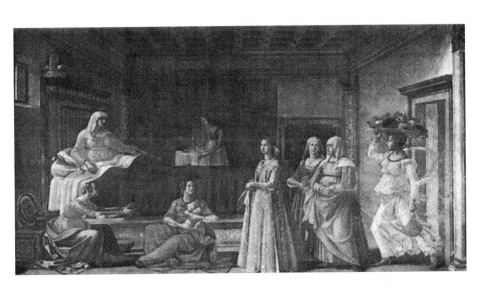

Domenico Ghirlandaio—*Nascita di Giovanni Battista*
Chiesa di Santa Maria Novella, FIRENZE

Francesco Cossa—*La Sala dei mesi*
Palazzo Schifanoia, FERRARA

Francesco Cossa—The black man with the rope
—*La Sala dei mesi*— (Detail)
Palazzo Schifanoia, FERRARA

Eduard Manet—*Le dejeneur sur l'herbe*
Le Louvre, PARIS

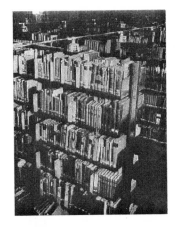

AbyWarburg In 1912

Book stacks inside the library

Fritz Saxi

The library completed

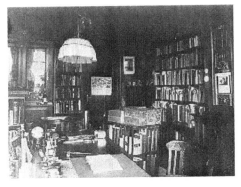

The studying room of Aby
Warburg

Building process of the library in
Heilwigstrasse

Indispensable Notes

1. Parts of the correspondence and diaries, including the passage on the Nymph from a letter to Andre Jolles, have been drawn from Ernst Gombrich's book, *Aby Warburg. An Intellectual Biography* (The Warburg Institute, London 1970).
2. All financial data concerning the M.M.Warburg Bank have been extracted from Jacques Attali's essay, *Sir Sigmund G. Warburg 1902-1982. Un homme d'influence* (Fayard, Paris 1985).
3. All descriptions concerning the KBW's architecture and organization have been drawn from Tilmann von Stockhausen's text, *Die Kulturwissenschaftliche Bibliothek Warburg. Architektur, Einrichtung und Organisation.* (Deming und Galitz Verlag, Hamburg 1992).
4. The text of the declaration of war is quoted from the *Times* of 7/31/1914
5. The poem of Rainer Maria Rilke is quoted from *The Selected Poetry of Rainer Maria Rilke,* Edited and Translated by Stephen Mitchell (Vintage International, 1989).
6. The passages from the *Serpent Ritual* lecture are drawn variably from the translation published in the *Journal of the Warburg Institute,* II (1938/39), which differs slightly from the first draft transcribed from the original notes jotted down by Warburg himself
7. Ernst Cassirer's speech was reprinted as an introduction to his book *Individuum und Kosmos in der Philosophie der Renaissance* (G.B.Teubner, in Volume X of the "Studien der Bibliothek Warburg") [translation by Stephen Sartarelli].

8. The information on the Warburg Institute in the Post Scriptum was drawn from the volume, *The Book Collector* (Volume 39, no.2, Summer 1990, The Warburg Insitute, London).

Bibliography

Agamben, Giorgio. "Aby Warburg e la scienza senza nome." *Aut-Aut* 1-4 (1984), pp. 51-66. (Originally published in *Settanta*, July-September 1975).

Agosti, Giovanni. "Qualche Voce Italiana della Fortuna Storica di Aby Warburg. *"Quaderni Storici* 58, (April 1985), pp. 39-50.

Argan, G.C. "Fritz Saxl," *Bollettino d' Arte*, (1948), pp. 180-81.

Attali, Jacques. *Une homme d' influence: Sir Sigmund* G. *Warburg, 1902-1982.* Paris [Fayard], 1985.

Galitz, Robert and Brita Reimers (curators). *Aby Warburg. Portrait eines Gelehrten* (Abstracts of the Hamburg Symposium, June 1994 Hamburg [Dolling und Galitz Verlag] 1995.

Bing, Gertrude. "A.M. Warburg." *Journal of the Warburg and Courtauld Institutes*, XXVIII (1965), pp. 299-313.

Bing, Gertrude. "Fritz Saxl (1890-1948): A memoir." pp. 1-46 in D. J. Gordon, editor, *Fritz Saxl, 1890-1948: A Volume of Memorial Essays from his friends in England*. London, Edinburgh, Paris, Etc. [Thomas Nelson and Sons Ltd.] 1957.

Bing, Gertrude. "Storici e Storia: Aby M. Warburg." *Rivista storica italiana*, 72 (1960), pp. 100-113.

Bing, Gertrud. "The Warburg Institute," *The Library Association Record*, s. IV, I (1934).

Binswanger, Ludwig *Being in the World: Selected Papers of Ludwing Binswanger.* [Souvenir Pr.] 1978.

Binswanger, Ludwig *Sogno ed Esistenza (Traum und Existenz).* [SE] 1993.

Birmingham, Stephen. *"Our Crowd": The Great Jewish Families of New York.* New York [Harper and Row] 1967.

Bleuler, Eugen. *Dementia Praecox or the Group of Schizophrenias* [International University Press] 1966.

Calabrese, Omar. "La geografia di Warburg. Note su linguistica e iconologia." *Aut-Aut 104* (1984), pp. 109-120.

Carchia, Gianni. "Aby Warburg: simbolo e tragedia." *Aut-Aut* 1-4 (1984), pp. 92-108.

Chernow, Ron. *The Warburgs.* [Random House] 1993.

Dal Lago, Alessandro. "L'arcaico e il suo doppio: Aby Warburg e l'antropologia." *Aut-Aut* 1-4 (1984), pp. 67-91.

Farrer, David. *The Warburgs: The Story of a Family.* New York [Stein & Day] 1975.

Ferrari, Massimo. "Il Tempo e la Memoria. Warburg, Cassirer, E. Panofsky in una Recente Interpretazione." *Storia della filosofia*, 2 (1987), pp. 305-319.

Ferretti, Silvia (Translated by Richard Pierce). *Cassirer, Panofsky and Warburg: Symbol, Art and History.* New Haven and London [Yale University Press] 1989. (Originally published as *Il demone della memoria. Simbolo e tempo storico in Warburg,*

Cassirer, Panofsky. Casa Editrice Marietti, 1984. See also Ferrari 1987, above).

Foster, Kurt W. "Aby Warburg's History of Art: Collective Memory and the Social Meditation of Images," *Dedalus*, N. 1-4, 1976.

Freud, Sigmund. *Lutto e Melancolia* in Opere Complete [Boringhieri] 1975.

Freud, Sigmund. *Casi clinici I (Signorina Anna 0.)* in Opere Complete [Boringhieri] 1975.

Gay, Peter. *Masters and Victims in Modernism Culture.* [Oxford University Press] 1978.

Gilbert, Felix. "From Art History to the History of Civilization: Gombrich's Biography of Aby Warburg." *The Journal of Modern History*, 44, #3 (September 1972), pp. 381-391.

Ginzburg, C. "Da A. Warburg a E. H. Gombrich. Note su un problema di metodo." pp. 29-105 in Ginzburg, Carlo. *Miti Emblemi Spie: Morfologia e storia.* Torino [Giulio Einaudi], 1986. (Originally published in *Studi Medioevali*, s. III, VTI-2 (1966), pp. 1015-1065).

Giorgetti, Alceste. "Aby Warburg," *Archivio Storico Italiano.* s. VII, 1935.

Gombrich, Ernst H. (translated from the German by Renato Cristin). "Aby Warburg, 1866-1929." *Aut-Aut*, 1-4 (1984), pp. 1-8. (Originally published in *Neue Zürcher Zeitung*, 11 December 1966).

Gombrich, Ernst H. *Aby Warburg: An Intellectual Biography.* London [The Warburg Institute, University of London] 1970.

Gombrich, Ernst H. "Rezension der Gesammelten Schriften Aby M.Warburg (1938). In *Aby Warburg Ausgewanlte Schriften und Wurdigungen.* Nerausgegeben von Dieter Wuttke. Baden-Baden, 1979.

Gombrich, Ernst H. "The Ambivalence of the Classical Tradition: The Cultural Psychology of Aby Warburg (1866-1929)." pp. 117-138 in E.H. Gombrich. *Tributes: Interpreters of our Cultural Tradition.* Ithaca, NY [Cornell University Press] 1984.

Hazard. Paul. *La crise de la conscience européenne.* Paris [Boivin]. 1935.

Heise, Carl Georg. *Personliche Erinnerungen an Aby Warburgs.* Hamburg [Gesellschaft der Biicherfreunde] 1959.

Heise. Carl Georg. "Aby M.Warburg als Leherer" (1966). in *Aby Warburg Ausgewanlte Schriften und Wurdigungen* Nerausgegeben von Dieter Wuttke. Baden-Baden 1979.

Hoffman. W.; Syamken. G.; Warnke M. *Die Menschenrechte des Auges. Uber Aby Warburg.* Frankfurt [Europäische Verlagsanstalt] 1970.

Klein. Robert. *La forme et l'intelligible: Ecrits sur la Renaissance et l'art moderne.* Paris [Gallimard] 1970.

Klibansky. Raymond. Erwin Panofsky and Fritz Saxl (Translated by Renzo Federici). *Saturno e la Melanconia.* Torino [Giulio Einaudi]. 1983. (Originally published as *Saturn and Melancholy. Studies in the History of Natural Philosophy, Religion and Art.* London [Thomas Nelson and Sons]).

Kris, Ernst and Otto Kurz (Translated by Giovarmi Niccoli). *La Leggenda dell'Artista.* Torino [Boringhieri]. 1989. (Originally

published as *Die Legende vom Kunstler.* Ein histroischer Versuch Vienna [Krystall]. 1934).

Liebeschutz. Hans. *Aby Warburg: An Interpreter of Civilization.* The Leo Baeck Institute Yearbook XVI. London 1971.

Mesnil. J. "La Bibliothèque Warburg et ses publications." *Gazette des Beaux-Arts~* Vs. XIV (1926).

Meyer. Anne Marie. "Aby Warburg in His Early Correspondence." *The American Scholar* (Summer 1988), pp. 445-452.

Neumeyer. Alfred. Review of Carl Georg Heise. *"Personliche Erinnerungen an Aby Warburg."* *American-German Review.* N.14., December 1947.

Pasquali. G. "Aby Warburg." *Pegaso* (April 1930). pp. 40-54. (Originally published as *Pagine stravaganti de un filologo.* Lanciano. 1933).

Pauli. Gustav. "In Memory of Professor Aby M. Warburg." *Hamburg-Amerika Post.* I (1929).

Pedretti, B. "Anche gli dèi emigrano. Note sulla tradizione warburghiana." *Quaderni piacenti*, 6 (1982), pp. 145-176.

Pedretti, B. "Il bibliotecario degli dei. Aby Warburg, il Maestro di Saxl," *Il Manifesto, 9* January 1983, p. 7. See also Settis piece of same date, below.

Poley, Joachim. "Aby Warburg zum Gedachtnis," *Neues Hamburg,* XI (1956).

Porter, Roy. *A Social History of Madness.* [Weidenfeld & Nicolson] 1987.

Radnoti, S. *Das Pathos und der Dämon, Über Aby Warburg.* Acta Hist.Art Hung, Tomus 31, 1985.

Raulff, Ulrich. "Zur Korrespondenz Ludwig Binswanger— Aby Warburg im Universitätsarchiv Tübingen." *Akten des internationalen Symposions Hamburg 1990.* Hamburg [Weinheim] 1991, pp. 55-70.

Raulff, Ulrich, editor. *Aby Warburg, Schlangenritual, Ein Reisebericht.* Berlin, 1988. (esp. pp. 84-94, "Zauberberg Bellevue").

Rossanda R. "Le avventure della mente. II campo infinito di Aby Warburg. Memoria/La Biografia di Abi Warburg Scritta de Ernst Gombrich." pp. 1-2 in *La Talpa giovedi* (supplement to *II Manifesto,* June 12, 1984).

Saxl, Fritz. "The History of Warburg's Library, 1886-1944." pp. 325-338 in E. H. Gombrich. *Aby Warburg: An Intellectual Biography.* London [The Warburg Institute, University of London] 1970.

Saxl, Fritz. "Pagan Sacrifice in the Italian Renaissance." *Journal of the Warburg and Courtauld Institutes,* II (1938/39), pp. 346-367.

Saxl, Fritz. *La storia delle immagini.* Roma-Bari [Editori Laterza], 1982. (Originally published as *Collected Lectures,* London [The Warburg Institute] 1957).

Saxl, Fritz (translated from the English by Alessandro Dal Lago). "La visita di Warburg nel Nuovo Messico." *Aut-Aut,* 1-4 (1984), pp. 10-16. (Originally published as pp. 325-330 in Saxl. Fritz. *Collected Lectures.* London [The Warburg Institute] 1957).

Saxl, Fritz. "Warburgs Mnemosyne Atlas" (1930).

Saxl, Fritz. "Die Bildersamrnlung zur Geschichte von Stemglaube und Sternkunde" (1930)

Saxl, Fritz. "Die Kulturwissenschaftliche Bibliothek Warburg in Hamburg" (1930).

Saxl, Fritz. "Rinascimento dell' Antichita." Studien zu den Schriften A. Warburg (1922).

Saxl, Fritz. "Odrucksgebarden der bildenden Kunst" (1932).

Saxl, Fritz. "Warum Kunstgeschichte?" (1948/1957) in *Aby Warburg. Ausgewanlte Schriften und Würdigungen* Nerausgegeben von Dieter Wuttke. Baden-Baden 1979.

Schafer, Karl-Heinz. Ernst Gombrich. Carl Georg Heise. *Aby Warburg zum Gedachtnis.* Hamburg Universitatsreden. Hamburg 1966.

Settis, Salvatore. "*Libri/La Storia Delle Immagini di Fritz Saxl.* Il passato del mondo vive nelle immagini. Con Fritz Saxl nellaboratorio di Aby Warburg." *II Manifesto, 9* June 1983, p. 7.

Settis, Salvatore. "Warburg *Continuatus.* Descrizione di una Biblioteca." *Quaderni Storici* 58 (April 1985), pp. 5-38.

Stockhausen, Tilmann von. *Die Kulturwissenschaftliche Bibliothek Warburg: Architektur, Einrichtung und Organisation.* Hamburg [Dölling und Galitz Verlag], 1992.

Trapp, Joseph B (translated by Antonio Gargano). "Aby Warburg e la sua Biblioteca." Text of lecture or essay dated 16 April 1983 (no further bibliographic information).

Warburg, A. (translated by Roberto Calasso). "Burckhardt e Nietzsche." *Aut-Aut 1-4* (1984), pp. 46-49. (Originally appeared in *Adelphiana,* 1 (1971), pp. 9-13).

Warburg, A. (translated by Gianni Carchia). "Il Dejeuner sur l' herbe di Manet: La funzione prefigurante delle divinita pagane elementari per l' evoluzione del sentimento moderno della natura." *Aut-Aut*, 1-4 (1984), pp. 40-45.

Warburg, A. "A Lecture on Serpent Ritual." *Journal of the Warburg Institute*, II (1938/39), pp. 277-293. (Originally delivered as a lecture in German on 25 April 1923 to fellow patients at the sanitarium.) (See also Italian translation by Gianni Carchia, "Il rituale del serpente." *Aut-Aut* 1-4 (1984), pp. 17-39).

Warburg, A. (collected by Gertrud Bing). *La rinascita del paganesimo antico*. Florence [La Nova Italia editrice], 1980. (Originally published as *Gesammelte Schriften*. Leipzig, 1932.)

Warburg, Eric M. "The Transfer of the Warburg Institute to England in 1933." *Warburg Institute Annual Report*, 1952-53, pp. 13-16.

Warburg, Max M. *Aus meinen Aufzeichnungen*. Glückstadt and New York. 1952 (esp. pp. 1-10, covering family background and childhood).

Wind, Edgar (translated by Renato Cristin). "Il concetto di Kulturwissenschaft di Warburg e il suo significato per l'estetica." *Aut-Aut*, 1-4 (1984), pp. 121-135. (Originally published as "Warburgs Begriff der Kulturwissenschaft und seine Bedeutung fur die Aesthetik." *Zeitschrift fur Aesthetik und allgemeine Kulturwissenschaft*, 25 (1931)).

Wind, Edgar. "On a Recent Biography of Warburg," *The Times Literary Supplement*, June 25, 1971, pp. 735-736 (Review of Gombrich, E.: *Aby Warburg: An Intellectual Biography*).

Wind, Edgar. "The Warburg Institute Classification Scheme." *The Library Association Record*, s. IV, II (1935).

Wittkower, Rudolf. *Allegoria e Migrazione dei Simboli.* Torino [Giulio Einaudi], 1987.

Wuttke, D. *Warburg, A.: Ausgewahlte Schriften und Würdigungen.* Baden-Baden, 1981.